Magic Lantern Guides

Nikon D8()

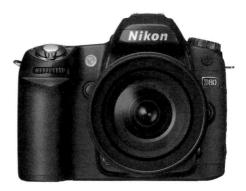

Simon Stafford

Editor: Haley Pritchard Art Director: Michael Robertson Cover Designer: Thom Gaines Associate Art Director: Shannon Yokeley Editorial Assistance: Delores Gosnell and Kathy Sheldon

Library of Congress Cataloging-in-Publication Data

Stafford, Simon. Nikon D80 / Simon Stafford. -- 1st ed. p. cm. -- (Magic lantern guides) ISBN-10: 1-60059-112-4 (pbk.) ISBN-13: 978-1-60059-112-9 (pbk.) 1. Nikon digital cameras--Mandbooks, manuals, etc. I. Title. TR263.N557325 2007 771.3'3-dc22 Digital camera S 2006038100

10987654321

First Edition

Published by Lark Books, A Division of Sterling Publishing Co., Inc. 387 Park Avenue South, New York, N.Y. 10016

Text @ 2007, Simon Stafford Photography @ 2007, Simon Stafford unless otherwise specified

Distributed in Canada by Sterling Publishing, c/o Canadian Manda Group, 165 Dufferin Street Toronto, Ontario, Canada M6K 3H6

Distributed in the United Kingdom by GMC Distribution Services, Castle Place, 166 High Street, Lewes, East Sussex, England BN7 1XU

Distributed in Australia by Capricorn Link (Australia) Pty Ltd., P.O. Box 704, Windsor, NSW 2756 Australia

This book is not sponsored by Nikon Inc. The written instructions, photographs, designs, patterns, and projects in this volume are intended for the personal use of the reader and may be reproduced for that purpose only. Any other use, especially commercial use, is forbidden under law without written permission of the copyright holder.

Nikon, Nikkor, Speedlight, and other Nikon product names or terminology are trademarks of Nikon Inc. Other trademarks are recognized as belonging to their respective owners.

Every effort has been made to ensure that all the information in this book is accurate. However, due to differing conditions, tools, and individual skills, the publisher cannot be responsible for any injuries, losses, and other damages that may result from the use of the information in this book. Because specifications may be changed by manufacturers without notice, the contents of this book may not necessarily agree with software and equipment changes made after publication.

If you have questions or comments about this book, please contact: Lark Books 67 Broadway Asheville, NC 28801 (828) 253-0467 www.larkbooks.com

Manufactured in the USA

All rights reserved

ISBN 13: 978-1-60059-112-9 ISBN 10: 1-60059-112-4

For information about custom editions, special sales, premium and corporate purchases, please contact Sterling Special Sales Department at 800-805-5489 or specialsales@sterlingpub.com.

Contents

B 5185 0474718 3

Introduction	15
Production of the Nikon D80	18
About This Book	
Conventions Used In This Book	
Introducing the Nikon D80	
Design	
Power	
MB-D80 Battery Pack	
Sensor	
Low Pass Anti-Aliasing Filter	
Infrared Coating Layer	
Micro-Lens Layer	
Bayer Pattern Filter	
File Formats	
The Viewfinder	
The Control Panel	
Autofocus	
Auto and Digital Vari-Program Modes	
Exposure Modes	
Exposure Control	
3D Color Matrix Metering II	
Center-Weighted Metering	
Spot Metering	
White Balance	
Image Processing	
The Shutter	
Shooting Modes	
Remote Release	
Additional Shooting Features	
The LCD Monitor	
Menus	46

Built-In Speedlight (Flash)	47
External Ports	49
Using Your D80	50
Quick Start – Getting Ready to Shoot	
Charging/Inserting the Battery	
Attaching the Camera Strap	
Choosing a Language	
Setting the Internal Clock	53
Mounting a Lens	54
Adjusting Viewfinder Focus	
Using a Memory Card	
Inserting a Memory Card	57
Formatting a Memory Card	58
Removing a Memory Card	
Simple "Point-and-Shoot" Photography	
Select an Automatic Exposure Mode	
Check the Camera	
Auto Mode Default Settings	61
Holding the Camera	
Composing, Focusing, and Shooting	63
Auto and Digital Vari-Program Modes	. 64
Auto	. 64
Portrait	. 66
Landscape	. 68
Close-Up	
Sports	
Night Landscape	
Night Portrait	. 72
Optimize Image Settings in the	
Point-and-Shoot Modes	
Basic Image Review	. 74
D80 Shooting Operations in Detail	. 76
Powering the D80	
Using The EN-EL3e Battery	
Using The MB-D80 Battery Pack	
External Power Supply – EH-5 AC Adapter	
The Clock/Calendar Battery	
Battery Performance	. 83

Secure Digital (SD) Memory Cards	86
Secure Digital High Capacity (SDHC)	
Memory Cards "	07
Formatting	87
File Formats	88
JPEG	90
NEF (RAW)	92
Which Format?	94
Image Quality and Size	94
Setting Image Quality and Size	96
White Balance	97
What Is Color Temperature?	98
White Balance Options	99
Selecting a White Balance Option 1	
Fine Tune Control of White Balance Values 1	
White Balance / Color Temperature Values 1	
Choose Color Temperature 1	04
Preset White Balance 1	
White Balance Bracketing 1	07
ISO Sensitivity with the D80 1	
ISO Rating 1	08
Setting ISO Sensitivity 1	09
ISO Auto 1	
TTL Metering 1	
Matrix Metering 1	12
Center-Weighted Metering 1	15
Spot Metering 1	15
Exposure Modes 1	16
P – Programmed Auto Mode 1	17
A – Aperture-Priority Auto Mode 1	18
S – Shutter-Priority Auto Mode	18
Shutter Speed Considerations 1	20
M – Manual Exposure Mode 1	20
Autoexposure Lock	
Exposure Compensation1	
Bracketing Exposure 1	23
Bracketing Considerations 1	25
Shutter Release 1	
Shooting Modes 1	
Single-Frame1	28

Continuous Frame	
Self-Timer	
Using a Remote Release Quick-Response Remote	122
Quick-Response Remote	132
Delayed Remote	132
Exposure Delay Mode (CS-31)	127
Multiple Exposure Image Overlay	126
The Autofocus System	
Autofocusing Sensor	
Focusing Modes	140
Single-Servo vs. Continuous-Servo	142
Predictive Focus Tracking	143
Trap Focus	144
Autofocus Area Modes	
AF Mode and AF-Area Mode Overview	
Focus Lock	
AF-Assist Illuminator	
Limitations of the AF system	
Using Non-CPU Lenses	151
Depth of Field	151
Depth-of-Field Preview	
Depth-of-Field Considerations	
Digital Infrared Photography	
Two-Button Reset	
Image Review Options	15/
Single Image Playback	
Information Pages	
Thumbnail Playback	
Playback Zoom	
Protecting Images	
Deleting Images	162
Assessing the Histogram Display	
Optimizing Images	
D80 – Optimize Image Options	
Optimize Image – Custom Options	168
Sharpening	
Tone Compensation	
Color Mode	
Saturation	1/4

Hue	175
Black and White	175
Camera Menus and Custom Settings	1/8
Accessing the Menus	180
Playback Menu	181
Delete	
Playback Folder	
Rotate Tall	
Slide Show	185
Hide Image	187
Print Set	
Shooting Menu	190
Optimize Image	190
Image Quality	190
Image Size	
White Balance	
ISO Sensitivity	
Long Exposure Noise Reduction	
High ISO Noise Reduction	
Multiple Exposure	
Custom Settings Menu	196
Simple Menu	
Detailed Menu	
Help Button	
Menu Reset	
CS-1: Beep	
CS-2: AF-Area Mode	
CS-3: Center AF Area	
CS-4: AF Assist	
CS-5: No Memory Card?	
CS-6: Image Review	
CS-7: ISO Auto	
CS-8: Grid Display	
CS-9: Viewfinder Warning	
CS-10: EV Step	
CS-11: Exposure Compensation	
CS-12: Center-Weighted	
CS-13: Auto BKT Set	
CS-14: Auto BKT Order	207

	CS-15: Command Dials	208
	CS-16: FUNC. Button	208
	CS-17: Illumination	210
	CS-18: AE-L/AF-L	210
	CS-19: AE Lock	213
	CS-20: Focus Area	213
	CS-21: AF Area Illumination	214
	CS-22: Flash Mode	214
	CS-23: Flash Warning	216
	CS-24: Flash Shutter Speed	216
	CS-25: Auto FP	217
	CS-26: Modeling Flash	
	CS-27: Monitor Off	
	CS-28: Auto Meter-off	219
	CS-29: Self-timer	
	CS-30: Remote on Duration	220
	CS-31: Exposure Delay Mode	
	CS-32: MB-D80 Batteries	
Set	tup Menu	
	ĊSM/Setup Menu	222
	Format Memory Card	223
	World Time	224
	LCD Brightness	225
	Video Mode	225
	Language	226
	USB	226
	Image Comment	227
	Folders	229
	File Number Sequence	231
	Mirror Lock-Up	
	Dust Off Reference Photo	232
	Battery Info	234
	Firmware Version	235
	Auto Image Rotation	235
Re	touch Menu	236
	Selecting Images	237
	Image Quality and Size	
	D-Lighting	238
	Red-Eye Correction	238
	Trim	239

Monochrome	239
Filter Effects	240
Small Ricturo	241
Image Overlay	242
Nikon Flash Photography	244
The Creative Lighting System	
i-TTL (Intelligent TTL) Flash Exposure Control	
Flash Output Assessment	
The Built-In Speedlight	
Nikon External Speedlights	
SB400	
SB-600 and SB-800	254
TTL Flash Modes (for Built-In and External Speedlights)	255
Understanding Nikon's Terminology	257
Non-TTL Flash Modes (SB-800 Speedlight)	260
Manual Flash Mode (Built-In Speedlight)	261
Repeating Flash (Built-In Speedlight)	262
Flash Sync Modes	263
Flash Synchronization in P, S, A,	
and M Exposure Modes	263
Flash Synchronization with	
Digital Vari-Program Modes	265
Slow Synchronization Flash	
Flash Exposure Compensation	
Flash Value (FV) Lock	
Flash Color Information Communication	
Auto FP High-Speed Sync	
Wide-Area AF-Assist Illuminator	
Shutter Speeds Available with the Built-In Flash	
Flash Range, Aperture, and Sensitivity (ISO)	
Maximum Aperture Limitations	
Limitations of the Built-In Speedlight	
Lens Compatibility with the Built-In Speedlight	
Using a Single Speedlight Off-Camera	
D80 Built-In Speedlight (Commander Mode)	277
Effective Range of the	
Advanced Wireless Lighting System	.280

Nikon Lenses and Accessories	
DX-Format Sensor	
Choosing a Lens	
Lens Compatibility	
Using Non-CPU Lenses	
Incompatible Lenses and Accessories	
Features of Nikkor Lenses	289
Filters	292
Polarizing Filters	292
Neutral Density (ND) Filters	292
Graduated Neutral Density Filters	293
General Nikon Accessories	294
Working Digitally	296
Digital Workflow	
Preparation	
Shooting	
Transfer	
Edit and File	
Processing	
Archive	
Display	
Caring for Your D80	
Cleaning the Low-Pass Filter	302
Troubleshooting	304
Error Messages and Displays	
Electro-Static Interference	
Approved Memory Cards	
Nikon D80-Approved Memory Cards	310
Memory Card Capacity	311
Image Information	
Exchangeable Image File Format (EXIF)	
International Press Telecommunications	515
Council (IPTC)	314
Connecting to a Television or Video Monitor	
Connecting to a Computer	
Card Readers	
Direct Printing	
Linking the D80 with a Printer	
Printing Multiple Images via PictBridge	320
rinning multiple images via rictoriuge	520

Digital Print Order Format (DPOF)	. 321
Nikon Software	323
Nikon PictureProject	324
Nikon View Pro	326
Nikon Capture NX	327
Nikon Camera Control Pro	. 329
Web Support	329
Glossary	330
Index	335

Introduction

For the past fifty years, Nikon has been one of the bestknown names in photography. From its first 35mm film camera—the Nikon I, introduced in 1948—through the launching of the F5 pro camera and the highly popular F100, Nikon has been a leader in film camera design. Yet, few would have predicted at the turn of the millennium that just a few years later Nikon would cease production of all film cameras with the exception of the F6. The effect of the explosive rise in the popularity of digital photography has forever changed the face of photography for amateur and professional photographers alike.

Nikon Corporation is not new to the business of building digital cameras; it has accrued many years of experience in this field. Its first efforts, during the early- to mid-1990s, involved a collaboration that combined sensors developed by Kodak with modified Nikon film-camera bodies. The first wholly independent Nikon digital SLR camera, the D1, was launched in 1999, followed by the D1X and D1H. These models broke new ground technically and made high-quality digital photography financially viable for many professional photographers.

By 2002, advances in sensor technology and the more economical price of Nikon's third generation camera, the D100, tempted many Nikon enthusiasts to take the digital plunge. Building on these solid foundations, the company went on to introduce the professional D2-series cameras, beginning with the D2H and including most recently the D2Xs, launched in mid-2006. Simultaneously on the consumer side, other cameras such as the entry-level D50 cam-

As Nikon's eleventh D-SLR, it is no surprise that the D80's imaging capabilities are superb.

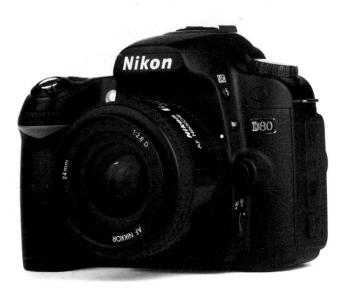

The D80 is a great addition to the fine line of Nikon D-SLRs.

era and the phenomenally successful D70-series models were introduced. The D70/D70s has been the best-selling Nikon camera manufactured to date. It is from this heritage that Nikon developed the D80, its eleventh digital SLR (D-SLR) camera model.

Nikon has high expectations for the D80, and believes its popularity will be at least as high, if not higher, than that of the D70/D70s. And it is no coincidence that many of the core features and functions of the D80 can also be found in other recent popular Nikon camera models, such as the D50 and D200. Rationalization of component parts from a variety of cameras works very much in Nikon's favor on two fronts: First, it allows a new model to reach the market much faster because of the use of existing tried-and-trusted parts rather than engineering new ones. Second, it permits the

The D80 is assembled at Nikon's production facility in Thailand.

economies of scale to be exploited by using higher volumes of single components, with the consequent reduction in the unit cost of manufacture. With the D80, Nikon has used these factors in achieving its goal of producing a camera that offers a good balance of features and performance at a very attractive price point. The D80 offers the flexibility to be operated either in a simple, fully automatic, point-and-shoot style, or with total user control of all its features and functions. This results in a camera with a broad appeal for very many photographers, from first-time D-SLR owners to a significant number of professionals.

The D70 and D200 were also manufactured at the Nikon Thailand plant.

Production of the Nikon D80

The D80 is assembled at Nikon's wholly owned production facility, Nikon Thailand. Many of the camera's parts are manufactured elsewhere, such as the camera's main printed circuit board, viewfinder optics, and lens mount, which are produced at the Nikon factory in Sendai, Japan. The Nikon Thailand plant, with 8000 mostly locally employed staff, has nearly 15 years in precision manufacturing experience, including production of the D70 and D200 digital cameras.

About This Book

To get the most from your Nikon D80, it is important that you UIIUUISUUID its footures so you can make informed choices about how to use them for your style UI pliotogra phy. This book is designed to help you achieve this objective. Besides explaining how all the basic functions work, this book also provides you with useful tips on operating the D80 and maximizing its performance. It does not have to be read from cover to cover; you can move from section to section as required, study a complete chapter, or just absorb the principal features of the functions you want to use. If you also want visual action tips and instructions on working with the camera to get you quickly acquainted with it, you may want to supplement this comprehensive guide with the Magic Lantern DVD Guide for the D80 camera.

Magic Lantern DVD Guide for the Nikon D80 camera.

The key to success, regardless of your level of experience, is to practice with your camera and take a lot of pictures. You do not waste money on film and processing costs with a digital camera; once you have invested in a memory card, it can be used over and over again. Therefore, you can shoot as many pictures as you like, review your results immediately, delete your near misses, and save your successes. This trial-and-error method is a very effective way to learn!

Conventions Used In This Book

Unless otherwise stated, when the terms "left" and "right" are used to describe the location of a camera control, it is assumed the camera is being held to the photographer's eve in the horizontal shooting position. When referring to a specific Custom Setting, it will often be mentioned in the abbreviated form "CS-xx," where xx is the identifying number of the function. In describing the functionality of lenses and external flash units, it is assumed that the appropriate Nikkor lenses (generally D- or G-types) and Nikon Speedlight units are being used. Note that lenses and flash units made by independent manufacturers may have different functionality. If you use such products, refer to the manufacturer's instruction manual, or better yet, check with an authorized Nikon dealer to check compatibility and operation. When referring to Nikon's software, such as Nikon PictureProject (initial deliveries of the D80 are supplied with version 1.7) or the optional Nikon View Pro, Nikon Camera Control Pro, and Nikon Capture NX, it is assumed that the most recent versions of each application are used to ensure full compatibility with D80 image files.

Simon Stafford Wiltshire, England

Introducing the Nikon D80

Design

The approach Nikon adopted when designing the D80 was to develop a camera that would integrate the ease of operation of their popular "prosumer" digital SLR models, such as the D50 and D70-series, with the professional specification and contemporary performance of the advanced D200 camera. Has Nikon achieved its aim? I believe they have, as the D80 is a very flexible camera that can be used by many different photographers with a wide range of ability, from the inexperienced family photographer who seeks nothing more than point-and-shoot convenience, to an experienced enthusiast photographer who expects to be able to control every aspect of their camera in order to fine hone their results.

Externally, the D80 appears somewhat akin to its predecessors, the D70s and D50 models, due principally to its compact size, though that is about as far any similarity goes. The D80 has an all-polycarbonate body, which encases an entirely new sensor that supports a two-channel processing regime (a modification of the four-channel sensor used in the D200 camera), a new electronically-timed mechanical shutter unit, and a 420-pixel RGB sensor for TTL metering and flash exposure control. Another new aspect of the camera is its autofocus sensor, the Multi-CAM1000, which also had its debut in the D200. Add to this the fact that the camera has a set of features and a comprehensive menu system that mirrors very closely those available on the semi-professional D200 camera model, and you soon realize how much potential the D80 possesses.

The first step to taking great pictures with the Nikon D80 is getting comfortable with the layout of the camera and its various features and functions.

Nikon D80 – Frontview

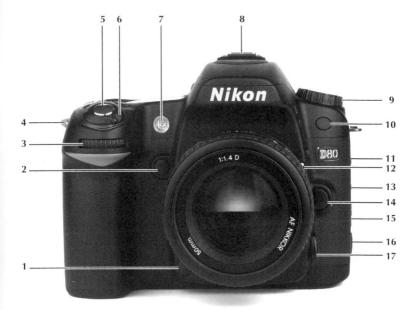

- 1. Depth-of-field preview button
- 2. FUNC. (Function) button
- 3. Sub-command dial
- 4. Eyelet for camera strap
- 5. Shutter release button
- 6. Power switch
- 7. AF-assist illuminator
- 8. Accessory shoe
- 9. Mode dial

- 10. Infrared receiver
- 11. USB connector
- 12. Lens mounting index
- 13. DC-IN connector for EH-5 AC adapter
- 14. Lens release button
- 15. Video connector
- 16. Remote cord connector
- 17. Focus mode selector

Nikon D80 – Rearview

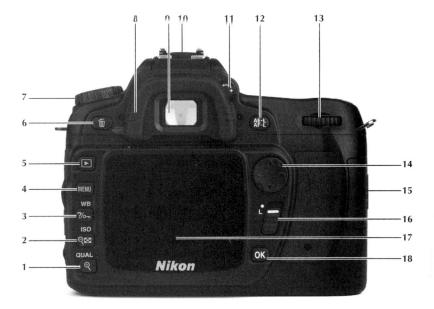

- 1. Playback zoom button / QUAL (image size/ .9 quality) button QUAL
- 2. Thumbnail button ବ୍ଞ 1 ISO sensitivity button 150
- 3. Help/Protect button 26-/ WB (white balance) button WB
- 4. MENU button MENU
- 5. Playback button
- 6. Delete button (/ Format button

- 7. Mode dial
- 8. Viewfinder eyepiece cup
- 9. Viewfinder eyepiece
- 10. Accessory shoe
- 11. Diopter adjustment control
- 12. AE-L/AF-L button
- 13. Main command dial
- 14. Multi selector
- Memory card slot cover
 Focus selector lock
- 17. LCD monitor
- 18. OK button

Nikon D80 – Topview

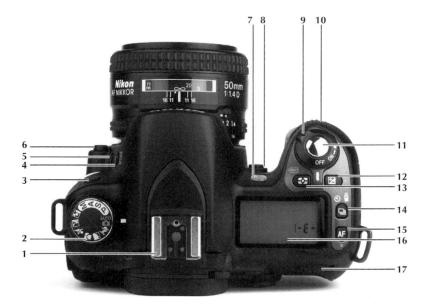

- 1. Accessory shoe
- 2. Mode dial
- 3. Infrared receiver
- 4. Flash mode button 0
- 5. Bracketing button
- 6. Lens release button
- 7. AF-assist illuminator
- 8. FUNC. (Function) button
- 9. Power switch
- 10. Sub-command dial

- 11. Shutter release button
- 12. Exposure compensation button
- Metering mode button
 Format button
- 14. Shooting mode button
- 15. AF mode button
- 16. Control panel
- 17. Main command dial

The D80 is an interchangeable lens D-SLR (digital singlelens reflex) camera that offers complete automation of exposure and focusing, as well as full manual control of all its features and functions. The current body is huilt from a polycarbonate material that imparts a rigid, solid feel to the camera while maintaining its lightweight quality. It has approximate dimensions of (W x H x D) 5.2 x 4.1 x 3.0 inches (132 x 103 x 77 mm) and weighs approximately 21 ounces (585 g) without battery or memory card.

The D80 has a Nikon F lens mount with an automatic focusing (AF) coupling and electrical contacts. The origins of this lens mount design can be traced back to the Nikon F 35mm SLR introduced in 1959; many early Nikkor lenses can be used with the D80. The greatest level of compatibility, however, is achieved with either AF-D, or AF-G type Nikkor lenses. Other lenses may be used, but they will provide a variable level of compatibility depending on their design. AF and Ai-P type Nikkor lenses offer a slightly reduced functionality in terms of the camera's TTL metering system (i.e., standard Color Matrix metering as opposed to 3D Color Matrix metering). It is even possible to use a number of manual focus Ai, Ai-s, Ai converted, and E-series Nikkor lenses, although the camera's TTL metering system, including TTL flash control, does not function, and lens aperture must be set via the aperture ring on the camera.

Data storage is accomplished using Secure Digital (SD) memory cards. The D80 is also able to support the new generation of Secure Digital High Capacity (SDHC) cards based on SDA 2.00 specification. These high capacity cards provide memory storage up to between 4 GB (gigabytes) 32 GB.

Power

A single Nikon EN-EL3e (7.4V, 1500mAh) rechargeable lithium-ion battery that weighs approximately 2.8 ounces (80 g) powers the D80. It is distinguished from other types of EN-EL3 batteries by its light grey casing. There is no alternative power source for the D80 that can be fitted internally; the standard camera body cannot accept any other type of non-rechargeable, or rechargeable battery. Battery performance is dependent on a number of factors, including condition of the battery, the camera functions and features used, and the ambient temperature. At a normal room temperature of $68^{\circ}F$ ($20^{\circ}C$), the power-up time of the camera is just 0.18 seconds, and it is quite possible to make many hundreds of exposures on a single fully charged EN-EL3e. The Nikon EH-5 AC adapter can also be used to power the D80 for extended periods of use.

Note: The D80 is not compatible with the earlier EN-EL3 or EN-EL3a batteries originally supplied with the Nikon D70-series and Nikon D50 cameras, although these camera models are compatible with the new EN-EL3e.

MB-D80 Battery Pack

The MB-D80 is a battery pack/grip that attaches to the base of the standard D80 body via the tripod socket. It can accept either one or two EN-EL3e batteries, or six AA-sized batteries that must be fitted in the MS-D200 battery holder. In addition to providing extra battery capacity, the MB-D80 has a shutter release button, main and sub-command dials, and an AE-L/AF-L button to improve handling when the camera is held in the vertical (portrait) orientation.

Hint: Fitting the MB-D80 requires the battery chamber door of the D80 camera to be removed; to prevent its loss, stow the battery chamber door in the slot set into the shaft of the MB-D80 that enters the camera's battery chamber.

Note: All electronically controlled cameras very occasionally exhibit some strange behavior with unexpected icons or characters appearing in the LCD display, or the camera ceases to function properly. This is usually due an electrostatic charge. To remedy the situation, try switching the camera off all removing and replacing the battery, or disconnect then reconnect the mains AC supply before switching the camera on again. If the problem persists, press the Reset button located next to the DC-in terminal on the left side of the camera.

Sensor

The Charge Coupled Device (CCD) sensor used in the D80 is a modified version of the sensor used in the Nikon D200 camera. Produced by Sony (a fact not officially acknowledged by Nikon), it has a total of 10.92 million photosites (pixels) of which 10.2 million are effective image-forming areas. Each photosite is just 5.9 microns square. This gives the camera a maximum resolution of 3872 x 2592 photosites (pixels), sufficient to produce a 16 x 11-inch (40 x 27.5 cm) print at 240 ppi (pixel per inch) without interpolation (resizing) in image-processing software.

The imaging area is 0.66 x 0.93 inches (15.6 x 23.7 mm), which is smaller than a full 35mm film frame of 1 x 1.5 inches (24 x 36 mm), but conveniently retains the same 2:3 aspect ratio. Nikon calls this their DX-format (elsewhere it is often referred to as the APS-C format), and uses this same DX designation to identify those lenses that have been optimized for use with their DX-format D-SLRs. Due to the smaller size of the DX-format digital sensor, the angle-ofview offered by any focal length is reduced when compared with a lens of the same focal length used on a 35mm film camera. Consequently, if the D80 is your first Nikon DX-format digital camera, the focal length of any lens you have used on a 35mm Nikon film camera should be multiplied by 1.5x to provide an approximation of the field of view the same focal length provides on the D80 (see page 283 for a full explanation.)

In a process adopted from the "flagship" D2Xs and the D200 models, the D80 performs what Nikon call "color independent analogue pre-conditioning" prior to the analogue signal from the sensor reaching the analogue-to-digital converter (ADC). The signal sent to the ADC from the sensor will often have a different output level for each channel (i.e. the red, green, and blue channels). The gain is altered for each channel prior to the analogue signal reaching the ADC to make certain it is in the optimum condition prior to the conversion process to a digital form, and thus as much of the data as much as possible is preserved to ensure maximum image quality.

Low-Pass Anti-Aliasing Filter

In front of the CCD sensor is a filter with an array of layers called the low-pass anti-aliasing filter. It has four specific purposes, and light passing through the camera on its way to the CCD sensor surface encounters these layers in a specific order: When you take a picture of a scene that contains very fine detail (i.e., the weave pattern in a piece of material), it is possible that the frequency of the detail matches (or is close to) that of the photosites (pixels) on the sensor. During the conversion from an analogue to a digital signal, this can lead to moiré effects or color fringes appearing between two areas of different color or tone, or on either side of a distinct edge. In the analogue-to-digital conversion process, there is a specific frequency, known as the Nyquist frequency, that is related to the pitch of the photosites on the sensor. Input frequencies below the Nyquist frequency will be reproduced properly but those above it have an increased tendency to generate moiré and color fringing (also known as aliasing) effects. The anti-aliasing filter of the D80 is designed to transmit frequencies that are lower than the Nyquist frequency for the pitch of the photosites on the camera's sensor; hence it is referred to as a "low-pass" filter.

Infrared Coating Layer

Although not visible to the human eye, a CCD sensor can detect infrared (IR) light. This is a problem in digital cameras because IR light can cause a perceived loss of image sharp-

The D80 cannot be used for digital infrared photography because the low-pass filter blocks nearly all IR light from reaching the sensor.

ness, reduced contrast, and other unwanted effects such as color shifts. Therefore, the optical low-pass filter used in the D80 has an anti-reflective IR layer to virtually eliminate the transmission of IR light to the sensor. Consequently, the D80 cannot be used for digital IR photography in the way that some earlier Nikon D-SLR cameras, such as the D70-series models, can.

Micro-Lens Layer

A CCD sensor is most efficient when the light striking it is perpendicular to its surface. To help realign the light rays projected by the camera lens onto the sensor, the filter array contains a layer of micro-lenses.

Bayer Pattern Filter

The pixels on the CCD sensor do not see in color; they can only detect a level of brightness. To impart color to the image, this layer has a series of minute red, green, and blue filters arranged in a Bayer pattern, named after the Kodak engineer who invented it. These filters are arranged in an alternating pattern of red/green on the odd numbered rows and green/blue on the even numbered rows. The final image that comprises 50% green, 25% red, and 25% blue is reconstructed by interpolating the values at each pixel site.

File Formats

The D80 can record images as two types of file; files compressed using the JPEG standard and files saved in Nikon's proprietary Nikon Electronic File (NEF) RAW format. The NEF files can only be saved in a compressed form; the D80 provides no option to record uncompressed NEF files. The files using the JPEG standard can be saved in three different sizes: Fine (low compression 1:4), Normal (medium compression 1:8), and Low (high compression 1:16). As the level of compression increases, there is a greater loss of original image file data. Furthermore, all JPEG compressed files are saved, ultimately, to an 8-bit depth in-camera.

The highest quality results come, potentially, from the NEF format; files recorded using this method contain the values direct from sensor without modification and virtually no other in-camera processing apart from the addition of information concerning camera settings. Nikon states that the compression applied to the 12-bit NEF files is "visually lossless," which is not quite the same as saying "lossless". The "visually lossless" claim comes about due to the method of compression used by the camera during the processing of an NEF file. It averages out the highlight data to reduce the file size but when this is converted back to a 12-bit form highlight tones can become restricted. However, since the human eye is unlike to resolve any change, Nikon describes the system as "visually lossless." To get the most out of your

NEF files, you will need additional software such as Nikon Capture NX, or a high-quality third party RAW file converter such as Adobe Camera RAW (see page 92 for details).

The Viewfinder

The D80 has a fixed optical pentaprism eye-level viewfinder that shows approximately 95% (vertical and horizontal) of the full frame coverage. It has an eve-point of approximately 0.77 inches (19.5 mm), which should provide a reasonably good view of the focusing screen and viewfinder information for users who wear eveglasses, plus there is a built-in diopter adjustment. To set the diopter, mount a lens on the camera and leave it set to infinity. Point the camera at a plain surface that fills the frame. Rotate the diopter adjustment dial (to the right of the viewfinder eyepiece) until the AF sensor brackets appear sharp. It is essential to do this to ensure that you see the sharpest view of the focusing screen. Since the built-in correction is not particularly strong, optional eyepiece correction lenses are available. These are attached by slotting them on to the eyepiece frame (the DK-21 rubber eyecup must be removed first). Similarly, the viewfinder eveniece does not have an internal shutter to prevent light from entering when the D80 is used remotely, so the camera is supplied with the DK-5 evepiece cap that must be fitted, using the same method as the evepiece correction lenses, whenever the camera is used this way in any of the automatic exposure modes.

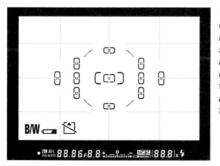

The viewfinder provides a comprehensive amount of information; the focusing screen markings show the active focus sensing area, optional grid lines, and warning signals for black-and-white mode, low battery, and no memory card.

Nikon D80 - Viewfinder

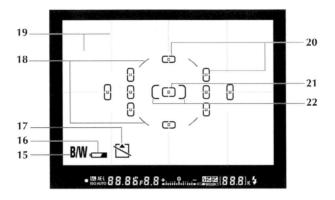

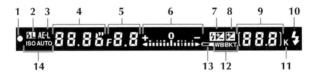

- 1. Focus indicator
- 2. Flash value (FV) lock
- 3. Autoexposure (AE) lock
- 4. Shutter speed
- 5. Aperture (f/number)
- 6. Electronic analog exposure display
- 7. Flash compensation indicator
- 8. Exposure compensation indicator
- 9. Number of exposures remaining / Number of shots remaining before buffer fills / Preset white balance recording indicator / Exposure compensation value / Flash compensation value / PC connection indicator

- 10. Flash-ready indicator
- "K" (appears when memory remains for over 1000 exposures)
- 12. Bracketing indicator
- 13. Battery indicator
- 14. Auto ISO sensitivity indicator
- 15. Black-and-white indicator
- 16. Battery indicator
- 17. "No memory card" warning
- 8 mm (0.31 inch) reference circle for center-weighted metering
- 19. Framing grid
- 20. Focus brackets
- 21. Normal-frame focus brackets
- 22. Wide-frame focus brackets

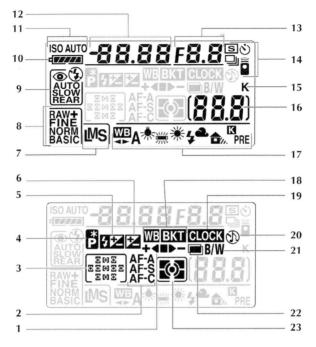

- 1. Bracketing progress indicator
- 2. AF mode
- 3. Focus area / AF-area mode
- 4. Flexible program indicator
- 5. Flash compensation indicator
- 6. Exposure compensation indicator
- 7. Image size
- 8. Image quality
- 9. Flash sync mode
- 10. Battery indicator
- 11. ISO AUTO indicator / Auto ISO sensitivity indicator
- Shutter speed / Exposure compensation value / Flash compensation value / ISO sensitivity / White balance fine-tuning / Color temperature
- 13. Aperture (f/number) / Bracketing increment / PC connection indicator

- 14. Shooting mode / Self-timer mode / Remote control mode
- "K" (appears when memory remains for over 1000 exposures)
- Number of exposures remaining / Number of shots remaining before memory buffer fills / PC mode indicator / Preset white balance recording indicator
- 17. White balance mode
- 18. Bracketing indicator
- 19. "Clock not set" indicator
- 20. "Beep" indicator
- 21. Black-and-white indicator
- 22. Multiple exposure indicator
- 23. Metering mode

The focusing screen is fixed and the viewfinder provides a very useful magnification of approximately 0.94x (much better than the D70-series and D50 cameras). The viewfinder display includes essential information about exposure and focus, including shutter speed, lens aperture, number of remaining exposures/number of remaining exposure before buffer memory is full, exposure and/or flash compensation warning, focus confirmation, low-battery warning indicator, and flash ready signal. The focusing screen is marked with four arcs to define a central .31-inch (8 mm) reference circle, and eleven small squares to indicate the center point of each autofocus sensing area. The D80 employs an LCD mask system in place of the more conventional LED type illumination for its focusing screen, so the screen only shows the bracket markings for the active focus area, which makes the rest of the viewfinder image far less cluttered and easier to see. There is a user selectable reference grid pattern that can also be displayed, which is very useful for aligning critical compositions, and keeping horizons level.

The Control Panel

This large monochrome LCD display on the top plate of the D80, which Nikon call the control panel, should not be confused with the color monitor on the rear. If the power is switched off, the only information shown is the number of remaining exposures available with the installed memory card, and if no card is inserted the display shows ($-\varepsilon$ -) to indicate empty. As soon as the camera is powered on, the display shows a wide range of camera control settings, including battery status, shutter speed, aperture, shooting mode, active focus sensor and focus area mode, white balance, audible warning, and image quality and size. Other controls will be indicated as and when they are activated.

Autofocus

The autofocus system is based on the new CAM1000 AF module (I.e., the system has up to 1000 individual points that are assessed in the process of focus acquisition, depending on the autofocus area mode selected), first seen in the D200 camera. It features seven sensors arranged in a diamond pattern. The central sensor is a cross type, whereas the other six (top, bottom, inner left, outer left, inner right, and outer right) are single line sensors. The inner columns of sensing areas, left and right of the central sensing area, are configured to operate as three distinct autofocus sensing areas by way of an electronic masking system; this provides the D80 with no less than eleven separate AF sensing areas. It also has the ability to vary the coverage of the central cross type sensor between its normal area and a wide area; the latter can improve the camera's ability to acquire focus with a moving subject.

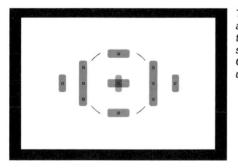

The diagram shows the approximate coverage of the seven autofocus sensing areas of the CAM1000 AF module used in the D200.

The detection range of the AF system is -1 to +19 EV at ISO 100. In low light levels, there is an AF assist lamp that has an effective range from 1'8'' - 9'10'' (0.5 m - 3 m). The system has three focusing modes: single-servo focus, continuous-servo focus, and manual focus. The camera will activate focus tracking automatically if it detects subject movement while the autofocus system is operating. In the continuous-servo focus mode, the camera will attempt to predict the position of the subject at the moment the shutter is released. The camera has three focus area modes: Single-area AF, Dynamic-area AF, and Auto-area AF.

The autofocus mode is selected via the AF mode button on top of the camera, which improves speed and handling compared with having to navigate through a camera menu to make the required setting.

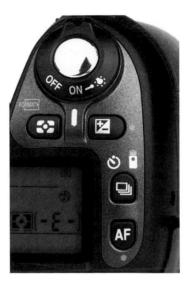

Auto and Digital Vari-Program Modes

The D80 is capable of being operated in a fully automated way for point-and-shoot photography. The Auto $\overset{\text{MTO}}{\square}$ option relinquishes all control to the camera and does not allow the user to apply influence or compensation on any of the settings selected by the camera pertaining to exposure or white balance, including exposure bracketing. In addition to the Auto setting there are six scene/subject specific automatic modes that Nikon refers to as Digital Vari-Program modes. These are: Portrait $\stackrel{\text{C}}{=}$, Landscape $\stackrel{\text{C}}{=}$, Close-up $\stackrel{\text{C}}{=}$, Sports $\stackrel{\text{C}}{=}$, Night Landscape $\stackrel{\text{C}}{=}$, and Night Portrait $\stackrel{\text{C}}{=}$.

Exposure Modes

The D80 offers four user-controlled exposure modes that determine how the lens aperture and shutter speed values are set. These are: Programmed Auto (P), Aperture Priority (A), Shutter Priority (S), and Manual (M).

- **P** Programmed Auto mode selects a combination of shutter speed and aperture automatically, but the photographer can override this using the flexible program feature (see page 117).
- **A** Aperture-Priority mode allows the photographer to select the lens aperture while the camera assigns an appropriate shutter speed.
- **S** Shutter-Priority mode allows the photographer to select the shutter speed while the camera assigns an appropriate lens aperture.
- **M** Manual mode places selection of both the shutter speed and lens aperture in the hands of the photographer.

Exposure compensation can be set over a range of -5 to +5 stops in increments of 1/3, or 1/2 EV. Exposure and/or flash exposure bracketing is available for either 2 or 3 frame sequences in increments/decrements of 1/3 or 1/2 EV up to a maximum step of +/-2 EV. In the automatic exposure modes (P, S, and A), the exposure settings can be locked using the AE-L/AF-L button I located on the rear of the camera.

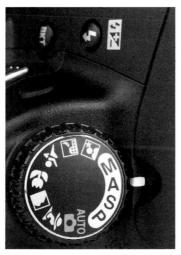

The exposure mode is selected via the mode dial; here aperture-priority (A) mode is set. The D80 has a sensitivity range (ISO equivalent) between ISO 100 and ISO 1600 that can be set in steps of 1/3 EV. Additionally, the sensitivity can be increased by up to 1 EV above ISO 1600, again in steps of 1/3 EV, to an equivalent ISO rating of 3200. The camera also has a noise reduction function that can operate at sensitivities of ISO 400, or above.

Exposure Control

The D80 offers three options within its TTL metering system, enabling the camera to cope with a variety of different lighting situations.

3D Color Matrix Metering II

The D80 uses a 420-pixel RGB sensor (the same one used in the D50 model but the D80 uses more advanced algorithms for data processing) located within the camera's viewfinder head to assess the brightness, color, and contrast of light with this metering method. Additional information from compatible lenses (D- or G-type Nikkor lenses) and the autofocus system is also taken in to account; based on the focus distance and which focus sensing area is active, the camera makes an assumption as to the likely position of the subject within the frame area. The D80 then uses a reference of over thirty thousand examples of photographed scenes and compares these with the information from the metering system to provide a final suggestion for the exposure value.

Note: Standard Color Matrix Metering is performed if CPU type lenses other than D- or G-type are attached to the camera. If you attach a non-CPU type lens (i.e., Ai, Ai-modified, Ai-s, or E-series types) the TTL metering system of the D80 does not operate, although it is still possible to use Manual exposure mode (the shutter speed is set on the camera, and the lens aperture via its aperture ring) and manual focus.

Center-Weighted Metering (*)

The camera meters from the entire frame area, but at its default setting assigns a bias to a central .31-inch (8 mm)

diameter circle in a ratio of 75:25. The diameter of the metered area can be altered from within the Custom Setting menu (CS-12).

Spot Metering

The camera meters a 0.13-inch (3.5 mm) circle, which represents approximately 2.5% of the full frame area and is centered on the active focus sensing area brackets. This occurs regardless of whether normal-area or wide-area AF coverage is selected for the central AF sensing area (CS-3).

Note: The 3D Color Matrix Metering II and center-weighted metering systems have an Exposure Value (EV) range of 0 - 20 EV, and spot metering is 2 - 20 EV.

White Balance

The D80 offers several choices for white balance control, including a fully automatic option **A** that uses the same 420-pixel RGB sensor in the viewfinder as the metering system. There are six user selectable modes for specific lighting ✤ (for incandescent lighting), Fluoconditions: Tungsten (for fluorescent lighting), Direct Sunlight rescent (for lighting by both the internal and ⋇ Flash 4 (for daylight under an external flash units), Cloudy overcast sky), and Shade five. (for daylight in deep shade). Each of these settings can be fine-tuned to impart a slightly warmer (redder) or cooler (bluer) color. In addition, the D80 has options to set the white balance control to a specific color temperature from thirty-one different values expressed K , or you can use the Preset PRE in degrees Kelvin option that can be set by assessing the color temperature of the prevailing light reflected from an appropriate test target (only one white balance value can be stored in the Preset selection at a time and recalled as required).

Image Processing

In the fully automated point-and-shoot Auto and Digital Vari-Program modes, values for image attributes of sharpening, tone (contrast), color mode, saturation, and hue are assigned automatically; the user has no level of control over the settings used by the camera. In P, S, A, and M exposure modes, on the other hand, values for image attributes of sharpening, tone (contrast), color mode, saturation, and hue are assigned by a number of options found in the D80's Optimize Image control. The purpose of these options is to allow an image to be processed according to how it will be used, or the type of subject/scene being photographed. The Optimize Image options include: Normal, Softer, Vivid, More Vivid, Portrait, Custom, or Black & White. The camera sets values automatically for all options, with the exception of the Custom option, which allows the user to define their own settings, and the Black and White option that allows the user to set the level of sharpening and tone (contrast) as required via its internal custom option (see page 175 for a more detailed description.)

The Shutter

The D80 uses an electronically timed mechanical shutter. The shutter release lag time is just 80 milliseconds, with a viewfinder (mirror) blackout time of approximately 105 milliseconds, and a maximum flash sync speed of 1/200 second (assuming Automatic Hi-speed FP Sync mode—CS-25—is not active in the P, A, S, and M exposure modes). The shutter speed range runs from 30 seconds to 1/4000 second and can be set in increments of 1/3 or 1/2 EV. There is also a bulb option for long exposures beyond 30 seconds.

To help reduce the effects of internal camera vibrations caused by the movement of the reflex mirror when it is raised up out of the light path, the D80 has an exposure delay mode (CS-31). After the shutter release button has

Use the D80's exposure delay mode (CS-31) to reduce camera shake due to internal vibrations.

been pressed, the reflex mirror lifts almost instantly, and the exposure delay mode then introduces a delay of four-tenths of a second before the shutter blades open. This allows time for any vibration generated by mirror movement to dissipate.

The D80 has a long exposure noise reduction function that can be set to operate at shutter speeds of 8 seconds or longer via the Shooting menu. However, the recording time for each exposure is extended by up to 100%, as the camera performs a dark frame exposure as part of the long exposure noise reduction process.

Shooting Modes

The shooting mode determines when the camera makes an exposure. In single shooting mode, the camera takes a single photograph each time the shutter release button is fully depressed. In continuous shooting mode, the camera shutter cycles up to a maximum rate of three frames per second (fps) while the shutter button is depressed. However, the effective frame rate will be limited by a number of factors, including the camera functions that are active, the selected shutter speed, and the capacity of the remaining buffer memory.

Self-Timer Mode

The self-timer mode is useful for self-portraits and reducing the loss of sharpness caused by vibrations generated by touching the camera, in particular the shutter release button, especially when shooting at a high magnification, or using a very long focal length. The delay of the self-timer can be set to 2, 5, 10, or 20 seconds.

Remote Release

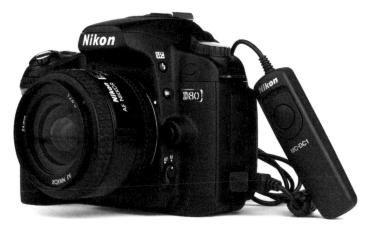

The shutter of the D80 can be released remotely via the MC-DC1 cable, which has a locking shutter button for making long time exposures.

The shutter of the D80 can be released remotely using one of two different accessories. The ML-L3 infrared remote release allows the shutter release to be activated wirelessly. Alternatively, the MC-DC1 remote release cable can be connected to the remote release terminal on the left side of the camera body. The MC-DC1 also features a locking shutter release button to enable long time exposures to be made with the D80 (see page 295 for a more detailed description of both these accessories).

Additional Shooting Features

- **Multiple Exposure** The D80 supports a multiple exposure mode that records either two or three separate exposures (using either NEF or JPEG standard files, but not a combination of the two) to form a single image. The user can select an automatic gain control within this feature to adjust the density of the final image to compensate for the total number of exposures made.
- **Image Overlay** It is possible for the D80 to create a single composite image that can be saved in either the NEF or JEPG format using two NEF files shot on the D80 camera and saved on the same memory card. The two original NEF files are unaffected by this process, as the new image is saved separately.

The LCD Monitor

On the rear of the D80 is a 2.5-inch, 230,000-pixel color LCD monitor that offers a viewing angle of 170° which, unlike the viewfinder display, shows virtually 100% of the image file during image review. Pictures can be reviewed either as a single image or in multiples. When used to display a single image, the review function has a zoom capability that enables it to be enlarged by up to 25 times, which equates to a 400% view of the image.

Using the multi selector, you can scroll through a range of five pages of shooting/image information (or six if the image was created using the Retouch selection options. These information pages are either superimposed on or shown beside the image when reviewed in single-image playback. They include a page of basic information, two pages of shooting data, a page that displays a highlight warning option that causes potentially overexposed areas to blink, and a single page showing individual histograms for each color channel (red, green, and blue) plus a histogram for the composite channel. The sixth page displays image data created using the Retouch menu options, including a Retouch menu history that lists changes made to the original image. You can edit your pictures while they are still held in the camera by reviewing them on the LCD monitor, with the option to delete them or protect them from being deleted unintentionally (see pages 161-162 for more details.)

In addition to image playback and the display of image information, the LCD monitor is used to display the various camera menus. These menus allow you to activate or deactivate a wide range of camera features and functions. The brightness of the LCD monitor screen can be adjusted via the Setup menu.

Menus

Although most of the principle controls of the D80 can be accessed easily and operated by buttons or dials located on the camera body, there are some core functions and features that must be set and/or applied via the camera's five menus: Playback \blacktriangleright , Shooting \frown , Custom Settings \mathscr{O} , Setup \Im , and Retouch \mathscr{O} . To facilitate access to items in any of the five menus available on the D80, a feature known as "My menu," selected via the Setup menu, allows you to select the options from the menu system that you use most often to be displayed.

The D80's internal menu system has a variety of helpful features to supplement the basic button and dial controls on the outside of the camera body.

To open any of the D80 menus, press the Menu button on the left back of the camera beside the LCD monitor. Select the appropriate menu by using the multi selector. The various options and sub-options are color coded to facilitate navigation and selection of the required setting. The D80 supports menus in no less than fifteen different languages, selected via the Setup menu.

Built-In Speedlight (Flash)

Nikon always refers to their flash units, built-in or external, as Speedlights. The D80 has a built-in Speedlight housed above the viewfinder. In Auto, Portrait, Close-up, and Night Portrait Digital Vari-Program modes, the built-in flash will pop up automatically if the camera determines the light

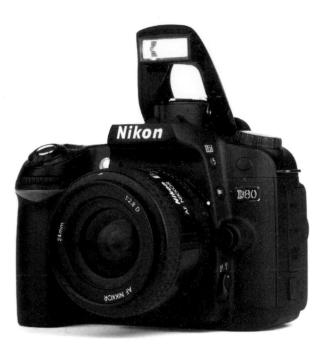

The built-in Speedlight of the D80 can be useful for providing fill flash and is capable of controlling multiple remote flash units for wireless TTL flash photography.

level is sufficiently low to require additional illumination. The built-in Speedlight will not pop up automatically in P, A, S, or M exposure modes, so if you wish to use it, it must be activated manually by pressing the Speedlight lock release button • on the left top of the camera beside the viewfinder head.

At full output, the Guide Number (GN) of the built-in Speedlight is GN 42/13 (ft/m, ISO 100), and is fully compatible with Nikon's Creative Light System, including the latest i-TTL flash exposure control system for balanced fill-flash, though it defaults to standard i-TTL flash when spot metering is selected. It also supports the Advanced Wireless Lighting system whereby the built-in flash can be used to control a number of romote flash units (SR-800, SB-600, or SB-R200).

The built-in flash can be used with any CPU-type lens with a focal length of between 18mm and 300mm. The minimum distance at which the Speedlight can be used is 2 feet (0.6 m). However, with certain lenses, the minimum distance must be greater due to the proximity of the flash tube to the central axis of the lens. Otherwise light from the flash is prevented from illuminating the entire frame area (see pages 244-281 for full details on using the D80 with flash).

External Ports

On the left side of the D80 camera body there are a pair of rubber port covers. Under the larger of the two covers (top) is a port for connecting the camera to a computer or printer (the D80 supports high-speed USB 2.0 for data transfer), a port for connecting the EH-5 AC adapter, and another for connecting the camera to a TV set for image playback; the Reset button is beside the terminal for the EH-5 AC adapter. Under the smaller cover (bottom) is the port for connecting the MC-DC1 remote shutter release cord.

Using Your D80

Quick Start Guide – Getting Ready To Shoot

It is only natural to want to start using your new D80 camera as soon as you lift it from its box. However, before you start shooting your first pictures there are a few basic steps that you need to take to prepare the camera. It is also well worth spending a little time to acquaint yourself with the principle controls and functions of the camera to ensure that you're getting the most out of its many features.

Charging/Inserting the Battery

The D80 is entirely dependent on electrical power so, at the risk of stating the obvious, it is essential that the EN-EL3e battery is fully charged before any extended use of the camera. (The battery supplied with the camera is only partially charged.) There is no need to pre-condition the battery, but for its first charge, leave it connected to the MH-18a charger until it is cool to the touch. Do not be tempted to remove it as soon as the charge indicator lamp on the MH-18a has stopped flashing.

The EN-EL3e battery is charged using the dedicated MH-18a AC charger.

Before heading out for a day of shooting, be sure that you have a fully charged battery inserted in the D80. To insert the battery, first make sure that the camera power switch is set to OFF. Then, turn the camera over and slide the battery-chamber cover lock toward the center of the camera. Open the cover, and insert the battery, making sure its three contacts face the battery-chamber cover and enter first. Lower the battery into place, and then press the chamber cover down until it locks; you should hear it click into place. Now turn the camera power switch to ON and check the battery-status indicator in the control panel LCD to confirm that the battery is fully charged; **T**

The control panel LCD displays a wealth of information, including the condition of the battery. Note the battery charge icon the batin the top left-hand corner.

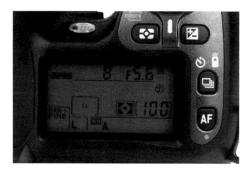

The EN-EL3e battery is able to communicate a range of information to the D80 so that the user can monitor battery status via the <Battery info> option in the setup menu, and check the battery charge level by observing the display in the control panel LCD screen.

Attaching the Camera Strap

The camera strap is not only useful for securing the camera while carrying it to prevent it from being dropped accidentally, but also for bracing the camera to help reduce the risk of camera shake spoiling your pictures. Adjust the strap to a length where, when it is wound around your arm, it is taught and aids in the support of the camera. To attach the strap to the camera, start by threading one end through the left strap eyelet on the camera body, then feed the strap back through the keeper-loop. Next, pass it through the inside of the buckle, under the section of the strap that already passes through it, before pulling the strap tight. Repeat this process with the other end of the strap, working it through the right camera eyelet. Finally, adjust the strap to your preferred longth

Choosing a Language

Once you have inserted a fully charged battery, turn the camera on by rotating the power switch (located on the right top of the camera) to the ON position.

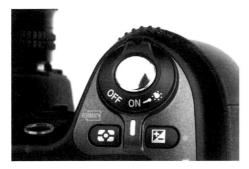

The main power switch to the D80 is located on a collar around the shutter release button.

To select the language to be used for the camera menu system, press the we button. When you do this after switching the camera on for the first time, the <Language> option from the Setup menu is displayed. Press the multi selector button up or down until the required language is highlighted, then press the we button to confirm and lock your selection. If you wish to change the language at any time, open the Setup menu, highlight the <Language> option, then repeat the procedure just described.

Setting the Internal Clock

The D80 has an internal clock powered by an independent rechargeable battery. This battery is charged from the camera's principal power source (either the EN-EL3e battery or the EH-5 mains AC supply).

Note: The clock battery is not accessible by the user. It requires approximately 48 hours of charging to power the clock for approximately one month. Should the clock battery become exhausted, the **CLOCK** icon will flash in the control panel and the clock is reset to a date and time of 2006.01.01 and 00:00:00 respectively. It will be necessary to reset the clock to the correct date and time should this occur.

Once you have selected the language, the <Time Zone> option in the <World Time> menu will be displayed; use the multi selector to highlight the appropriate local time zone and press the button to confirm and lock your selection.

The <Daylight Saving Time> page will now open, and you can use the multi selector to highlight either <On> or <Off> as required for your local time zone, then press the button to confirm and lock your selection. The last page to open is the <Date> page; press the multi selector to the left or right to highlighted each box and press it up or down to adjust the setting as required. Once you have completed setting the date and time, press the for monitor will turn off and the camera is returned to shooting mode.

Hint: The internal clock is not as accurate as many wristwatches and domestic clocks, so it is important to check it regularly, particularly if the camera has not been used for a few weeks.

Mounting a Lens

To access all the functions and features of the D80, you will need either a G-type, or D-type Nikkor lens (see pages 282-291 for more details). Identify the index mark (white dot) on the lens and align it with the index mark (white dot) next to the bayonet ring of the camera's lens mount. Enter the lens bayonet into the camera and rotate the lens counter-clockwise until it locks into place with a positive click.

Hint: Whenever you attach or detach a lens from the D80, ensure that the camera is turned off. If you leave the camera turned on there is a risk that, as the lens is rotated, the electrical contact pins on the lens mount could cause an improper connection with the contact plates in the camera, resulting in an electronic malfunction.

Mounting a lens on the D80 requires the two white index marks one on the lens the other on the edge of the camera's lens mount flange—to be aligned.

Apart from G-type lenses that lack a conventional aperture ring, it is necessary to set the aperture ring of all other CPU-type Nikkor lenses to the minimum aperture value (highest f/number) before mounting the lens. I also recommend that you use the small locking switch to ensure the aperture ring is secured in this position.

Hint: If you turn the camera on after mounting a lens and **FE E** appears blinking in the control panel and viewfinder, the lens has not been set to its minimum aperture value. In this state, the shutter release is disabled and the camera will not operate.

To remove a lens from the camera, press and hold the lens release button (on the left front of the camera next to the lens mount), then turn the lens clockwise until the index mark on the lens is aligned with the index mark next to the camera's lens mount. Now lift the lens clear of the camera body. If you do not intend to mount another lens right away, always replace the BF-1A body cap to help prevent unwanted material from entering the camera.

Adjusting Viewfinder Focus

The viewfinder eyepiece of the D80 has diopter adjustment so that the camera can be used regardless of whether you normally wear eyeglasses or not. To check and set the viewfinder focus, attach a lens to the camera as described in the previous section, then turn the camera on and select the central focus sensor area using the multi selector button. Now look through the viewfinder and rotate the diopter adjustment control wheel (located on the right side of the viewfinder on the camera back) until the focus area brackets appear sharp. If the viewfinder display turns off as you are making adjustments, press the shutter release button halfway to reactivate the focus sensor displays.

The viewfinder has a diopter adjustment control located to the right of the viewfinder eyepiece on the camera back.

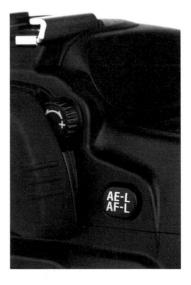

Note: It is usually easier to assess viewfinder focus if the camera is pointed at a plain, light-colored surface. To prevent the autofocus system from "hunting" when pointed at a featureless subject such as this, switch to manual focus by rotating the focus-mode selector (located of the left front of the camera below the lend release button) to M and adjust the lens to infinity focus (set the infinity mark on the lens distance scale against the focus index point).

Using a Memory Card

The D80 uses Secure Digital (SD) memory cards to record pictures. SD cards use a solid-state flash memory (i.e., there are no moving parts). The D80's memory card slot can accommodate one card at a time. (A list of memory card brands that have been tested and approved by Nikon is shown on page 310).

Inserting a Memory Card

First, ensure that the power switch is set to the OFF position. Open the memory card slot cover by sliding it towards the back of the camera (follow the small arrow mark); the door will swing open to reveal the memory card slot. Insert the card with its contacts pointing into the slot; the small writeprotect switch should be at the bottom and the main label on the memory card should be facing you. The card will slide in so far and then you will feel a slight resistance. Keep pushing the card until it clicks in to place (the green memory card access lamp illuminates briefly as confirmation that the card is installed properly). Finally, close the memory card slot cover.

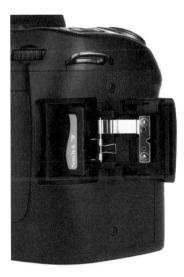

The memory card slot cover on the D80 simply slides backwards to reveal the memory card slot. **Hint:** Pay attention to the orientation of the memory card when you insert it. The main label of the memory card should face you (face toward the back of the camera) and the beveled corner should be to the top left as you look at the card.

Formatting a Memory Card

All new memory cards must be formatted before first use. If an unformatted card is inserted in the camera, the following error message is displayed on the monitor screen: "This card is not formatted. Format card?" To format a card with your D80, insert an SD card as described in the previous section and switch the camera to the ON position. Press and hold the 🛛 and 🔘 buttons for approximately two seconds until (For) appears flashing in the control panel together with a flashing frame count display. Then push the Ð and **(** buttons again to initiate formatting. Alternatively, you can use the format command in the Setup menu, but this method is slower to perform and involves using the LCD monitor, which increases power consumption and drains the battery faster. Once formatting is complete, the frame count display shows the approximate number of photographs that can be recorded at the current size and quality settings.

Caution: If you press any other button after **(For**) begins to flash, the format function is cancelled and the camera returns to its previous state.

Caution: Be careful not to switch the camera off or otherwise interrupt the power supply to the camera during the formatting process.

Hint: It is good practice to format your memory card each time you insert it into the camera, even if you have deleted the contents of the memory card using a computer. If you do not get in to the habit of doing this, there is an increased the risk of problems occurring with the communication between the memory card and the camera, particularly if the memory card is used in different camera bodies.

Before removing a memory card from the D80, make sure that the green access lamp is extinguished or you may interrupt the data transfer and cause images to be corrupted or lost.

Removing a Memory Card

Make absolutely sure that the green memory card access lamp has gone out before switching the camera off and attempting to remove a memory card. Then, open the memory card slot cover and push the exposed edge of the SD memory card towards the center of the camera. The memory card will be partially ejected and can then be pulled out by hand.

Note: You should be aware that memory cards can become warm during use; this is normal and not an indication of a problem.

If the D80 has no memory card inserted when a charged battery is installed, or it is connected to a mains AC supply via the EH-5 AC adapter, [-E-] appears in the exposure counter brackets in both the viewfinder and control panel displays

Simple "Point-and-Shoot" Photography

The Nikon D80 is designed to operate in many ways like a 35mm film SLR, and has many features in common with other Nikon SLR cameras, both film and digital. At its most basic level, the D80 can be used for simple "point-and-shoot" photography in which the camera controls most of the settings according to the shooting conditions that prevail. As well as its fully automatic Auto mode there are six additional scene-specific automatic modes in which the camera attempts to tailor its settings to suit the nature of the subject. While these Digital Vari-Programs, as Nikon calls them, may appear tempting to the less experienced photographer, it is important to remember that a camera cannot think for itself—only photographers can do that!

By using one of these modes, you not only relinquish all exposure control to the camera, but you are also locked out of several other key functions, including white balance, metering mode, exposure compensation, exposure bracketing, and flash exposure compensation. In my opinion, the Digital Vari-Program modes are potentially more of a hindrance than a help to any photographer seeking to develop their photographic skills; you can never be sure what settings the camera is using. Still, Nikon has seen fit to include these options, and I am sure a great many users of this camera will be content to rely on them. Therefore, this section provides a guide to using the D80 as a fully automatic camera.

The D80 is easily capable of lending itself to simple pointand-shoot type photography due to its highly automated options, such as the Auto mode.

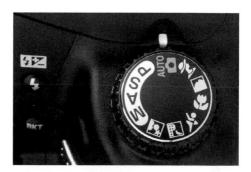

Select an Automatic Exposure Mode

Once you have prepared the camera for shooting, rotate the mode dial to are or choose one of the Digital Vari-Program modes (selected by turning the mode dial so that the desired mode icon is aligned with the white index mark on the right side of the viewfinder head).

Check the Camera

Switch the camera on. Check that the battery indicator in the control panel LCD to see that the battery is fully charged and determine the remaining number of available exposures in the frame counter. If the installed memory card has reached capacity, the figure '0' will flash in the frame counter and the shutter speed display will show the word **Full**. Generally, the camera cannot take any more pictures in this state until either one or more pictures are deleted or another memory card is installed. However, it may be possible to take further pictures if you reduce the image quality and size settings. Next, ensure that the camera is set to perform autofocus by checking the position of the focus-mode selector switch on the front of the camera, which should be positioned at AF.

Hint: All the Digital Vari-Programs, including Auto require a lens with a CPU (central processing unit) to be fitted to the D80. If you attach a non-CPU lens the shutter release will be disabled.

AUTO Auto Mode Default Settings

When shooting in mode, the camera uses the following default settings:

- Image quality: Normal pictures are compressed (1:8) using the JPEG standard
- Image size: Large (L) images are 3,872 x 2,592 pixels in size
- **Shooting mode:** Single frame one exposure is made each time you press the shutter release button

- Flash sync mode: Auto standard front curtain flash sync is performed
- Autofocus mode: AF-A automatic selection of either single-servo or continuous servo modes
- Autofocus-area mode: Auto-area all focus points selected, camera determines which one to use
- Sensitivity (ISO): ISO Auto the camera adjusts sensitivity automatically as needed to maintain proper exposure

Note: It is possible to alter the default settings in mode, and regardless of whether you switch to another mode and return to mode subsequently (or turn the camera off), the adjusted settings remain unaltered. Use the two-button reset option (see page 156) to restore the mode default settings.

Hint: If you open a menu while using mode or one of the Digital Vari-Programs and find that an option is grayed out, it is not available for use in your current exposure mode.

Holding the Camera

It may sound obvious, but how you hold your camera can have a significant influence on your ability to produce sharp pictures. Camera shake, the inadvertent movement of the camera when it is held in your hands, is probably the principal cause of pictures being spoiled because they appear blurred. Proper hand holding technique will reduce the risk of pictures being blurred due to the effects of camera shake. Regardless of whether you want to shoot with the camera held horizontally or vertically, it should be grasped firmly but not in an overly tight grip. The finger of your right hand should wrap around the handgrip in such a way that your index finger is free to operate the shutter release button. Cup your left hand under the camera so it acts like a cradle to support the camera and lens; your left thumb and index finger can rotate either the focus, or zoom ring of a lens. Keep you elbows tucked in towards your body while standing with your feet shoulder-width apart, one foot half a pace in front of the other.

Composing, Focusing, and Shooting

Compose each shot so that the main subject is completely covered by one of the autofocus sensing area points (any of the small black squares shown on the focusing screen). Press the shutter release button lightly to its halfway position to activate the focusing system. If the camera can acquire focus, you will see one or more of the auto focus sensing area bracket pairs illuminate and you will hear a beep (assuming CS-1 is set to <On>), and the in-focus indicator

• will appear in the viewfinder. The focus will lock at the current camera-to-subject distance.

Note: If the subject is moving closer to (or further away from) the camera before you release the shutter, and assuming the camera is set to AF-A (automatic selection of autofocus mode), the camera should select AF-C (continuous-servo autofocus mode) and begin tracking the moving subject.

Note: If the in-focus indicator • blinks, the camera has not been able to acquire sharp focus; recompose the picture and place the autofocus area brackets over an alternative part of the subject, then press the shutter release halfway again.

Hint: Remember, the D80 shows approximately 95% of the full frame in its viewfinder. There is a narrow boarder around all four sides that you cannot see but will be included in the final picture.

As mentioned previously, when the D80 is set to mode it automatically selects a shutter-speed and aperture as soon as you press the shutter-release button halfway. Check these values, which are displayed in the viewfinder. If the light level is such that the picture would be overexposed, if i will be displayed. In this case, your only option is to fit a neutral density (ND) filter to the lens to reduce the amount of light passing through the lens. If the picture

would be underexposed, the built-in Speedlight flash unit will lift automatically. Provided the camera battery is in a good state of charge the flash ready indicator will appear in the viewfinder within a couple of seconds. Finally, to make an exposure, gently squeeze the shutter-release button down; to prevent camera shake, avoid "stabbing" it with your finger.

Note: If you override the flash sync mode of **AUTO** f and cancel flash operation by selecting f, it is possible (though it would require very low level of light) that the shot will be underexposed, in which case **Lo** will be shown in the viewfinder. In this case, reset the flash sync mode to **AUTO** f.

Note: The shutter release is disabled until the flash is fully charged and **4** is displayed in the viewfinder.

Note: The flexible program option (see page 117) is disabled in **Mode**, so it is not possible to alter the combination of shutter-speed and aperture.

Hint: To conserve battery power, always return the Speedlight to its closed position when it is not in use, otherwise it will continue to draw power from the camera battery so that it remains in a charged state.

Auto and Digital Vari-Program Modes

AUTO Auto

The mode is designed as a universal point-and-shoot mode. The camera attempts to select a combination of shutter speed and aperture that will be appropriate for the current scene. It does this by using information from the TTL metering system in the camera, which assesses the overall level of illumination, contrast, and color quality of the prevailing light together with information from the autofocus system that it uses to estimate whereabouts in the frame area and how far from the camera the subject is likely to be. This mode is most effective for general-purpose "snapshot" photography, such as family events or vacations.

AUTO mode, the D80 uses its 3D Color Matrix Meter-In ing II system with U- or U-type lenses. At the detault settings, it selects AF-A for autofocus mode and the camera will select the appropriate focus mode according to the camera's assessment of information from the eleven autofocus sensing areas. The D80 invariably chooses single-servo AF (AF-S), although it is possible to override this selection by pressing the button to select continuous-servo AF (AF-C) manually. The selection of autofocus-area is fully automatic, as the camera defaults to Auto-area AF, although it is possible to set either single-area, or dynamic-area via CS-2 (see pages 145-149 for details of autofocus modes and autofocus-area modes).

Note: If you alter the default settings for autofocus mode, or autofocus-area mode the new settings are only retained while the camera remains in Mode. If you turn the mode dial to an alternative Digital Vari-Program mode the defaults settings for autofocus operation for that mode are restored.

The built-in Speedlight will activate automatically if the camera determines that additional illumination is required. The camera automatically selects standard front curtain flash sync mode **AUTO** \checkmark and an appropriate shutter speed between 1/60 and 1/200 second. Alternatively, you can select Auto slow-sync with red-eye reduction **SLOW** S or flash cancelled S ; other flash modes are not available.

Hint: It is important to make sure your subject is within the shooting range of the flash. The built-in Speedlight has a Guide Number (GN) of 42/13 (ISO100, ft/m), which means that at an aperture of f/4, and the base sensitivity of the D80 that is equivalent to ISO100, the maximum effective range of the flash unit is approximately 10 feet (3 m). If the flash symbol in the viewfinder blinks after the flash has fired, the shot may be under-exposed. In this case either set a higher sensitivity, or move closer to the subject.

Portrait mode is good for quick snapshots of people, but remember that you have no control over camera settings in this fully automatic Vari-Program.

💈 Portrait

The **Z** mode is designed to select a wide aperture in order to produce a picture with a very shallow depth of field. Generally, this renders the background out of focus, preventing it distracting the viewer from the main subject, although the effect is partially dependent on the distance between the subject and the background. This mode is most effective with telephoto or telephoto-zoom lenses, and when the subject is relatively far away from the background.

In this mode, the D80 uses its 3D Color Matrix Metering II system with D- or G-type lenses. At the default settings it selects AF-A for autofocus mode and the camera will select the appropriate focus mode according to the camera's assessment of information from the eleven autofocus sensing areas; in the \mathbf{Z} mode it appears that the D80 chooses single-servo AF (AF-S) invariably, although it is possible to

override this selection by pressing the **u** button to select continuous-servo AF (AF-C) manually. The selection of auto-fucus-area Is fully automatic, as the camera defaults to Auto-area AF, although it is possible to set either single-area, or dynamic-area via CS-2 (see pages 145-149 for details of autofocus modes and autofocus-area modes).

Note: If you alter the default settings for autofocus mode, or autofocus-area mode the new settings are only retained while the camera remains in \mathfrak{Z} mode. If you turn the mode dial to an alternative Digital Vari-Program mode the defaults settings for autofocus operation for that mode are restored.

The built-in Speedlight will activate automatically if the camera determines that additional illumination is required. The camera automatically selects standard front curtain flash sync mode **AUTO** \ddagger and an appropriate shutter speed between 1/60 and 1/200 second. Alternatively, you can select Auto slow-sync with red-eye reduction **SLOW** () or flash cancelled (); other flash modes are not available.

Hint: When shooting portraits, the best results are often achieved when the subject either fills, or nearly fills the frame. Since at the default setting selection of the autofocus area is fully automatic there is no guarantee that the camera will focus on at least one of the subject's eyes. Therefore, I recommend, strongly, that you override the default option and use CS-2 to select single-area AF, and ensure your chosen autofocus sensing area covers one of the subject's eyes to ensure it is focused sharply.

Hint: It is important to make sure your subject is within the shooting range of the flash. The built-in Speedlight has a Guide Number (GN) of 42 feet (13 m) at ISO 100. This means that, at an aperture of f/4 and the base sensitivity of the D80 (equivalent to ISO 100), the maximum effective range of the flash unit is approximately 10 feet (3 m). If the flash symbol in the viewfinder blinks after the flash

has fired, the shot may be underexposed. In this case, either set a higher sensitivity, or move closer to the subject.

Landscape

The mode is designed to select a small aperture in order to produce a picture with an extended depth of field. Generally, this renders everything from the foreground to the horizon in focus, although this will depend to some degree how close the lens is to the nearest subject. This mode is most effective with wide-angle or wide-angle zoom lenses, and when the scene is well lit.

In this mode, the D80 uses its 3D Color Matrix Metering Il system with D- or G-type lenses. At the default settings it selects AF-A for autofocus mode and the camera will select the appropriate focus mode according to the camera's assessment of information from the eleven autofocus sensmode it appears that the D80 ing areas: in the chooses single-servo AF (AF-S) invariably, although it is possible to override this selection by pressing the button to select continuous-servo AF (AF-C) manually. The selection of autofocus-area is fully automatic, as the camera defaults to Auto-area AF, although it is possible to set either single-area, or dynamic-area via CS-2 (see pages 145-149 for details of autofocus modes and autofocus-area modes). Operation of the built-in Speedlight and AF-assist lamp is cancelled in *mode*; there are no flash modes available in the Landscape mode.

Note: If you alter the default settings for autofocus mode, or autofocus-area mode the new settings are only retained while the camera remains in mode. If you turn the mode dial to an alternative Digital Vari-Program mode the defaults settings for autofocus operation for that mode are restored.

Hint: It is important to ensure the main area of interest in your composition is in sharp focus. Since, at the default setting, selection of the focusing area is fully automatic the camera may not focus where you expect it to; in mode you may prefer to override the default option and select single-area AF via CS-2, to ensure you know which part of the scene the camera is focusing on.

Hint: When using a wide-angle focal length (i.e., a focal length less than 35mm) try to include some element of litterest in the foreground of the scene, as well as the middle distance, to help lead the viewer's eye in to the picture.

Close-Up

The mode is designed to select a small aperture in order to produce a picture with an extended depth of field when taking pictures at short shooting distances, of subjects such as flowers, insects, and other small objects. Generally, when working at very short focus distances, depth of field is limited even at small apertures, so this program endeavors to renders as much of the subject in focus as possible. To some degree the final effect will be dependent on how close the lens is to the subject, because depth-of-field will be reduced at shorter focus distances. This mode is most effective with lenses that have a close-focusing feature, or dedicated Micro-Nikkor close-up lenses.

In this mode, the D80 uses its 3D Color Matrix Metering II system with D- or G-type lenses. At the default settings, it selects AF-A for autofocus mode and the camera will select the appropriate focus mode according to the camera's assessment of information from the eleven autofocus sensing areas; in the \textcircled mode it appears that the D80 chooses single-servo AF (AF-S) invariably, although it is possible to override this selection by pressing the \textcircled button to select continuous-servo AF (AF-C) manually. Again, at the default settings the camera selects single-area AF and the central autofocus sensing area is activated (although an alternative autofocus sensing area can be selected by pressing the multi selector button).

The built-in Speedlight will activate automatically if the camera determines that additional illumination is required. The camera automatically selects standard front curtain flash sync mode **AUTO** \oint and an appropriate shutter speed between 1/60 and 1/200 second. Alternatively, you can select Auto slow-sync with red-eye reduction **SLOW** \bigcirc or flash cancelled \bigcirc ; other flash modes are not available.

Note: The coverage of the central autofocus sensing area is determined by CS-3; if you select mode the current setting for CS-3 will be used.

Hint: Due to the emphasis this mode places on using a small aperture, the shutter-speed can quite often be relatively slow. To prevent pictures being spoiled by camera shake use a tripod in conjunction with the exposure delay mode (CS-31), and release the shutter via either the MC-DC1 remote release cable, or ML-L3 infrared remote release.

💐 Sports

The \checkmark mode is designed to select a wide aperture in order to maintain the highest possible shutter-speed to freeze motion in fast-paced sports, or everyday action such as active children. It also has a beneficial side effect as this combination produces a picture with a very shallow depth-of-field that helps to isolate the subject from the background. This mode is most effective with telephoto or telephoto-zoom lenses, and when there are no obstructions between the camera and the subject that may cause the autofocus function to focus on something other than the subject.

In this mode the D80 uses its 3D Color Matrix Metering II system with D- or G-type lenses. At the default settings it selects AF-A for autofocus mode and the camera will select continuous-servo AF (AF-C) focus mode. Again, at the default settings the camera selects dynamic-area AF and the central autofocus sensing area is activated (although an alternative autofocus sensing area can be selected as the focus area from which autofocus is initiated by pressing the multi selector button). The combination of continuous-servo auto focus mode, and dynamic autofocus-area mode enables the autofocus system of the D80 to track, automatically, a moving subject. Although the focus sensing area used initially to establish focus remains highlighted in the control panel should the subject move out of this sensor's coverage focus will be maintained, as autofocus control will shift to one of the neighboring autofocus sensing areas. Provided you keep the shutter release pressed halfway, the camera will attempt to predict where the subject will be for each exposure making it possible to follow the action and shoot a sequence pictures at the action occurs (see pages 145-149 for details of autofocus modes and autofocus-area modes). Operation of the built-in Speedlight and AF-assist lamp is cancelled in $\stackrel{\bullet}{\prec}$ mode; there are no flash modes available in the Sports mode.

Hint: The D80 has a shutter lag of about 80ms, that is to say that there is a slight but perceptible delay between pressing the shutter release button and the shutter opening. Therefore, it is important to anticipate the peak moment of the action to record it. If you see it in the viewfinder you will have missed the shot!

Night Landscape

mode is designed for use in natural low light con-The 🖬 ditions after sunset and before sunrise but it is also very effective with artificial lighting, such as a floodlit building, or a scene lit by street lighting. In this mode, the D80 uses its 3D Color Matrix Metering II system with D- or G-type lenses. At the default settings it selects AF-A for autofocus mode and the camera will select the appropriate focus mode according to the camera's assessment of information from the eleven autofocus sensing areas; in the mode it appears that the D80 chooses single-servo AF (AF-S) invariably, although it is possible to override this selection by pressing the B button to select continuous-servo AF (AF-C) manually. The selection of autofocus-area is fully automatic, as the camera defaults to Auto-area AF, although it is possible to set either single-area, or dynamic-area via CS-2 (see pages 145-149 for details of autofocus modes and autofocus-area modes). Operation of the built-in Speedlight and AF-assist lamp is cancelled in mode; there are no flash modes available in the Night Landscape mode.

Note: If you alter the default settings for autofocus mode, or autofocus-area mode the new settings are only retained while the camera remains in \blacksquare mode. If you turn the mode dial to an alternative Digital Vari-Program mode the defaults settings for autofocus operation for that mode are restored.

Hint: It is important to ensure the main area of interest in your composition is in sharp focus. Since, at the default setting, selection of the focusing area is fully automatic the camera may not focus where you expect it to; in mode you may prefer to override the default option and select single-area AF via CS-2, to ensure you know which part of the scene the camera is focusing on.

Hint: Due to the ability of this mode to select a long shutterspeed you should consider using a tripod or some other form of camera support to prevent pictures being spoiled by camera shake. If you do not have a tripod resting the D80 on a solid surface such as a table or a wall will be just as effective. To prevent touching the camera to operate the shutter use either the self-timer function, MC-DC1 remote release cable, or ML-L3 infrared remote control to release the shutter, and consider using the Exposure Delay mode (CS-31) as well.

Hint: If you shoot under natural low light conditions the best results are often obtained in the twilight or pre-dawn periods of daylight, when the sky area has some color rather than being just a featureless black.

Hint: If the camera indicates a shutter speed of 8 seconds or longer switch on the Long Exposure Noise Reduction feature from the Shooting Menu to help reduce the level of electronic noise in the picture.

Night Portrait

The mode is designed to capture properly exposed pictures of people against a background that is dimly lit. It is most effective when the background is in low light as opposed to near dark conditions. For example a city scene lit by artificial lighting, or a landscape at twilight. For a fore-ground subject that is in particularly low light the built-in Speedlight, or an external Speedlight such as the SB-600, can be used to supplement the ambient light.

In this mode, the D80 uses its 3D Color Matrix Metering II system with D- or G-type lenses. At the default settings it

selects AF-A for autofocus mode and the camera will select the appropriate focus mode according to the camera's assessment of Information from the eleven autofocus sensing areas; in the Immation from the eleven autofocus sensing single-servo AF (AF-S) invariably, although it is possible to override this selection by pressing the Umbut button to select continuous-servo AF (AF-C) manually. The selection of autofocus-area is fully automatic, as the camera defaults to Autoarea AF, although it is possible to set either single-area, or dynamic-area via CS-2 (see pages 145-149 for details of autofocus modes and autofocus-area modes).

Note: If you alter the default settings for autofocus mode, or autofocus-area mode the new settings are only retained while the camera remains in \blacksquare mode. If you turn the mode dial to an alternative Digital Vari-Program mode the defaults settings for autofocus operation for that mode are restored.

The built-in Speedlight will activate automatically if the camera determines that additional illumination is required. The camera automatically selects standard front curtain with slow flash sync mode **AUTO 4 SLOW** and an appropriate shutter speed between 30 seconds and 1/200 second. Alternatively, you can select Auto slow-sync with red-eye reduction **SLOW ()**, or flash cancelled **()**; other flash modes are not available.

Hint: It is important to ensure the main area of interest in your composition is in sharp focus. Since, at the default setting, selection of the focusing area is fully automatic the camera may not focus where you expect it to; in and wou may prefer to override the default option and select single-area AF via CS-2, to ensure you know which part of the scene the camera is focusing on.

The following settings are common to all Digital Vari-Program Modes:

• All photographs are recorded in the sRGB color space

- All shooting modes (single, continuous, remote, and remote-delay) can be used
- If the light levels exceed the sensitivity of the TTL metering system in the D80 either #1 will be displayed in the viewfinder if the overall level of illumination is too bright, or Lo will be displayed if the overall level of illumination is too low.

Optimize Image Settings in the Point-and-Shoot Modes The D80 applies the values set out in the following table when either AUTO, or one of the Digital Vari-program modes is selected. The user has no control over these settings, which are applied automatically by the camera.

	Sharpening	Tone	Color Mode /Space	Saturation	Hue
Auto	Auto	Auto	la / sRGB	Auto	0
Portrait	Auto	Auto	la / sRGB	Auto	0
Landscape	Auto	Auto	IIIa / sRGB	Auto	0
Close-up	Auto	Auto	IIIa / sRGB	Auto	0
Sport	Auto	Auto	la / sRGB	Auto	0
Night Landscape	Auto	Auto	IIIa / sRGB	Auto	0
Night Portrait	Auto	Auto	la / sRGB	Auto	0

Basic Image Review

Assuming CS-6 is set to its default setting of <On>, a photograph will be displayed on the monitor screen almost as soon as the exposure is made. If no picture is displayed, the most recent picture recorded by the D80 can be displayed by pressing the I button. To review other pictures use the multi selector button pressing it either left or right to scroll through the pictures stored on the memory card. To return to the shooting mode at any time just press the shutter release button halfway. If you want to delete the displayed picture press the mathematical hutton A message will be chown ever the displayed picture asking for confirmation of the delete action, with an option to cancel the operation if required. Press the fibutton again to proceed with the deleting of the picture. To cancel the delete operation either press I , or press the shutter release button halfway.

To protect an image from accidental deletion display it on the monitor screen by pressing and press the button. A key icon will appear in the top left corner of the displayed image to indicate its protected status. To remove the protection display the image as described, and press the button again; the key icon will disappear.

Note: Never be in too much of a hurry to delete pictures unless they are obvious failures; I always recommend that it is better to leave the editing process to a later stage, as your opinions about a particular picture can, and often do, change.

Note: Any image file marked as protected will maintain this status as a read-only file even when the image file is transferred to the computer or other data storage device.

Shooting Operations in Detail

Powering the D80

The D80 can be powered by a variety of sources. The main battery is the rechargeable lithium EN-EL-3e (7.4V, 1500mAh) that weighs approximately 2.8 oz (80 g). The profile of the battery ensures that it can only be inserted the correct way into the camera. It is charged with the dedicated MH-18a Quick Charger (supplied with the camera); alternatively, the MH-18 (predecessor to the MH-18a) can also be used, as can the MH-19 Multi-Charger, which supports both mains AC and DC power supplies. A fully discharged EN-EL3e can be completely recharged in approximately 135 minutes using the MH-18a (or MH-18). Unlike some other types of rechargeable batteries, the EN-EL3e does not require conditioning prior to its first use. However, it is advisable to ensure that the initial charge cycle for a new battery is continued until the battery cools down while still in the charger before removing it. Do not be tempted to remove it as soon as the charging/charged indicator lamp stops flashing, as the battery is unlikely to have reached full charge.

Using the EN-EL3e Battery

To insert an EN-EL3e into the D80:

- 1. Invert the camera and push the small button on the battery chamber lid toward the tripod socket. The battery chamber lid should swing open.
- 2. Open the lid fully and slide the battery into the camera, observing the diagram on the inside of the chamber lid.
- 3. Press the lid down (you will feel a slight resistance) until it locks. You will hear a click as the latch closes.
- Use the shooting capabilities of the D80 to capture scenes just the way you want to.

The profile of the EN-EL3e battery ensures that it can only be inserted in the camera in the correct orientation.

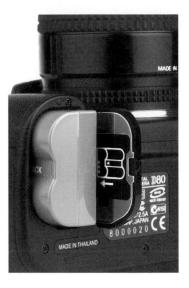

To remove an EN-EL3e from the D80:

- 1. Repeat Step 1 (above).
- 2. Hold the lid open, turn the camera upright, and allow the battery to slide out taking care that it does not drop.
- 3. Close the battery chamber lid.

Whenever you insert or remove an EN-EL3e, it is essential that you set the power switch of the D80 to the OFF position. If you are in the process of making any changes to the camera settings and the battery is removed while the power switch is still set to the ON position, or the power supply from the EH-5 is interrupted, the camera may not retain the new settings. Likewise, if the camera is still in the process of transferring data from the buffer memory to the storage media when the battery is removed, image files are likely to be corrupted, or data lost. To charge an EN-EL3e:

1. Connect the MH-18a to an AC power supply.

Note: The MH-18a and MH-18 chargers can be used worldwide, connected to any mains AC supply, at any voltage from 100V to 250V, via an appropriate power socket adapter.

2. Align the slots on the side of the battery with the four lugs (two each side) on the top of the MH-18a / MH-18 and lower the battery before sliding it toward the indicator lamp until it locks in place. The charge lamp should begin to flash immediately, indicating that charging has commenced. A full charge of a completely discharged battery will take approximately 135 minutes.

Hint: To ensure the battery has recharged fully do not remove it from the charger as soon as the charge lamp stops flashing. Leave the battery in place until it has cooled to the ambient room temperature.

Hint: Lithium batteries do no exhibit the "charge memory" effects associated with NiCd batteries, therefore a partially discharged EN-EL3e can take a "top-up" charge without any adverse consequences to battery life or performance.

Hint: If you carry a spare EN-EL3e, always ensure that you keep the semi-opaque plastic terminal cover in place. Without it, there is a risk that the battery terminals may short and cause damage to the battery.

The EN-EL3e rechargeable battery has an electronic chip in its circuitry that allows the D80 to report detailed information regarding the status of the battery. This is the reason that the EN-EL3e battery has three contact plates, as opposed to the two contacts found on the earlier EN-EL3 and EN-EL3a battery types. To access this information, select <Battery Info> from the Setup menu and three parameters concerning the battery will be displayed on the monitor screen (see the table on next page). Parameter Bat. Meter

Pic. Meter

Charge Life

The EN-EL3e battery can be charged in the MH-18a mains AC charger; a fully discharged battery requires approximately 135 minutes to recharge.

Description

Current level of battery charge expressed as a percentage. Number of times the shutter has been released with the current battery since it was last charged. This number will include shutter release actions when no picture is recorded (e.g. to record an Image Dust Off reference frame, or measure color temperature for a preset white balance value). Displays the condition of the battery as one of five levels (0 -4); level 0 indicates the battery is new, and level 4 indicates the battery has reached the end of its charging life and should be replaced.

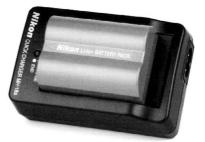

Note: The EN-EL3 and EN-EL3a battery types are not compatible with the D80. If you attempt to enter either of these two battery types into the battery chamber of the D80, they will not fit. These batteries should be used with the D100, D70-series, and D50 camera models.

Note: The EN-EL3e battery supplied with the D80 can be used in the D100, D70-series, and D50 camera models.

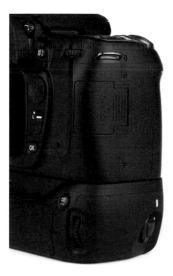

As well as increasing the shooting capacity of the D80 by accention two FN-FL3e batteries, the MD-D80 offers an additional shutter release button, command dials, and AE-L/AF-L button to facilitate shooting in the vertical (portrait) format.

Using The MB-D80 Battery Pack

The MB-D80 is a battery pack/grip that attaches to the base of the standard D80 body via the tripod socket. It can accept either one or two EN-EL3e batteries, or six AA-sized batteries that must be fitted in the MS-D200 battery holder. In addition to providing extra battery capacity, the MB-D80 has a shutter release button, main and sub-command dials, and an AE-L/AF-L button to improve handling when the camera is held in the vertical (portrait) orientation.

Hint: Fitting the MB-D80 requires the battery chamber door of the D80 camera to be removed. To remove the door open it and hold it at a 35-degree angle to the camera base, before lifting one end away from the hinge. The door can then be lifted away from the other end of the hinge. To prevent its loss stow the battery chamber door in the slot set in to the shaft of the MB-D80 that enters the camera's battery chamber.

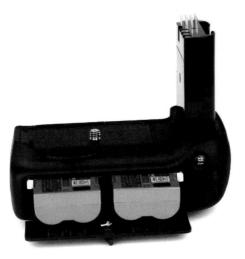

The MB-D80 can accept two EN-EL3e batteries.

Note: If the MB-D80 battery pack is fitted to the D80 and has two EN-EL3e batteries inserted, the <Battery Info> display will show information for each battery separately; it is listed as <L Slot> for the battery in the left hand chamber and <R Slot> for the battery in the right hand chamber (as viewed from the back of the MB-D80). If AA sized batteries are inserted in the MS-D200 battery holder no information about the batteries is available.

External Power Supply - EH-5 AC Adapter

The Nikon EH-5 AC mains adapter, which is available separately, can also power the D80; this accessory is particularly useful for extended periods of shooting, or camera use such as image playback through a TV set and data transfer direct from the camera to a computer. Any interruption to the camera's power supply during recording or transfer of data to an external device may lead to files becoming corrupted or data being lost. The adapter connects to the DC-in socket, the middle of the three terminals under the larger of the rubber covers on the left side of the camera. The EH-5 is also useful to prevent the camera from powering off while the reflex mirror is raised during use of the mirror lock-up function (found in the Setup menu) for inspection or cleaning of the low-pass filter array.

Hint: Always ensure that the power switch is set to the OFF position before connecting/disconnecting the EH-5 to the DC-in socket. There is a risk that the camera's circuitry could be damaged if you plug/unplug the EH-5 while the power switch is set to the ON position.

Note: All electronically controlled cameras very occasionally exhibit some strange behavior with unexpected icons or characters appearing in the LCD display, or the camera ceases to function properly. This is usually due an electrostatic charge. To remedy the situation, try switching the camera off and removing and replacing the battery, or disconnect then reconnect the mains AC supply before switching the camera on again. If this does not rectify the problem, switch the camera off and push the reset button, which is located next to the DC power terminal on the left side of the camera.

The Clock/Calendar Battery

The D80 has an internal clock/calendar that is powered by a rechargeable battery. Fully charged, it will power the clock/calendar for approximately one month. It requires charging for approximately 48 hours by the camera's main power supply. Should the clock battery become exhausted the **CLOCK** icon will flash in the control panel and the clock is reset to a date and time of 2006.01.01 00:00:00. If this occurs, the clock/calendar will need to be reset via the <World Time> option in the Setup menu.

Hint: Since the clock/calendar battery is not changeable by the user, if it becomes exhausted you will need to take the camera to a service center for a replacement battery to be fitted.

Battery Performance

Obviously, the more functions the camera has to perform, the greater the demand for power. Reducing the number of functions and the duration for which they are active is fundamental to reducing power consumption. Since operation of the D80 is totally dependent on an adequate power supply, here are a few details about the D80's power consumption, as well as some suggestions as to how you can preserve battery power:

- A fully charged EN-EL3e battery, in good condition, will retain close to its full capacity over a period of a week or so if it is not used. However, if the battery is left dormant for a month or more, expect it to suffer a substantial loss of charge, so ensure you recharge it fully before use.
- Using the camera's LCD monitor increases power consumption significantly. Consider setting the <Image Review> option in the Playback menu to <OFF>; the default setting is <ON>.

Hint: If the <Image Review> feature is set to <ON>, as soon as you have reviewed your picture, press the shutter release button lightly. This returns the camera to its shooting mode and prepares it to take another picture, switching the LCD monitor off immediately.

- While driving the autofocus function of lenses places a relatively high load on the battery, this only occurs for a brief period. So unless you are using the autofocus function excessively, it will not have a significant impact on battery charge.
- The Vibration Reduction (VR) feature available with some Nikkor lenses remains active as long as the shutter release button is depressed, thereby reducing battery life by approximately 10%.
- Maintaining a connection to either a computer or Pict-Bridge compatible printer will have a significant affect on battery charge, as both draw considerable power. Always disconnect the D80 from these devices as soon as you have finished using them.

The Vibration Reduction feature is great for adding some extra stabilization to shots taken at longer shutter speeds, but it does reduce battery life by about 10%.

- The viewfinder uses an LCD overlay mask to display the various markings on the focusing screen. You should be aware that even when the power is switched off this feature continues to draw a trickle charge if a battery is left installed in the camera.
- Low temperatures can impair any battery's performance, regardless of its type. Lithium batteries like the EN-EL3e are fairly resilient to cold conditions, however, you should keep a spare battery in a warm place such as an inside pocket to exchange it with the colder battery as needed to ensure you can keep shooting. Allow the used battery time to warm up again and keep rotating between the two batteries to maximize their shooting capacity.
- If you expect to store the camera for more than four weeks, remove the battery. Avoid storing a battery that has less than 5-10% charge remaining. If the charge drops to 0% and the battery is left in this condition for any period of time, there is a risk it may be damaged permanently.

Secure Digital (SD) Memory Cards

These small solid-state memory cards measure 1.3 x .9 x .08 inches (34 x 22 x 2 mm), have a capacity of up to 2 GB, and are organized similarly to the hard drive disk of your computer; they have a file directory, file allocation table, folders, and individual files. They are capable of retaining data even when they are not powered, and since they have no moving parts, they are reasonably robust. Even so, you should treat any memory card with the same care you would your other camera equipment, and it is advisable to keep them in the small plastic case generally supplied with each card. A minor impact from the card being dropped 8 to 10 feet (2.7 - 3 m) or exposure to the natural elements should not cause any problems. However, total immersion in water should be avoided! Typically, SD cards have a temperature operating range of -4F° to 167F°(-20°C to 75°C) and no altitude limit. SD cards have a small sliding write protect switch on one edge that when set to the "lock" position prevents any data from being written to or deleted from the card. (If you insert a locked SD card into the D80, the camera will display a warning message.) Finally, unlike photographic film, mem-

The D80 is compatible with both SD and SDHC memory cards

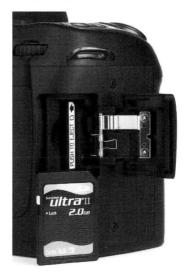

ory cards are not affected by ionizing radiation from X-ray security equipment such as that used at airports.

Secure Digital High Capacity (SDHC) Memory Cards

To support the larger file sizes generated by contemporary digital cameras and other devices, there has been a growing requirement for SD cards with a capacity in excess of 2 GB. To meet this demand, a new design of SD card has been introduced; it retains the same physical dimensions and write-protect feature of standard SD cards and complies with the SD specification version 2.0, which supports a card capacity of 4 GB and over. This newly designed SD card is called Secure Digital High Capacity (SDHC). The SD Association has created and defined three speed classes for performance capabilities/minimum requirements of SDHC cards and products that support the SDHC format. (Full details on specifications the SD 2.0 can be viewed at: http://www.sdcard.org.) At the time of this writing, the first 4 GB cards have been launched, but eventual card capacities of up to 32GB are likely.

Note: The D80 supports standard SD cards and SDHC cards. It is important to remember, however, that while SDHC compliant devices support both SD and SDHC cards, a device that is only compliant with SD cards cannot support SDHC cards. This may affect your ability to use an SDHC card with some card readers and other non-SDHC compliant devices.

Formatting

As mentioned previously, the memory of an SD or SDHC card has a similar structure to that of a hard disk drive, with a file directory, file allocation table, folders, and files. As data is written to and erased from the card, small areas of its memory can become corrupted and files can become fragmented, particularly if you delete individual image files from the card. By formatting the card in-camera, the worst effects of fragmentation are generally cleaned up.

Nikon's statement in the D80 instruction book that formatting a memory card "permanently deletes all photographs and any other data the card may contain" is somewhat misleading. The process of formatting actually causes the existing file directory information to be overwritten so that it no longer "points" to the image data held on the card; it does not actually delete all the data as Nikon states it does. That said, once the card is formatted, it is difficult (though not impossible) to recover previously written data from the card. If you should format a card inadvertently, there are software programs designed to recover data that may enable you to retrieve your image files. To maximize your chances of recovering the data successfully, ensure that no new data is written to the card before carrying out the recovery process. Since prevention is better than cure, always save your images to a computer or other storage device (and make a back up copy) before formatting a card.

Note: The D80 supports FAT32, which allows it to use a SDHC memory cards with a capacity in excess of 2 GB. FAT16 is used when formatting any memory card already formatted in FAT16.

File Formats

The D80 saves images to the memory card in two forms: the Joint Photographic Experts Group (JPEG) compression standard and the Nikon Electronic File (NEF), Nikon's proprietary RAW file.

Note: Strictly speaking, JPEG is not a file format; it is a standard of compression established by the Joint Photographic Experts Group (JPEG). These days, however, the term "JPEG format" is ubiquitous.

Tucked away in the press release material issued at the launch of the D80 was the following phrase: "high-precision 12-bit digital image processing algorithms." Since this point

receives no fanfare, you may think it is of little importance, hut in fact it does have a significant affect on the JPEG images produced by the D80. The camera processes image data destined for saving as a JPEG file at a 12-bit depth by taking the 12-bit data from the sensor and only reduces the data to an 8-bit depth at the point when the JPEG compression encoding is performed. In previous Nikon D-SLR cameras, the application of image attributes such as sharpening, tone (contrast), and color adjustments is done at an 8-bit level, which can result in an effect known as "posterization" that causes the loss of certain tonal values. In shadow tones, this can result in uneven shadow areas, and in highlight tones, it will generally result in highlights that lack detail.

By maintaining the image data at a 12-bit depth when performing in-camera modifications, the D80 overcomes this problem. The net result is that the D80 produces far better looking JPEG files compared with previous Nikon D-SLR models, particularly in the shadow areas. Once the 12-bit image data is reduced to an 8-bit depth, the JPEG compression regime is applied. To prevent a build up of contrast and loss of acuity, I recommend you use the lowest level of compression and select <JPEG Fine> for the <Image Quality> option.

Using the NEF format, the camera deals with the sensor data in a different way. The D80 records compressed NEF files, so some of the 12-bit data from the sensor is discarded in a process that Nikon describe as being "visually lossless." The camera settings in use at the time the image is taken are recorded and saved to the relevant fields in the EXIF file. The camera also creates and stores a small thumbnail image akin to a JPEG file alongside the NEF file.

Note: There is no option to record uncompressed NEF (RAW) files with the D80.

To summarize, the principal difference between the JPEG format and the NEF format concerns how the camera deals with the data from the sensor that forms the image. Using the JPEG format, the camera produces a "finished" image

from the sensor data and the settings at the time of the exposure selected by either you or the camera. I put "finished" in quotation marks because, although it is possible to use a JPEG file direct from the camera to produce a print or post to a website, these files can still be worked on, if required, after they have been imported to a computer. Using the NEF format requires that the work involved in producing a "finished" image be done by the photographer using appropriate software and a computer.

If you are beginning to form the impression that to eek out every last ounce of quality the D80 has to offer you should shoot in the NEF format, you are not too far off. However, that last sentence requires justification because, while many photographers refer to RAW as being "better" than JPEG, I prefer to consider the issue in terms of the flexibility the two formats offer, and recommend that you use the one that is best suited to your specific requirements. It is worth taking a look at the attributes of each format so you can make an informed decision.

JPEG

JPEG files have three attributes that can, potentially, influence image quality in an adverse manner:

- The in-camera processing reduces the 12-bit data from the sensor to 8-bit values when it creates a JPEG file. The D80 does, however, have an advantage over many other D-SLRs in that all in-camera adjustments are made at a 12-bit level before the data is reduced to an 8-bit level. So, if you have no intention of carrying out any post processing work on your images, the reduction to 8-bits is of no real consequence. However, if you make significant changes to an image using software in post-processing, the 8-bit data of a JPEG file can impose limits on the degree of manipulation that can be applied.
- When the camera saves an image using JPEG, it encodes most of the camera settings for attributes such as white balance, sharpening, contrast, saturation, and hue into

When choosing between shooting in NEF or JPEG, consider the attributes of both so you can make an informed decision.

the image data. If you make an error and inadvertently select the wrong setting, you will need to try and undo your mistake in post processing using a computer. Inevitably, this is time consuming and there is no guarantee it will be successful.

• The technology of digital imaging is fast paced and the electronics used in any particular camera are only as good as the day the manufacturer decided on their specification and finalized the design of the camera. Granted, most modern cameras can have their firmware (installed software) upgraded by the user, and to some extent this helps to off set obsolescence, but it is only effective for so long. By processing images in software on a computer, you can often take advantage of the very latest advances in image processing, which are unavailable to the camera.

NEF (RAW)

Using NEF has only one real disadvantage in my mind, and that is the extra time you will need to invest in processing each image to produce a finished picture. The larger file size of the NEF format can also be an issue in terms of the amount of available storage on your memory card and external storage facilities for archiving your pictures. Equally, there can be limitations with some third party software when it comes to the ability to read and interpret Nikon's proprietary NEF RAW files. The benefits of NEF include:

- More consistent and smoother tonal graduations
- Color that is more subtle and accurate to the original subject or scene
- A slight increase in the level of detail that is resolved
- The ability (within fairly limited parameters) to adjust exposure in post processing to correct for slight exposure errors
- The ability, in post processing, to correct and/or change image color by resetting attributes such as the white balance value, contrast, saturation, and hue

Note: Most modern software is capable of reading NEF files generated by the D80. There are a wide variety of third party RAW file converters that enable NEF files to be opened in most popular digital imaging software. For compatibility between NEF files from the D80 and Nikon software you will need PictureProject 1.6.7, Nikon View 6.2.7, or Nikon Capture NX 1.0.1

Nikon describes the compression applied to NEF Raw files as being "visually lossless," by which they mean it is impossible to differentiate the difference between compressed NEF files and uncompressed NEF files. The compression process used by Nikon is selective; it only works on certain image data while leaving other data unaffected. Nikon's use of the word "compression" in this context is rather misleading. as the propose involves two distinct phases. The first phase sees certain tonal values grouped and then rounded, and the second phase is the point at which a conventional lossless compression is applied. It works as follows: Once the analogue signal from each pixel site on the sensor has been converted to digital data, it has one of 4096 possible values (i.e., a 12bit depth). A value of 0 represents pure black (no data) and a value of 4095 represents pure white (total saturation). During the first phase of the compression process, the values that represent the very dark tones are separated from the rest of the data. Then the data with values that represent the remaining tones is divided into groups, but this process is not linear: as the tones become lighter the size of the group increases, so the group with the lightest tones is larger than the group containing mid-tone values. A lossless compression is then applied to each individual dark tone value and the rounded value of each group in the mid and light tones.

When an application such as Nikon View Pro or Nikon Capture NX opens an NEF file, it reverses the lossless compression process. The individual dark tone values are unaffected but, and here is the twist, each of the grouped values for the mid and light tones must be expanded to its appropriate range on a 12-bit scale. Since the rounding error in each group becomes progressively larger as the tonal values it represents become lighter and lighter, the "gaps" in the data caused by the rounding process also become progressively larger at lighter tonal values.

It is important to put these data "gaps" into perspective. A single compression/decompression cycle performed on an NEF file produces an image that is indistinguishable from one produced from an uncompressed NEF file. The human eye does not respond in a linear way to increased levels of brightness, so it is incapable of resolving the very minor changes that take place, even in the lightest tones where the rounding error is greatest and therefore the data "gap" is largest (remember Nikon's phrase – "visually lossless"). Furthermore, our eyes are generally only capable of detecting

tonal variations equivalent to those produced by 8-bit data, and since even a compressed NEF file has the equivalent to more than 8-bit data, the data "gaps" caused by Nikon's compression process are of no consequence. Many photographers will ultimately reduce their 12-bit NEF files to 8-bit TIFF or JPEG files prior to printing, which masks any loss of tonal graduation caused by compressing NEF Raw files.

Note: It is worth mentioning that there is a small latent risk that the data loss caused by compression of NEF files might manifest in the highlight areas of an image subjected to a significant level of alteration during post-processing (i.e., considerable color shift, significant modification of tone, or excessive sharpening).

Which Format?

In considering the attributes of JPEG and NEF, many photographers make an analogy with film photography; they compare the NEF file to having an original film negative to work from and the JPEG file as being akin to a machine-processed print. I do not disagree, but this is where my point about flexibility of the two formats comes in; not every photographer has the desire, ability, or time to spend processing NEF files. The good news is that we have a choice, so consider the points made in this section and make your decision about which format to use based on which one is most suited to your purposes. If you have sufficient storage capacity, you could even select the <NEF (Raw) + JPEG Fine> option, which tells the D80 to save a copy of a single image in both formats.

Image Quality and Size

The D80 allows you to save JPEG files at three different levels of quality:

- FINE uses a low compression of approximately 1:4
- NORMAL uses a moderate compression ratio of approximately 1:8:
- **BASIC** uses a high compression ratio of approximately 1:16

The QUAL button on the rear of the D80 is used in conjunction with the command dials to set image quality (file format) and file size

Each JPEG file can also be saved by the D80 at one of three different sizes:

- L Large (3872 x 2592 pixels)
- M Medium (2896 x 1944 pixels)
- **S** Small (1936 x 1296 pixels)

Note: As the processing involved in the creation of a JPEG files uses compression that discards data, to maintain the highest image quality, you should select the lowest level of compression. A file saved at the FINE setting will be visually superior to a file saved at the BASIC setting.

Note: JPEG compression can generate visual artifacts; the higher the compression ratio the more apparent these become. If you are shooting for web publication, this is unlikely to be an issue, but if you intend to make prints from your JPEG file pictures you will probably want to use the Large FINE settings.

There is no size option with NEF files since the D80 always uses the full 3872 \times 2592 resolution of the sensor. NEF files

can only be saved in a compressed form. The file size of a compressed NEF file quoted in the Nikon manual is 12.4 MB (megabytes); Nikon describes this as a "design figure," which in essence means it is the largest file size you can expect when recording an image in the compressed NEF format. (It also appears that this is the figure used to estimate the figure displayed as the "number of exposures remaining.") Typically, a compressed NEF file from the D80 is more likely to be in the range of 8 – 10 MB in size, so it is often the case that the camera will record more pictures than the figure for the "number of exposures remaining" displayed initially, but remember that the final file size will be influenced by the nature of the scene recorded and, to some extent, the make of memory card used to store the recorded image file.

Note: Compressed black and white NEF files are slightly smaller than color NEF files due to thumbnail image embedded in the NEF file being a smaller grayscale file, with no color information.

Setting Image Quality and Size

To set image quality on the D80, open the Shooting menu and use the multi selector to highlight <Image Quality>, then press the multi selector to the right to open the list of options and press it up or down to highlight the required setting. Finally, press the State button to confirm your selection. Alternatively, a much more convenient and quicker way to select image quality is to use the button and dial method: Press and hold the **QUAL** button then rotate the main command dial. The selected value is displayed in the control panel. There are seven options: NEF (Raw), JPEG Fine, JPEG Normal, JPEG, Basic, NEF (Raw) + JPEG Fine, NEF (Raw) + JPEG Normal, and NEF (Raw) + JPEG Basic.

To set image size for JPEG files on the D80, open the Shooting menu and use the multi selector to highlight <Image Size>, then press the multi selector button to the right to open the list of options and press it up or down to highlight the required setting. Finally, press the **OK** button to confirm your selection. Once again, a more convenient way to access

these options is to press and hold the **QUAL** button then rotate the sub-command dial; the selected value is displayed in the control panel, as L (large), M (medium), or S (small).

White Balance

We are all familiar with the way the color of daylight changes during the course of a day from the orange/yellow colors immediately after sunrise, to the cooler look of light around midday, to the red/orange colors that appear as the sun sets. These changes are significant and our eyes can see them quite clearly. However, the color of light changes in subtler ways at other times of day and in different climatic conditions. Furthermore, different types of light sources, such as a household bulb or a camera flash, give their own color casts to the light.

The color of light is referred to as its color temperature (see panel – What is Color Temperature? – on page 98), and in many instances our eyes and brain are remarkably good at adapting to these changes in the color temperature of the light so that they are not apparent to us. Think about what you see when you stand outside a building in which the interior lamps are switched on in daylight; the light the lamps emit often appears very yellow, but if you look at the same building after dark the light from the lamps appears to be white. This is an example of the adaptive process that our eyes and brain apply to light, one which cameras, regardless of whether they use film or a digital sensor, cannot perform.

Cameras have a fixed response to the color temperature of the light they record; film has a response limited to a specific color temperature (for daylight balanced film this is equivalent to direct sunlight at midday under a clear sky), but digital cameras such as the D80 are far more flexible, as they can process the picture data to equate to a variety of specific color temperatures, either automatically, or by selecting the color temperature manually. This function is known as the white balance control.

What Is Color Temperature?

The color of light is often referred to as its color temperature, which is expressed in units called degrees Kelvin (K). It sounds counter intuitive, but warm light (red/orange tones) has a low temperature and cool light (blue tones) has a high temperature. Why is this? Well, the color temperature of a light source equates to the color of something called a "black body radiator," a concept used by scientists that involves a theoretical object that can re-emit 100% of the energy it absorbs as it is heated; as it gets hotter, its color changes from black, to red, orange, yellow, all the way to blue. The spectral output of a particular light source is said to approximate to a "black body" at the same temperature. Thus, at low color temperatures, light contains a high proportion of red wavelengths, and conversely, at high color temperatures, the light is comprised predominantly of blue wavelengths.

Generally during the manufacturing stage, most film is balanced to either direct sunlight under a clear sky at midday (5500K) or to the light emitted by a tungsten photoflood lamp (3400K). If you use these films in conditions where the temperature of the ambient light you are shooting under differs from the prescribed values your photographs will take on a color cast that must be countered by color correction filters.

Note: The color temperature of daylight will vary according to a number of factors, including time of day, time of year, latitude, altitude, and the prevailing atmospheric and climatic conditions.

Digital cameras, on the other hand, are far more versatile. Most allow you to set a specific color temperature in addition to their automatic white balance capabilities, so when you view the image in the camera, or computer, the colors are matched to your chosen white balance value. Assuming this value corresponds to the color temperature of the prevailing light, the scene will be rendered without any color casts. Of course, you can also use the white balance feature creatively by setting an alternative value that does not correspond to the prevailing light and thereby induce a color shift deliberately.

White Balance Options

The D80 camera offers nine principal white balance options: <Auto>, \$1X pre-determined values (<incandescent>, <rluorescent>, <Dir. Sunlight>, <Flash>, <Cloudy>, and <Shade>), setting a specific value using the <Choose Color Temp.> option, or a programmed <Preset> option. These options are only available when shooting in the P, A, S, and M exposure modes. The approximate color temperature for each option, except <Choose Color Temp.> and <Preset>, is given in parentheses in the following list of descriptions:

A Auto (3500 – 8000K): Nikon suggest that the D80 will measure light with a color temperature between 3500K and 8000K automatically. In most instances, the <Auto> option is very effective, but as with all automatic features on any camera, you do need to think for yourself and step in to take control when appropriate. For example, if you shoot indoors under normal electric lighting, the color temperature is likely to be lower than 3500K. Alternatively, outdoors in bright overcast conditions the color temperature is likely to exceed 8000K.

Incandescent (3000K): Use this in place of the <Auto> option when shooting indoors under tungsten lights. If you find that the results still look too warm (red), use the white balance fine-tuning control (see page 102) to make further adjustments.

Fluorescent (4200K): The light emitted from fluorescent tubes is notorious for causing unwanted color casts in pictures. This is due to the way the tubes work and the variability in the color temperature of the light the produce. However, this white balance option is accurate enough for any tubes that are described by their manufacturer as being daylight balanced.

Birect sunlight (5200K): This option is intended for subjects or scenes photographed in direct sunlight during the middle part of the day (from around two hours after sunrise to two hours before sunset). At other times when the sun

is lower in the sky, the light tends to be "warmer," which produces pictures with a redder appearance.

Hint: White balance is a very subjective issue, but to my eye, Nikon's color temperature for the <Dir. Sunlight> option is too low (produces a result that looks too cool). When shooting in these conditions, I prefer to use either the <Flash> or <Cloudy> white balance selections.

4 Flash (5400K): As its name implies, this option is intended whenever you use flash as the main light source for your image.

Hint: Similar to my thoughts on the <Dir. Sunlight> option, I consider the color temperature of the <Flash> option to be too low. I often select the <Cloudy> option when working with flash as the main light source.

▲ Cloudy (6000K): This white balance option is for shooting under overcast skies when daylight has a high color temperature. It ensures that the camera renders colors properly without the typical "cool" blue appearance that often results when shooting in this type of light, particularly in pale skin tones.

►... Shade (8000K): This option applies a greater degree of correction than the <Cloudy> option, and is intended for those situations when your subject or scene is in open shade beneath a clear, or nearly clear, blue sky when the color temperature is likely to be very high. Under these conditions, the lighting will be biased strongly towards blue, as it comprises principally of light reflected from the blue sky above.

Choose Color Temperature (2500 – 9,900K): The <Choose Color Temp.> option allows the user to select a range of specific color temperature values expressed in degrees Kelvin (K). If you know the specific color temperature of the light illuminating the subject or scene you are shooting, the camera can be set to match it.

PRE Preset: This white balance option allows you to ubtain a measurement of the autor temporature of the light illuminating the subject or scene by making a test shot. Or, alternatively, you can use an existing image stored on the memory card as a reference for the color temperature value.

Note: The white balance options listed above are only available when shooting in the P, A, S, and M exposure modes. In the and Digital Vari-Program modes, the white balance value is always selected automatically.

The white balance button on the rear of the camera can be used in conjunction with the command dials to set the white balance value.

Selecting a White Balance Option

The white balance options of the D80 camera can be selected in one of two ways: You can press the web button, use the multi selector to open the Shooting menu, navigate to the <White balance> option and multi select right, then scroll down the list to highlight your choice and multi select right again. If <Auto> or one of the six pre-determined white balance values are selected (<Incandescent>, <Fluorescent>, <Dir. Sunlight>, <Flash>, <Cloudy>, and <Shade>), the next menu page will show the white balance fine-tune option. Use the up and down keys on the multi selector to set any fine-tune factor required; if none is required, leave it set to <0>. Finally, multi select right to set the white balance, with or without a fine-tune factor applied.

Note: White balance fine tuning cannot be applied to the <Choose Color Temp.> and <Preset> options.

The other, faster way to select a white balance option is to use the **WB** button on the back of the camera. Press and hold this button then rotate the main command dial to select a white balance option. Use the sub-command dial to set the fine-tuning factor (if required); as you do this, the values are displayed in the control panel.

Note: If you select the <Choose Color Temp.> option and hold down the **WB** button while rotating the sub-command dial, the color temperature value will change up and down the scale of available settings depending on the direction the dial is rotated. The selected value is displayed in the control panel.

Fine-Tune Control of White Balance Values

In addition to the color temperature values for the white balance options available on the D80 camera, regardless of whether the white balance is set automatically, or manually, the camera allows you to fine-tune the color temperature value by increasing or decreasing it (excluding the <Choose Color Temp.> and <Preset> options). However, rather than express this fine-tuning factor in degrees Kelvin, Nikon use a system of whole numbers between -3 and +3. Negative numbers set a higher color temperature making pictures appear "warmer" (redder) and positive numbers reduce the color temperature making pictures appear "cooler" (bluer). If a fine-tuning factor other than zero is selected and set, a pair of solid black arrowheads appears in the control panel beneath **WB** as a reminder.

White Balance / Color Temperature Values	White	Balance /	Color	Temperature	Values
--	-------	-----------	-------	-------------	--------

White		Fine	Tuning	- Color 1	ſempera	ture Valu	ies
Balance	None	-3	-2	-1	+1	+2	+3
A	3,500- 8,000K	Fine tuning value added to color temperature value selected by camera					a
*	3,000K	3,300K	3,200K	3,100K	2,900K	2,800K	2,700K
	4,200K	7,200K	6,500K	5,000K	3,700K	3,000K	2,700K
*	5,200K	5,600K	5,400K	5,300K	5,000K	4,900K	4,800K
4	5,400K	6,000K	5,800K	5,600K	5,200K	5,000K	4,800K
2	6,000K	6,600K	6,400K	6,200K	5,800K	5,600K	5,400K
a %.	8,000K	9,200K	8,800K	8,400K	7,500K	7,100K	6,700K
K	2,500- 9,900K	Not Available					
PRE	-						

Hint: If you are unsure about which fine-tune factor to set, you can activate <WB Bracketing> via CS-13 (see pages 206-207 for more details).

Hint: The D80 instruction manual says that, excluding the <Fluorescent> option, each +/- whole number increment is equivalent to 10-MIRED (Micro Reciprocal Degree – a method of calculating color temperature), but they provide no information about what a MIRED value means in practical terms. If you assume a picture is recorded with a neutral white balance at its 0 value, applying a -1 factor is like adding an 81-series (pale amber) filter. Thus, -2 is equivalent to a Wratten 81A filter, -3 is equivalent to an 81B. Applying a positive value is equivalent to adding a pale blue filter from the Wratten 82-series.

Hint: Do you want to get creative? You do not have to set the white balance to match the color temperature of the prevailing light; try mismatching it! For example, rather than shoot a subject or scene lit by daylight using one of the daylight white balance values, set the white balance to <Incandescent>. Now your picture will have a strong blue color cast, perfect if you're aiming to create a "cold" feel to the scene. Remember, if the color temperature of the prevailing light is lower than the color temperature of the white balance value set on the camera, the subject or scene will be rendered with a red/yellow color cast. Conversely, if the color temperature of the prevailing light is higher than the color temperature of the white balance value set on the camera, the subject or scene will be rendered with a red/yellow color cast. Conversely, if the color temperature of the white balance value set on the camera, the subject or scene will be rendered with a red/yellow color cast.

Choose Color Temperature

The <Choose Color Temp.> option allows you to select one of thirty-one predetermined color temperature values that range from 2500 to 9,900K in increments of approximately 10 MIRED. As with other white balance options, <Choose Color Temp.> can be selected via the Shooting menu, or by pressing the WB button on the back of the camera and rotating the main command dial. If the Shooting menu route is used, the specific color temperature value is selected by scrolling through the options using the multi selector, pressing it to the right to confirm your selection. If the WB button and command dial route is used, the option is selected by pressing and holding the WB button while rotating the main command dial, and pressing and holding the WB button while rotating the sub-command dial selects the value. The color temperature value will be displayed in the control panel.

Preset White Balance

The <Preset> option allows you to manually set a white balance value measured from the lighting falling on the subject or scene being photographed, and as such, provides the most accurate way of setting a white balance value. The D80 offers two methods of setting the <Preset> white balance value; you can either use the camera to measure light reflected from a white or gray card test target, or you can use the white balance value from a previ-

Hint: Nikon suggests that you can use either a white or gray card as a reference target for the <Preset> white balance option. I recommend strongly, however, that you use only a gray card for two reasons; for one thing, white cards often contains pigments used to whiten them, which can cause the camera to render colors inaccurately. Secondly, it is more difficult to expose correctly for a pure white subject, and errors in exposure can affect the white balance reading you obtain from the test target.

Hint: In place of a test target such as a piece of gray card, there are a number of products that can be attached directly to the lens and allow the camera to not only obtain a white balance measurement, but also to take an incident reading for the ambient light using its TTL metering system. Probably the best device I have used for this purpose is the ExpoDisc (www.expodisc.com).

Use of the <Preset> option (which is only available in P, A, S, and M exposure modes) involves a few more steps than the other white balance options. There are two methods available with the D80 for obtaining a preset value: direct measurement, and copying the white balance from an existing picture taken on a D80 camera. The camera can store only one value for the preset white balance, so consequently, it is always the white balance value measured most recently, regardless of the method used, that will be stored.

To use direct measurement to obtain a white balance value, select the <Preset> option from the <White Balance> submenu in the Shooting menu. Then, place your test target (preferably a gray card) in the same light as is falling on the scene or subject to be photographed. Select manual focus and set the focus distance on the lens to the infinity point. The exposure mode you use is not critical, but I recommend you use A (aperture-priority) mode. Point the camera at your test target, making sure you do not cast a shadow over it and that

Use the <Preset> option to manually set a white balance value based on the light falling on the scene.

it fills the viewfinder frame. (There is no need to focus on the test target card.) Then press the **WB** button on the back of the camera and rotate the main command dial until $Pr\xi$ is displayed in the control panel. Release the WB button briefly, then press and hold it until $P_r \xi$ begins to flash in the viewfinder and control panel displays. Now press the shutter release. If the camera is able to obtain a measurement and set a white balance value, **5d** will appear in the viewfinder and **Good** will be displayed in the control panel LCD; both icons will flash. The white balance is now set for the prevailing light falling on you subject or scene, and this value will be stored and retained, automatically replacing any previous value stored on the camera, until you make another measurement. If the camera is unable to set a white balance value, **b** d will be shown prefixed by "no" flashing in both the viewfinder and the control panel. In this case, repeat the process until a measurement is achieved.

White Balance Bracketing

The white balance bracketing footure creates multiple copies of a single image recorded by the camera, but each one has a different white balance value as determined by the settings the users selects.

Note: White balance bracketing is not available with the Choose Color Temp.> or **PRE** <Preset> white balance options. The feature also cannot be used with the NEF or any of the NEF + JPEG image quality settings.

To set white balance bracketing, select <WB Bracketing> from the options at CS-13 <Auto BKT Set>, then press the button and rotate the main command dial to select the number of different white balance values to be created by the bracketing process. (Remember, only one exposure is made; the camera applies the different white balance values as it processes the image data.)

Note: If the number of image files to be created will exceed the number of remaining exposures on the memory card, FULL is displayed in the control panel and FuL is shown in the viewfinder.

Number of Frames	Progress Indicator	Description
35	+480-	3 frames, unmodified, negative, positive
+25	+48	2 frames, unmodified, positive
25		2 frames, unmodified, negative

To select the level of adjustment to be applied, rotate the sub-command dial. Each increment is a whole number (1, 2, or 3) and represents a shift of approximately 10 MIRED. After making the single exposure, the camera will process the data to create the number of shots you specified for the sequence; each file will have a different white balance value

according to the increment selected. For example, if you select 3F +4D- and set an adjustment level of 2, the white balance bracketing feature will produce three frames; the first will be unmodified, the second will have a fine-tune factor of -2 applied, and the third frame will have a fine-tune factor of +2 applied.

Note: The effect of applying a white balance fine-tuning factor and white balance bracketing are cumulative (i.e., the bracketed values will be added to the fine tuning factor for each file the camera creates).

ISO Sensitivity with the D80

One of the great advantages of digital photography is that digital cameras generally allow you to adjust the sensitivity from picture to picture. The D80 is no exception, and offers sensitivity settings (in ISO equivalent values) from 100 to 1600, plus the option to increase sensitivity by a maximum of 1 EV above 1600, all in increments of 1/3 EV (one-third stop). There is a specific noise reduction feature for use with high ISO settings, and in addition to this, the camera has an <ISO Auto> feature that is intended to vary the sensitivity value automatically according to the light conditions.

Note: The word "sensitivity" should be used advisedly since the sensor in the D80 actually has a fixed sensitivity, equivalent to ISO 100. The higher ISO values are achieved by amplifying the signal from the sensor.

ISO Rating

In digital cameras, the sensitivity ratings used by manufacturers approximate to an ISO rating of film, but what is ISO? The International Organization for Standardization is an international standard-setting body composed of representatives from various national standard organizations. It has set the international standard for rating film speed (sensitivity) using the ISO scale, which combines both the ASA standard for rating film sensitivity developed by the American National Standards Institute (ANSI) and the DIN standard developed for the same purpose by the Deutsches Institut für Normung (DIN), the German Institute för Ständardization. Using the ISO convention, film with an ASA speed of 400 (DIN speed of 27°) is labeled ISO 400/27°. There is a popular misconception that ISO is an acronym for International Standards Organization; actually ISO comes from the Greek word "isos," meaning "equal."

Setting ISO Sensitivity

To set the sensitivity value on the D80 you can take two different routes; either open the Shooting menu and scroll to ISO sensitivity, multi select right to open the sub-menu of values, then scroll down it to highlight the required value and press the DS button to set it, or, alternatively, you can adjust the sensitivity (ISO) by pressing and holding the ISO button on the back of the camera, and then turning the main-command dial. The selected value is displayed in the control panel.

Pressing the ISO button and turning the main command dial is the quickest way to set the ISO sensitivity.

The analogy with film continues in so much as at higher sensitivity settings an image will show increasing amount of

1

digital noise. However, this noise is not as random as the distribution of grain in film, which tens to make it more visible, and it has the effect of reducing the tonality of pictures. As the sensitivity value is hiked higher and higher, so the saturation of color and level of image contrast are reduced.

For the optimum image quality keep the D80 set to ISO 100. However, image quality, in terms of color saturation, color fidelity, ISO noise, is highly commendable at all settings up to and including 400; the results are virtually indistinguishable. Above the 400 setting up to 800 there is slight increase in ISO noise but to be candid only the most discerning and critical user will detect a difference. Raising the sensitivity to 1600 does not detract from image quality by anywhere near the level seen in earlier Nikon D-SLR cameras, and renders extraordinarily good results all things considered. Push the D80 to its ISO limit, equivalent to 3200, and you will see a noticeable increase in grain effects, and a loss of both color saturation and fidelity but the results are still certainly useable if your back is against the "exposure wall."

Hint: Combining the H1.0 (ISO 3200 equivalent) setting with the black and white option in the <Optimize Image> menu can produce some very effective "grainy" results that emulate those achieved with traditional high ISO black and white film and push-processing.

Hint: If the light level begins to drop as you shoot you can either raise the ISO setting, or using a longer shutter-speed. Confronted with this situation I recommend putting the camera on a tripod, and selecting a longer exposure, and only increasing the sensitivity as a second option, unless of course the subject requires a fast shutter speed to render the required result.

ISO Auto

1

I dislike this option so much that I will begin this section by suggesting you ignore it completely. Why? Well, it is important to understand that it does not work in quite the way I expect most users imagine. In P (Programmed Auto) and A (Aperture-Priority) modes, the sensitivity will not change until the exposure reaches the limits of the shutter speed range. The upper limit is always 1/4000 second, but the lower limit can be adjusted within CS-07 via the <Min. Shutter speed> option to between 1 second and 1/125 second.

In S (Shutter-Priority) mode, the sensitivity is shifted when the exposure reaches the limit of the available aperture range. Indeed, this is the only exposure mode with which ISO Auto might be useful because it will raise the sensitivity setting and thus maintain the pre-selected shutter speed, which in this mode is probably critical to the success of the picture. In M (Manual) exposure mode, the sensitivity is shifted if the selected shutter speed and aperture cannot attain a correct exposure (as indicated by the display in the viewfinder). It is also possible to select a maximum sensitivity (ISO) setting for the ISO Auto control using the <Max Sensitivity> option in CS-07.

ISO-AUTO appears blinking in the control panel and the viewfinder when this function is active (i.e., when the sensitivity has been altered from the value set initially by the user). The drawback with the ISO Auto mode is that the only way to be sure of exactly what sensitivity value the D80 has set is to assign the display function <ISO display> to the Function button, using CS-16 (it is the default option), which in my opinion is a complete waste of the potential of this button that can be used perform far more useful functions.

TTL Metering

If the D80 is your first digital SLR camera, you may find controlling exposure a bit more demanding than it was in your film days. Color negative (print) film is very tolerant to exposure errors, particularly overexposure, and the automated processing machines used to produce your prints are capable of correcting exposure errors over a range of -2 to +3stops and adjust color balance at the same time. The chances are that you never noticed your exposure errors when looking at the finished prints! Controlling exposure with a digital SLR is analogous to shooting on transparency (slide) film in that there is virtually no margin for error. Even moderate overexposure will "blow out" highlight detail leaving no usable image data in these areas. Underexposure is little better since, to correct for its effects, the image data will require significant amplification. The result of correcting an underexposed digital image is often the manifestation of digital noise, which degrades image quality.

The D80 has three metering options that will be familiar if you have used a Nikon AF camera before. To select a metering mode, press the 🕑 button located on the right top of the camera behind the shutter release button and turn the main command dial until the appropriate icon is shown in the control panel display.

The metering mode is selected using the button in conjunction with the main command dial.

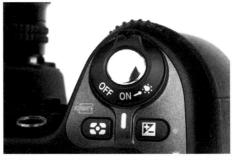

The Matrix metering II system used in the D80 covers virtually the entire frame area, as depicted by the shaded area in the diagram.

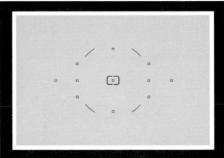

Matrix Metering

The metering pattern for this mode divides most of the image area into a series of segments and assesses the light seen through the lens for a number of attributes. The values for these attributes are then compared against a database of reference images stored in the camera's memory before the camera suggests a final exposure setting. The Matrix metering in the D80 uses a sophisticated 420-pixel RGB CCD-type sensor located in the viewfinder head that divides the frame area into 420 segments using an alternating pattern of red, green, and blue sensors to measure light values. It is the same sensor used in the earlier D50 model, but with enhanced data processing algorithms.

To get the most from the Matrix metering capabilities of the D80, use a D- or G-type Nikkor lens, as these provide additional information from the autofocus system, which assists the camera in estimating where in the frame the subject is likely to be (the camera assumes the subject is in the plane of sharp focus and located in the region of the active focus area). Hence, Nikon refers to the system as 3D Color Matrix metering II. If a Nikkor lens that does not communicate focus information to the camera is used, the system defaults to Color Matrix metering II (i.e., the 3D element is not performed). By assessing color as well as brightness, this metering system helps to reduce the influence of a monochromatic scene or subject, thereby improving its accuracy; earlier versions of Nikon Matrix metering system are less capable.

Note: The very extreme edges of the frame area are outside the area covered by the matrix-metering pattern.

Matrix metering uses four principle factors when calculating an exposure value:

- The overall brightness level of a scene
- The ratio of brightness between matrix pattern segments
- The active focus area (which suggests the position of the subject in the frame)
- The focused distance provided by the lens (D- or G-type only)

There has been a great deal of discussion on Internet forums about the accuracy of the Matrix metering system of the D80. The root of this lies in the fact that the pattern metering of the D80 places a stronger bias on the central area of the frame compared with the outer frame area when the central area is significantly lighter or darker than a middle gray tone. This is quite different than other Nikon D-SLR models to date, with the exception of the D50, which should not be surprising since that camera uses the same 420-pixel RGB metering sensor (although the bias when there is a nonmiddle toned subject in the central frame area is less with the D50). Here is an example of how the Matrix metering of the D80 might catch you by surprise. Let us say you want to photograph a white cat sitting on a lawn of green grass; if you frame the cat so it occupies just the central area of the frame (i.e., within the area bounded by the autofocus sensing areas) and shoot at the exposure settings suggested by the camera, the likely result will be the cat and mid-toned grass rendered as underexposed. Repeat the shoot but with a grav cat and it is likely both the cat and the grass will be exposed properly. However, repeat the shoot with a black cat and the likely result will be both the cat and mid-toned grass being rendered as overexposed. This central bias of the Matrix metering is significant because shooting like for like with the D2Xs, D200, and D80 I have noticed a deviance of up to +/-2EV between the latter and the two former models (which produce a more balanced exposure between the central and outer frame areas in the specific situation described above). Is this trait significant? Yes, it is! Particularly with a dark subject in the central frame area, since overexposure risks over-saturation of the photosites (pixels) resulting in highlight detail that is "burnt out" and unrecoverable.

The D80 will endeavor to preserve highlight values over shadow values because, like transparency film, once the highlight detail is overexposed, data is lost and no amount of subsequent image manipulation will recover it. However, it is possible to recover shadow detail from underexposed areas (although the risk of inducing electronic noise due to the required amplification is increased). Therefore, if the scene you photograph has a wide contrast range (large variation in hrightness) do not be surprised if it looks as though it has been very slightly underexposed. Fortunately, the Dau lias a couple of features that help you to evaluate an exposure: the histogram and highlights displays.

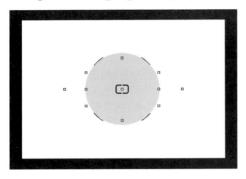

The center-weighted metering system used in the D80 assigns 75% of the metering sensitivity to a central circular area; at the default setting this is 8mm in diameter, and corresponds to the circle marked on the focusing screen.

Center-Weighted Metering

The center-weighted metering pattern harkens back to the very first TTL metering systems used by early Nikon SLR film cameras. In these cameras, the frame area was usually divided in a 60:40 ratio with the bias being placed in the central portion of the frame. The D80 uses a stronger ratio of 75:25, with 75% of the exposure reading based on the central area of the frame and the remaining 25% based on the outer area. Using CS-12, you can alter the diameter of the central metering area; at its default value of 0.31 inches (8 mm), it corresponds to the circle defined by the four quadrant marks in the center of the camera's focusing screen.

Hint: Center-weighted metering is the least accurate of the three metering patterns available on the D80. Matrix metering will do an excellent job in most situations, and for particularly tricky lighting, spot metering is more useful than the center-weighted pattern.

• Spot Metering

Spot metering is extremely useful for measuring a highly specific area of a scene. For example, faced with a subject against a virtually black background, which might cause the The spot metering system used in the D80 assigns the metering sensitivity to a circular area that represents approximately 2.5% of the total frame area; it can be set to be centered on any one of the eleven autofocus sensing areas.

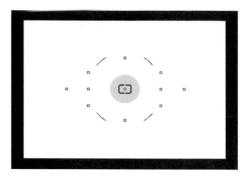

Matrix metering system to overexpose the subject, the spot meter allows you to take a reading from the subject without being influenced by the background. The sensing area for the spot metering function of the D80 is a circle approximately 0.14 inches (3.5 mm) in diameter. The center of the metering area is aligned with the center of the selected (active) autofocus sensing area.

Hint: It is essential to remember that every TTL metering system measures reflected light and is calibrated to give a correct exposure for midtones. When using the spot meter, you must make sure that the part of the scene you meter from represents a midtone, otherwise you will need to compensate the exposure value.

Hint: In dynamic-area AF, the D80 will attempt to follow a moving subject by shifting focus control between any of the autofocus sensing areas. If this occurs, the spot metering also shifts, following the active sensing area. If in doubt, switch to single-area AF, as the D80 will always position spot metering over the selected autofocus sensing area.

Exposure Modes

In addition to mode and the fully automated Digital Vari-Program options, the D80 offers four exposure modes that the user can control. To select an exposure mode, rotate the mode dial on the top of the camera until the desired

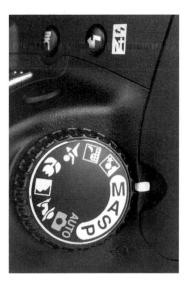

The exposure mode is selected by rotating the mode dial on the ton of the camera: here manual exposure mode has been selected.

mode (P, A, S, or M) is aligned with the index mark on the side of the viewfinder head.

Note: If you attach a non-CPU lens, the exposure metering system of the D80 is disabled.

P – Programmed Auto Mode

Program mode, as it is often referred to, automatically adjusts both the shutter speed and lens aperture to produce a correctly exposed image as defined by the selected metering mode. If you decide that a particular combination chosen by the camera is not suitable, you can override the Program mode settings by turning the main command dial when the camera meter is activated. P * appears in the control panel (the camera is now in flexible program mode), but there is no indication in the viewfinder that you have overridden the camera's chosen exposure settings other than the altered shutter speed and aperture values. The two values change in tandem, so the overall level of exposure remains the same (i.e., increasing the shutter speed decreases the aperture, and vice versa). **Hint:** If you decide to override P mode, the camera will remain locked to its new settings for shutter speed and aperture even if the meter auto-powers off and is switched on again by pressing the shutter release halfway. To cancel the override, you must manually rotate the main command dial until the indicator for flexible program P * is no longer displayed. Changing the exposure mode, turning the camera off, or performing a camera reset will also cancel the flexible program override.

Hint: In my opinion, Program mode is little better than the and Digital Vari-Program mode point-and-shoot options; in all of these modes, you relinquish control of exposure to the camera. If you want to make informed decisions about shutter speed and aperture for creative photography, use A, S, or M mode.

A – Aperture Priority Auto Mode

In this mode, the photographer selects an aperture value and the D80 will choose a shutter speed to produce an appropriate exposure. The aperture is controlled by the sub-command dial and is changed in increments of 1/3-stop (the default setting for CS-10). The shutter speed the D80 selects will also change in increments of 1/3-stop (default). The EV step level can be changed to increments of 1/2-stop using CS-10.

S – Shutter Priority Auto Mode

In this mode the photographer selects a shutter speed and the D80 will choose an aperture value to produce an appropriate exposure. The shutter speed is controlled by the main command dial and is changed in increments of 1/3-stop (the default setting for CS-10). The aperture value the D80 selects will also change in increments of 1/3-stop (default). The EV step level can be changed to increments of 1/2-stop using CS-10.

Note: In P, A, and S modes, if the subject or scene is too bright, the D80 will display a warning **H**: in the viewfinder and control panel. Likewise, if the subject or scene is too dark, the D80 will display a warning **Lo** in the viewfinder and control panel.

Use S mode when freezing action is a priority.

Hint: If you use the D80 remotely (without having your eye to the viewfinder when you make an exposure) as when taking a self-portrait using the self-timer or using the ML-L3 remote to release the shutter, you must cover over the viewfinder eyepiece. The metering sensor of the D80 is located within the viewfinder head, therefore, light entering via the viewfinder eyepiece will affect exposures made in P, A, and S, modes. Nikon supplies the D80 with the DK-5 eyepiece cover for this purpose, but in order to use it, the rubber eyecup fitted on the camera must be removed first. Personally, I find attaching the DK-5 a fuss, so I keep a small square of thick black felt fabric in my camera bag and drape this over the camera to block light from the viewfinder eyepiece.

Shutter Speed Considerations

If you handhold your camera, it is worth remembering a rule of thumb concerning the minimum shutter speed that is, generally, sufficient to prevent a loss of sharpness due to camera shake. Take the reciprocal value of the lens focal length and use this as the slowest shutter speed with that lens. For example, with a focal length of 200mm, set a minimum shutter speed of 1/200 second.

Shutter speed can be used for creative effect because it controls the way that motion is depicted in a photograph. Generally, fast shutter speeds are used if you wish to "freeze" motion in sports or action photography. Slower shutter speeds (1/30 second or longer) can be used to introduce a degree of blur that can evoke a greater sense of movement than a subject that is rendered pin-sharp. Alternatively, you can pan the camera with the subject so that it appears relatively sharp against an increased level of blur in the background.

If you want a moving element in your picture of a static subject to "disappear," a very long shutter speed of several minutes or more can often be very effective. While the subject is rendered properly, the moving elements do not record sufficient information in any part of the frame to be visible. Generally, this technique will require a strong neutral density filter to be effective in daylight conditions. So, the next time you want to take a picture of a famous building and exclude all the visitors from cluttering up your composition, try this technique.

M – Manual Exposure Mode

This mode offers the photographer total control overexposure, and is probably the most useful if you want to learn more about the effect of shutter speed and aperture on the final appearance of your pictures. You choose and control both the shutter speed (main command dial) and lens aperture (sub-command dial). An analogue display shown in the viewfinder indicates the level of exposure your settings would produce. If the camera determines the exposure values are set for a proper exposure, a single indent mark appears below the central '0'. If the camera determines that the settings would produce an UNUEREXPOSED result, the degree of underexposure is indicated by the number of indent marks that appear to the right (minus) side of the central '0'. Conversely, if the chosen settings would create an overexposed result, the degree of overexposure is indicated by the number of indent marks to the left (plus) side of the central '0'. The more indent marks that appear, the greater the degree of deviation from a "proper" exposure.

Autoexposure Lock

If you take a meter reading in P,A, or S modes and recompose the picture after taking a reading, it is likely, particularly with either center-weighted or spot metering, the metering mode sensing area will now fall on an alternative part of the scene and probably produce a different exposure value. To counter this, the D80 allows you to lock the initial exposure reading while you reframe and take the picture. Start by positioning the part of the scene you want to meter within the appropriate metering area, press the shutter release button halfway to acquire a reading, then press and hold the button (assuming the appropriate option is selected at CS-18). You can now recompose and take the picture at the metered value (AE-L will appear in the viewfinder display while this function is active). Alternatively, you can select <ON> for CS-19 so that once the shutter release button is depressed and held halfway down in P, A, or S mode, the exposure value remains locked.

Hint: While the autoexposure lock function works with all three metering modes, it is generally most effective with center-weighted and spot metering. These two modes are most useful in very difficult lighting conditions when a more accurate exposure reading can be to taken from a specific area of the scene that may otherwise "fool" the Matrix metering system.

Exposure Compensation

As mentioned previously, the TTL metering system of the D80 works on the assumption that it is pointed at a scene with a reflectivity that averages out to the equivalent of a midtone. Nikon appears to calibrate against a reference that has a reflectivity value of approximately 12% to 13%, so if you use a standard photographic 18% gray card to estimate exposure, you will find your results will be approximately a third to half-stop underexposed.

Many scenes you encounter will not reflect 12% to 13% of the light falling on them. For example, a landscape under a blanket of fresh snowfall is going to reflect far more light than a mountain covered with black volcanic rock. Unless you compensate your exposure, these more extreme scenes will both be rendered as midtones and look dull and flat. To set a compensation factor, hold down the button, then turn the main command dial until the required value (plus or minus) is shown in the control panel. The value is also displayed in the viewfinder while the button is held down.

Note: The degree of compensation will change in steps of +/- 1/3 EV or 1/2 EV, depending on which step size is selected at CS-10.

Note: If exposure compensation is set in P, A, or S exposure modes, an analogue display is shown in the viewfinder alongside the values for the shutter speed and aperture to indicate the degree of deviation from the exposure level suggested by the camera. If CS-10 is set to 1/3 EV steps, this displays up to +/- 2 EV; if CS-10 is set to 1/2 EV steps, it displays up to +/- 3 EV.

In Manual exposure mode, the exposure is set according to the value suggested by the camera's TTL meter if the analogue display shows no deviance either side of the '0' midpoint. If an exposure compensation factor is applied in this mode, the display shifts either to the left (plus compensation) or right (minus compensation) of the '0' midpoint by the amount of compensation you dial in, while the '0' blinks. As you dial in the compensation, you will see a small '+' or '-' icon displayed to the right of the analogue scale along the bottom of the viewfinder display (the exposure compensation button must be depressed to see this). As soon as you release the exposure compensation button, a '+/-' icon appears in its place and is also shown in the control panel LCD display on top of the camera.

However, unlike the other three exposure modes where the exposure compensation value is applied automatically, to put the exposure compensation in to effect with the Manual exposure mode, you must adjust the shutter speed and/or aperture manually so the analogue scale display is shifted back to where there is no deviance on either side of the '0' midpoint.

Note: Once you have made these adjustments in M mode and the analogue scale is centered on '0' again, if you press the exposure compensation button the analogue scale shifts to show the amount of compensation applied and the icon to the right of the scale indicates whether it is a plus or minus value. This is a useful and quick way to check how much compensation you have applied

The exposure compensation icon '+/-' remains visible in the viewfinder and control panel regardless of the exposure mode in use as a reminder that you have an exposure compensation value applied. Once you have set a compensation factor, it will remain locked until you hold down the button and reset the value to 0.0.

Bracketing Exposure

It is important when shooting digital pictures to expose as accurately as you can, as overexposure will lose highlight detail and underexposure tends to degrade image quality due to the effects of digital noise, as well as blocking up shadow detail. The TTL meter of the D80 is very effective, but not infallible. To increase the chances of getting an exposure spoton, particularly when confronted with difficult lighting conditions, it is often wise to bracket exposures (take a series of pictures at slightly different exposure settings).

The bracketing system in the D80 allows you to take a sequence of exposures varied by steps of either 1/3 EV or 1/2 EV over a range of values from 0.3 EV to 2.0 EV (subject to the setting selected at CS-10 <EV Step>). The bracketing sequence can be selected to affect the exposure only (<AE only>), flash output only (<Flash only>), or a combination of the two (<AE & Flash>) by selecting the appropriate option at CS-13 <Auto Bkt Set>.

Note: Exposure bracketing is only available in P, A, S, and M exposure modes.

Note: If you press the button but the exposure bracketing information is not displayed, the camera is set to perform white balance bracketing. Open CS-13 and select an appropriate exposure bracketing option.

To set the bracketing function, press the button (located on the left front of the camera just above the lens release button) and turn the main command dial to select the number of exposures to be made in the bracketing sequence; BKT will be displayed in the control panel and the viewfinder. Press the
 button and turn the subcommand dial to select the exposure increment to be applied. To cancel bracketing, press the BKT button and rotate the main command dial until the number of shots in the bracketing sequence is set to '0 F' (BKT is no longer displayed in the control panel and viewfinder). The full range of bracketing values for the <AE only>, <Flash only>, and <AE & Flash> options is shown in the table below:

Number of Shots	Progress Indicator	Sequence
35	+48>-	3 exposures: unmodified, minus, plus
+25	+48	2 exposures: unmodified, plus
25	■▶-	2 exposures: unmodified, minus

Bracketing Considerations

- Using **S** single-frame shooting mode the shutter release button must be depressed to make each exposure in the bracketing sequence.
- If you set the D80 to the continuous-frame shooting mode and press and hold the shutter release button down, the camera will only take the number of frames specified in the bracket sequence. The camera stops regardless of whether the shutter release continues to be depressed.
- If you turn the power to the D80 off, or have to change the memory card during a bracketing sequence, the camera remembers which exposure values are outstanding, so when you turn the camera on again, or insert a new memory card, the sequence will resume from where it stopped.
- You can combine a bracketing sequence with a fixed exposure compensation factor and the effect of setting both is cumulative. For example, if you set a bracket sequence of three frames at an increment of 1 EV (which would normally render three exposures at the unmodified value, -1EV, and +1EV), then you apply an exposure compensation of +1.0 EV to adjust exposure for a scene comprised predominantly of light tones, such as a snow covered landscape, the actual sequence of exposures made in the bracketing sequence will be equal to unmodified at +1 EV, the unmodified value, and +2 EV, respectively.

The shutter release button of the D80 is set inside a collar that forms the On/Off switch to power the camera.

Shutter Release

The shutter release button of the D80 is located, conventionally, on the right top of the camera. If the camera is switched on, lightly pressing the shutter release button halfway down will activate the metering system and initiate autofocus (assuming an autofocus mode has been selected). Once you release the button, the camera remains active for a fixed period, the duration of which depends on the selection made within CS-28 <Auto Meter-off>; 6 seconds is the default setting.

If you press the shutter release button all the way down, the shutter mechanism will operate and an exposure will be made. There is a short delay between pressing the button all the way down and the shutter opening that is usually referred to as shutter lag. The shutter release lag time of the D80 is approximately 80 ms (milliseconds), which is slightly less than the delay of the D70-series and D50 cameras but more than twice as long as the flagship D2Xs model. The mirror black out time of the camera is approximately 105 ms (1 ms = 1/1000 second). However, the release of the shutter can be delayed further, and in some cases prevented, if certain features and functions are in operation at the time the release button is pressed. The following are some of the reasons for causing a delay in shutter operation:

- The capacity of the buffer memory is probably the most common cause of shutter delay. It does not matter whether you shoul in single or continuous frame mode (see below for description); once the buffer memory is full, the camera must write data to the memory card before any more exposures can be made. As soon as sufficient space is available in the buffer memory for another image, the shutter can be released. For this reason using memory cards with a fast data write speed is to be recommended.
- If the camera is set to single-servo autofocus mode, the shutter is disabled until the D80 has acquired focus. In low light, or low contrast scenes the autofocus system can often take longer to achieve focus, adding to the delay.
- In low light situations, the D80 will activate the AF-assist lamp, provided it has been instructed to do so via CS-4, which introduces a short delay while the lamp illuminates and focus is acquired.

Note: The AF-assist lamp only operates in single-servo autofocus mode.

• The red-eye reduction function, which is one of the flash modes available on the camera, introduces an additional and significant one-second delay between pressing the shutter release button, and the exposure being made. This is the time the lamp used to emit light that causes a subject's eye pupils to constrict take to light, before the shutter opens and the flash unit fires.

Shooting Modes

Obviously, the D80 does not have to transport film between each exposure, so in that sense, it does not have a motor drive, but the shutter mechanism still has to be cycled. The camera offers a range of shooting modes: single-frame and continuous-frame, plus a self-timer option and a remote shutter release feature.

The shooting mode button is located beside the control panel LCD on the top of the camera

To set the shooting mode, hold down the shooting mode button and rotate the main command dial until the icon for the required option is displayed in the control panel: single-frame, continuous shooting, self-timer, delayed remote, and quick response remote.

Single-Frame S

In this shooting mode, a single image is recorded each time the shutter release button is pressed. To make another exposure the button must be pressed again. You can continue to do so until its buffer memory is full, in which case you must wait for data to be written to the memory card, or the memory card becomes full. **Hint:** You do not have to remove your finger from the shutter release button completely between frames; by raising it slightly after each exposure, maintaining a slight downward pressure on the shutter release button, you can keep the camera active and be ready for the next shot.

Hint: If you want to take a rapid sequence of pictures in single-frame mode avoid "stabbing" your finger down on the shutter release button in quick succession; keep a light pressure on it and roll your finger over the top of the button in a smooth, repeating action, as this will reduce the risk of camera shake spoiling your pictures.

Continuous Frame

In this mode, if you press and hold the shutter release button down, the D80 will continue to record images up to a maximum rate of 3 frames per second (fps).

Note: Nikon quote the frame rate for the D80 based on the camera being set to continuous-servo autofocus, manual or shutter-priority exposure mode, and a minimum shutter speed of 1/250 second. It is important to remember that buffer capacity, other auto-exposure modes, and single-servo auto-focus (particularly in low-light) can, and often does reduce the frame rate significantly.

When set to the self-timer option, the camera will not fire the shutter immediately when the shutter release button is pressed. Instead it waits for a predetermined period of time and then makes the exposure. The default time delay for the self-timer is 10 seconds, but it can be adjusted to 2, 5, or 20 seconds through CS-29.

Traditionally, the self-timer has been used to enable the photographer to be included in the picture being taken, but there is another very useful function for this feature. By using the self-timer to release the shutter, the photographer does not have to touch the camera to release the shutter, thus reducing the chance of camera shake. This is particularly useful for long exposures when the subject is static and precise timing of the shutter release is less critical.

To use the self-timer, the camera will normally be placed on an independent means of support such as a tripod. Compose the picture and ensure focus is confirmed before depressing the shutter release button (the shutter release will be disabled unless focus is acquired in AF-A or AF-S focus modes).

Hint: Make sure you do not pass in front of the lens after setting the self-timer, as the point of focus may shift, and may prevent the camera from operating. I recommend that the camera be set to manual focus mode when using the self-timer feature.

Note: If any of the fully automatic and Digital Variprogram modes, or P, A, and S exposure modes are used in conjunction with the self-timer feature it is essential to cover the viewfinder eyepiece with the supplied DK-5 eyepiece cap. In normal shooting the photographer has their eye to the viewfinder, which blocks extraneous light from entering the viewfinder eyepiece and influencing the camera's TTL metering sensor that is located in the viewfinder head.

Hint: Fitting the DK-5 requires the user to remove the DK-21 rubber eyecup; this is a nuisance and increases the risk that the eyecup might be lost. I recommend keeping a small square of thick felt material in your camera bag; drape this over the viewfinder eyepiece when using the self-timer mode, as it is far quicker and more convenient!

After the shutter release button is pressed the AF-assist lamp will begin to blink (if the audible warning is set via CS-1 to be active it will also emit a beep) until approximately two seconds before the exposure is due to be taken, at which point the light stops blinking and remains on continuously (the frequency of the beep will increase) until the shutter operates. To cancel the self-timer operation during the countdown, set the D80 to another shooting mode by pressing the source button.

The infrared receiver for the ML-L3 remote release is located immediately above the camera badge. Using a Remote Release

The D80 uses the Nikon ML-L3, wireless infrared (IR) remote release that is common to other Nikon cameras such as the D70-series, and D50. Pressing the transmit button on the ML-L3 sends an IR signal to the receiver, which is located behind a small widow on the upper, front left side of the D80, just above the camera's badge. The system has a maximum effective range of approximately 16 feet (5 m).

Hint: Nikon suggests in the instruction manual to the D80 that there must be a clear, unobstructed line of sight between the ML-L3 and the receiver on the D80. However, this is not necessarily the so, because it is quite possible to bounce the IR signal from the ML-L3 off a reflective surface such as a wall or window, which increases the potential of this feature.

Using a Remote Release

The ML-L3 can be used to release the shutter in two different ways:

Quick-Response Remote

The shutter is released as soon as you press the transmit button on the ML-L3 remote control. To set this function press the Dutton until Dappears in the control panel LCD display. The self-timer lamp will flash immediately after the shutter is released.

Delayed Remote

The shutter is released with a delay of approximately two seconds after you press the transmit button on the ML-L3 remote control. To set this function press the solution until appears in the control panel LCD display. The self-timer lamp will illuminate for approximately two-seconds, before the shutter is released.

Note: If AF-A (auto-select AF), or AF-S (single-servo AF) is selected the camera will return to its stand-by mode without the shutter operating if it is unable to acquire focus on a subject. The shutter release will operate without the camera focusing if manual focus, or AF-C (continuous-servo AF) is selected, or if focus has already been acquired by pressing the shutter release button.

Note: Regardless of which remote mode you choose the D80 will cancel it, automatically, after a fixed period of camera inactivity. At the default setting this period is one minute but you can also set it to 5, 10, or 15 minutes, via CS-30.

Note: If you require a flash unit to be used with either of the remote release options in P.A, S, and M exposure modes ensure that it is switched on, and that the flash ready light is illuminated, before you press the release button of the ML-L3.

Hint: If you want to make extremely long exposures with the D80 you can use the **buib** bulb setting (manual exposure mode only) in conjunction with the ML-L3. This works in both remote release modes. Used this way **buib** is replaced in the control panel display by a pair of dashes, and the exposure is started by the first press of the transmit button on the ML-L3, and finished with a second press of the button. A single flash of the AF-assist lamp confirms completion of the exposure. I recommend that you check that the battery is fully charged, and set the long exposure noise reduction feature, available in the shooting menu to on. The D80 will end the exposure, automatically, after 30 minutes.

Exposure Delay Mode (CS-31)

The exposure delay mode, which is set via CS-31, is a form of reflex mirror lock-up. It should not be confused with the mirror-up option available via the Setup menu, which is used to facilitate inspection and cleaning of the low-pass filter. Using this feature, the reflex mirror is raised and locked in its up position for approximately 0.4 seconds before the shutter is released, which helps to eliminate the vibrations that can often occur, particularly at shutter speeds between 1/2 second and 1/30 second, when the reflex mirror lifts up out of the light path to the camera's sensor. Once the exposure has been completed the mirror will return to its normal position. You can take repeated shots using the exposure delay mode, which remains active until CS-31 is set to <Off>

Note: Once in the raised position the reflex mirror prevents light from reaching the TTL meter sensor located in the viewfinder head, so if there is a significant change in the lighting conditions during this brief period the exposure will not be accurate. Likewise autofocus detection is no longer possible, so in autofocus modes the focus distance is locked at the distance set prior to the mirror being raised.

The D80 has an in-camera multiple exposure option, but you can also combine photos for this effect using image-processing software. Photo © Joe Meehan

Multiple Exposure

The D80 offers a method of combining separate exposures into a single picture using its <Multiple Exposure> feature. This enables you to combine multiple exposures (either two or three) into a single image. However, the images must be shot in consecutive order, and they are not saved as individual files but as a single combined image.

To use <Multiple Exposure>:

- 1. Select <Multiple Exposure> from the Shooting menu and multi select right.
- 2. Select <Number of Shots>, multi select right, then select 2 or 3 by multi selecting up or down.

- 3. Press the **OK** button.
- 4, Select <Auto Gain> and multi select right, then multi select up or down to select either <Un> or <U11> by highlighting the required option.

Hint: When <Auto Gain> is turned on, the camera will automatically make gain adjustments to each image recorded, so the final exposure is correct (i.e., it obviates the need to make exposure calculations to compensate for the cumulative effect of combining the individual exposures).

- 5. Select the required option by pressing the **D** button.
- 6. Highlight <Done> and press IN the OK button.
- 7. Frame and shoot the images you wish to combine.

The icon for multiple exposures appears in the control panel while the exposures are being made. When the selected number of exposures has been completed the icon will disappear from the control panel and the multiple exposure feature is turned off automatically. To create another multiple exposure repeat steps 1-7 above.

Note: To cancel the multiple exposure function once set but before taking any pictures, select Multiple exposure from the shooting menu, highlight Reset, and press the button. To cancel the multiple exposure function once at least one exposure has been made, select <Multiple Exposure> from the Shooting menu, highlight <Cancel>, and press the button.

Note: Shooting a multiple exposure sequence will stop if: the exposure meter turns off during shooting, the camera is turned off, the battery becomes exhausted, an exposure mode other than P, A, S, or M is selected, or a two-button reset is performed.

Note: To maintain the current settings for <Number of Shots> and <Auto Gain>, simply select <Done> from the <Multiple Exposure> options list to set another multiple exposure sequence.

Image Overlay

<Image Overlay> is the other feature available on the D80 that enables the user to combine multiple images. In the case of this feature it is limited to using a pair of NEF Raw files and combining them to form a single, new image (the original image files are not affected by this process). The images do not have to be taken in consecutive order but must have been recorded by a D80 camera, and be stored on the same memory card.

Note: The new image is saved at the image quality and size currently set on the camera. Therefore, before using the feature ensure that the image quality and size are set to the required values.

To use <Image Overlay>:

- 1. Select <Image Overlay> from the retouch menu, and multi select right.
- 2. The <Image Overlay> page will open with <Image 1> highlighted.
- 3. To select the first picture, press the Solution and a thumbnail view of all NEF files stored on the memory card will be displayed. Scroll through the images by pressing the multi selector button left or right to high-lighted the image you wish to select. Pressing displays the highlighted image full frame.
- 4. Press and the selected image will appear in the <Image 1> box and the <Preview> box.
- 5. Highlight the <Image 2> box and press **OK** to select the second picture to be combined with the first imaged selected using the same process as step 3.
- 6. Press **OK** to select the second image, which will appear in the <Image 2> box and in the <Preview> box, overlaying the first image.
- Adjust the gain value of <Image 1> and <Image 2> by scrolling up and down using the multi selector while the image you wish to adjust is highlighted. To highlight either image, multi select left or right. The effect of the

gain control can be observed in the preview box (the default value is x1.0).

- Once you have adjusted the gain of both images to achieve the desired effect, highlight the <Preview> box. To view a larger version of the preview image, press the sutton; press the button to return to the thumbnail view.
- 9. To generate a preview of the new image, highlight <Overlay> and press S
 To save the new image press
 To return to the <Image Overlay> editing screen press the S
 button. To save the image without a preview, highlight <Save> and press the S

Note: The image will be saved on the memory card using the quality and size settings currently selected. Image attributes such as white balance, sharpening, color mode, saturation, and hue will be copied from the image selected as <Image 1>. Similarly, the shooting data is copied from the same image.

The Autofocus System

The core components of the autofocusing system of the D80 were seen first in the D200 model, and at the time of writing, they are only available on these two cameras; the system has a number of aspects that make it quite different to any of the focusing systems used in any previous Nikon digital SLR cameras. While there are some similarities with the focusing system used in the D2-series cameras the overall coverage of the autofocus sensing areas in the D80, and the ability to select two distinct levels of coverage for the central autofocus sensing area, sets the camera apart.

Autofocusing Sensor

The D80 has a new autofocus (AF) module; the Multi-Cam 1000, as used in the D200 model. As its name implies the sensor, which analyses contrast in the subject/scene it is pointed at, has a total of 1000 photosites. When the contrast level is determined to be at a maximum focus is attained.

The 1000 photosites on the sensor module are divided in to seven defined sensing areas, and by using an electronic masking system the two areas, one immediately to the left and the other to the right of the central sensing area, are sub-divided into three autonomous sensing areas, to provide the camera with a total of eleven autofocus sensing areas. Each one of the eleven sensing areas is aligned, approximately, to the eleven small squares marked on the focusing screen that are arranged in a horizontally aligned, elongated diamond pattern orientated on the centre of the frame area.

The eleven small squares on marked on the focusing screen of the D80 define the centre of each of the eleven autofocus sensing areas; here the center autofocus sensor is selected, and set to Normal Zone coverage.

Here the center autofocus sensor is selected but set to Wide Zone coverage.

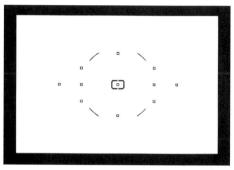

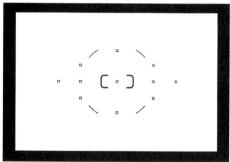

Only the central sensing area is a cross-type; this area is sensitive to detail in both a horizontal or vertical orientation. Therefore it is the most reliable sensing area. The remaining 10 sensing areas are line-types; these are only sensitive to detail in a direction that is perpendicular to the orientation of the sensing area. The sensing areas above and below the central focusing point are arranged horizontally, so detect detail

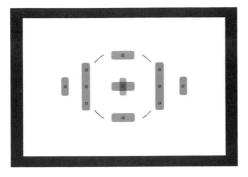

The actual area of coverage of the autofocus sensing areas extends beyond the area defined by the bracket pairs that are displayed on the focusing screen; the diagram shows, approximately, the total area of coverage of the autofocus system in the D80.

aligned with the short edge of the viewfinder frame. The other eight sensing areas area aligned vertically, so detect detail aligned with the long edge of the viewfinder frame.

Hint: Sometimes when using one of the line-type sensing areas the autofocusing system of the D80 will "hunt" (i.e., the camera will drive the focus of the lens back and forth but it is unable to attain focus). This is indicative of the detail in the subject being aligned in the same orientation as the focus sensing area. If this occurs try twisting the camera slightly $(10 - 15^\circ)$, as it is often sufficient to allow the camera to acquire focus, because the focus sensing area is no longer parallel to the detail. Once focus is confirmed, lock it and recompose the picture before releasing the shutter.

The central focus sensing area can be set to perform with either a normal area of coverage, or with an extended wide area coverage, depending on the option selected at CS-03 <Center AF area>. To achieve this the camera employs a system of electronic masking to define the active portion of the sensing area. To support the functionality of the autofocus system the display on the focusing screen is dynamic; set to <Normal Zone> the selected AF point is surrounded by a pair of bold brackets. If you switch to <Wide Zone> the area defined by these brackets is increased to correspond to the greater coverage of the center focus sensing area. The user's choice of a specific sensing area, and sensor area coverage has a profound effect on the abilities of the camera to perform autofocus.

Focusing Modes

The D80 offers two principal methods of focusing, AF (autofocus) and M (manual focus). To select these rotate the AF mode lever, located on the side of the lens mount below the lens release button, until its white index mark is aligned with appropriate position.

The focus mode is selected using the lever below the lens release button

If AF is selected the autofocus system offers three options known as the autofocusing modes: AF-A (auto select), AF-S (single-servo) autofocus, and AF-C (continuous-servo) autofocus.

AF-A – **Auto select:** In an attempt to remove the burden of choosing which of the two principal autofocus modes you should use Nikon developed this option, which the D80 has inherited from the D50 model, and has as its default autofocus mode. The camera assesses the focus information and selects either AF-S (single-servo) or AF-C (continuous-servo) autofocus mode, depending on whether it determines that the likely subject is stationary, or moving. I say likely subject because the autofocus sensing area detects an area of high

contrast, such as an edge between two colors or tones, it will, generally focus on that point, although it may not be the intended subject! More often than not the AF-A option will make a reasonably good job of selecting the appropriate autofocus mode but since there are fundamental differences between them, if the D80 gets it wrong the result can spell disaster!

Hint: The fully automated nature of the AF-A option simply is not sufficiently reliable for my purposes, and I always select either AF-S, or AF-C using the AF button on top of the camera; I would recommend you do the same.

AF-S - **Single-servo autofocus:** As soon as the shutter release button is pressed halfway, or all the down the D80 focuses the lens. The shutter can only be released once focus has been attained; the in-focus indicator \bigcirc is displayed in the viewfinder. The camera will only initiate predictive focus tracking in S (single-servo) autofocus mode if it detects that the subject was moving when focus was acquired.

AF-C - **Continuous-servo autofocus:** While the shutter release button is pressed halfway the D80 focuses the lens, continuously shifting focus to follow the subject if the camera-to-subject distance changes, regardless of whether the subject moves constantly, or stops and starts periodically, until either the shutter is released, or you remove your finger from the shutter release button. If the shutter release is pressed all the way down the shutter will operate irrespective of whether the camera has attained focus, or not. Predictive focus tracking is active at all times in AF-C (continuous-servo) autofocus mode (see Predictive Focus Tracking below).

M - Manual focus: The user must rotate the focusing ring of the lens to achieve focus. There is no restriction on when the shutter can be operated but the in-focus confirmation signal

• still functions, which is particularly useful in low light or low contrast.

Note: Normally the focus mode selector lever must be set to M with most AF-Nikkor lenses. However, if the lens you are using has a switch that allows you to select an M/A (manual/autofocus) mode you need only touch the focusing ring and the lens can be focused manually. As soon as you release the focusing ring the camera will resume autofocus operation. If the lens attached to the camera has an M/A mode option the focus mode selector lever on the D80 can be left set to AF.

Note: The AF mode lever represents, for me at least, one of the few weak points of the D80 design. I consider the lever protrudes too far forward when set to the M (manual focus) position; on a number of occasions while handling my D80 I have inadvertently moved it from this position to the AF position (autofocus). I have tested a number of D80 bodies and found that the resistance of this lever varies tremendously from body to body. You may be lucky and have a camera with a lever that is held in place, firmly once set, or like me check the position of the lever with due diligence!

Single-Servo vs. Continuous-Servo

It is important that you appreciate the fundamental difference between the AF-S (single-servo) and AF-C (continuous-servo) autofocus modes. In S (single-servo) the shutter cannot be released until focus has been acquired; Nikon refer to this mode as having "focus priority." Even if the shutter release is pressed all the way down, operation of the shutter is delayed until the camera has attained focus. In most shooting conditions, particularly in good light, this delay is so brief that it is not perceptible and it is has no practical consequence. However, under certain conditions, such as low-light, or photographing subjects with low contrast, there is often a discernable lag between pressing the shutter release button and the shutter opening, because, generally, it takes the camera longer to establish focus in these circumstances, particularly if one of the outer line-type focus sensing areas is used. Conversely, in AF-C (continuous-servo) the shutter will operate immediately on pressing the shutter release button all the

way down regardless of whether focus has been achieved; Nikon refer to this mode as having "release priority."

Some photographers assume mistakenly that if the shutter is released before the camera has attained focus in the C (continuous-servo) autofocus mode the picture will always be out-of-focus. In fact, in this mode the combination of constant focus monitoring and predictive focus tracking is normally successful in causing the focus point to be shifted, within the split second delay between the reflex mirror lifting and the shutter opening, to obtain a sharp picture. Even if the camera's calculations are slightly out minor focusing errors are often masked by the depth-of-field. However, when using AF-C (continuous-servo) autofocus mode to photograph a subject that is moving or likely to move it is imperative that the camera is given sufficient time to assimilate focusing data to perform the focusing action; either press and hold the shutter release button half way down, or select AF-ON as the function for the button AE-L/AF-L using CS-18, and press and hold it down in advance of releasing the shutter (see details of CS-18 on pages 210-212).

Predictive Focus Tracking

Whenever the shutter release is pressed all the way down to activate the shutter mechanism there is a short delay between the reflex mirror lifting out of the light path to the camera's sensor and the shutter actually opening. If a subject is moving toward or away from the camera the camera-to-subject distance will change during this delay. In these circumstances the D80 uses its predictive tracking system to shift the point of focus on the lens to allow for the change in camera-to-subject distance, regardless of whether the subject is moving at a constant speed, is accelerating, or decelerating. Predictive focus tracking is always initiated when the camera detects the camera-tosubject is changing (i.e. the subject is moving toward or way from the camera). The camera achieves this by comparing multiple samples of contrast level as the camera monitors subject movement; based on this data the camera shifts the focus point accordingly.

However, it is important to understand the distinction between how the predictive focus tracking system, which operates whenever the D80 performs autofocus, works in S (single-servo) and C (continuous-servo) modes. In S (singleservo) mode, predictive focus tracking is only initiated if the camera detects the subject to be moving toward or away from the camera at the time focus is attained. If the subject is stationary when focus is attained the focus distance on the lens is locked at that specific camera-to-subject distance. If the subject moves subsequently before the shutter is released the lens is not re-focused.

In C (continuous-servo) mode, predictive focus tracking is initiated as soon as the camera detects the subject to be moving regardless of whether this occurs while the camera is establishing focus, or if it detects the subject begins to move after focus is first attained as the camera monitors focus constantly before the shutter is released.

Note: Using AF-S type lenses (those that use a silent wave focus motor), which have an internal focusing motor that provides faster focusing, increases the chance of attaining sharp focus with a moving subject.

Note: The Nikon instruction manual implies that predictive focus tracking only operates in C (continuous-servo) mode; in fact the camera always uses predictive focus tracking when it detects a moving subject in both AF-S and AF-C autofocus modes.

Trap Focus

It is possible to use the functionality of the focus system in the D80 to perform the trap focus technique. Trap focus allows the camera to be pre-focused at a specific point and have the shutter released automatically as soon as a subject passes through it. Provided you can predict the path of the subject this technique can be very effective.

Trap focus with the D80 can be set as follows. Set CS-18 <AE-L/AF-L> to <AF-ON> (focusing is only performed when

this button is pressed, and not when the shutter release buttun is pressed). Soloct AF-S (single-servo) autofocus mode,

[1] single autofocus area mode, and if the lens has a focus mode switch on it set it to A or M/A (autofocus). Prefocus the lens to a distance from the camera the same as the point through which the subject will pass by aligning the selected autofocus sensing area with it (you can use any of the eleven autofocus sensing areas), and pushing the AE-L/AF-L button. Recompose the picture and ensure the selected autofocus sensing area covers the point through which the subject will pass. Keep the camera active by maintaining a light pressure on the shutter release button. When the subject arrives and fills the selected autofocus sensing area will detect focus, and the shutter will be released.

The focus mode selector is on the left front of the camera body. When AF (autofocus) is selected, you can further select from three autofocus area modes via CS-2.

Autofocus Area Modes

The D80 has three autofocus-area modes (not to be confused with the three autofocus modes described above) that determine how each of the eleven, autofocus sensing areas is used: single area AF, dynamic area AF, and auto-area AF. The autofocus area mode is selected via CS-2; the three options available operate as follows:

[1] **Single-area AF** – The D80 uses only the single autofocus sensing area selected, currently, for focusing; the camera takes no part in choosing which sensor to use. The selected area is highlighted in the viewfinder.

Auto-area AF – The Auto-area AF system used in the D80 is different from the Dynamic Area AF with closest subject priority AF system used in other Nikon Cameras, although confusingly the same icon is used to denote both. Auto-area AF uses all of the autofocus sensing areas to scan the frame area, from the level of defocus values calculated from the autofocus sensing areas, an algorithm then determines which sensing area(s) the camera should use to acquire focus. Auto-area AF does not default to the focus sensing area, which lies on the subject deemed to be closest to the camera as per dynamic-area AF with closest subject priority. If multiple potential subjects, all at different distances from the camera, are detected the autofocus system algorithm will determine which focus sensing area to use (Nikon have not disclosed the precise details of how this function works as it is considered confidential)

After determining which autofocus sensing area to use as the primary focus point and focusing with it, the brackets of the relevant autofocus sensing area displayed in the viewfinder, which are occupied by the subject, and any other focus sensing areas that report a similar level of defocus values will illuminate on the focusing screen, to indicate that these areas will also be in focus. However, in some cases the additional autofocus sensing areas that illuminate on the focusing screen may not be actually in focus, as other factors can, and often do, influence the defocus values, such as the type of lens used (use of a wide angle leffs will often result in more of the autofocus sensing area brackets illuminating compared to a telephote lons due to reasons related to the depth of field). Regardless of this the primary autofocus sensing area selected by the auto-area AF algorithm is not affected by these factors and focus will be sharp in this region.

Hint: In a similar fashion to the Auto-select option for the autofocus mode the Auto-area AF mode makes a reasonable job of selecting the correct autofocus sensing area for a majority of the time but it is far from foolproof, so if you want to remain in control of the autofocus system I recommend, strongly, that you avoid this option and use either the single-area AF, or dynamic-area AF options.

To select the autofocus area mode, open the custom menu and highlight CS-2 <AF-area mode> and multi select right. Highlight the required option buy pressing the multi selector up or down, and press it to the right to set the option.

Note: Selection of the autofocus area can be set to wrap round, by selecting the <Wrap> option in CS-20 <Focus Area>. If you press and hold the multi selector switch the selection of autofocus area will scroll continuously in the direction in which the multi selector switch is pressed. This enables the selected autofocus area to be shifted from one side of the frame area to the other, rapidly.

AF Mode and AF-Area Mode Overview

If you are new to Nikon's AF system, it will probably take a while to get used to the functionality of the Focus Mode and Focus Area Mode of the D80. Therefore, you may wish to reread the sections above and refer to the following table that sets out, in summary, the various autofocus operations.

AF Mode	AF-Area Mode	Selection of Focus Area
Single-servo	Single	User
Single-servo	Dynamic	User 1
Single-servo	Auto-area	Camera 2
Continuous-servo	Single	User
Continuous-servo	Dynamic	User 1
Continuous-servo	Auto-area	Camera 2

- 1. In dynamic-area mode the user selects the focus sensing area to be used initially but if the camera determines that the subject has left this area subsequently it will shift focusing to the focus sensing area it determines to be most appropriate (the focus sensing area used initially remains highlighted in the viewfinder).
- 2. If auto-area AF is chosen the camera selects the focus sensing area it determines to be most appropriate, and may illuminate other focus sensing areas that report a subject at the same focus distance.

Hint: I recommend avoiding use of **(III)** auto-area AF, since you have no control over which autofocus sensing area is being used by the camera.

Focus Lock

Once the D80 has attained focus it is possible to lock the autofocus system so the shot can be re-composed and focus will be retained even if the subject is no longer covered by an autofocus sensing area.

AF-S – (single-servo) autofocus: pressing the shutter release button halfway will activate autofocus, as soon as focus is attained the in-focus indicator ● is displayed in the viewfinder and focus is locked; it will remain locked while the shutter release button is depressed half way. Alternatively, press and hold the AE-L/AF-L button to lock focus; once focus is locked using the AE-L/AF-L button it is

not necessary to keep the shutter release button depressed (assumes one of the appropriate options has been selected at CS-18).

C – (continuous-servo) autofocus: the autofocus system remains active, constantly adjusting the focus point, while the shutter release button is held halfway down. To lock focus in this focus mode press and hold the AE-L/AF-L button (assumes one of the appropriate options has been selected at CS-18).

Hint: Use CS-18 to assign the function of the AE-L/AF-L button; it can be used to lock exposure and focus, exposure only, or focus only.

Hint: Once focus has been locked in either AF-S or AF-C focus modes ensure the camera-to-subject distance does not alter. If it does, re-activate autofocus and re-focus the lens at the new distance before using the autofocus lock options.

AF Assist Illuminator

The D80 has a small, built-in white light, known as the AFassist lamp, which is designed to facilitate autofocusing in low light conditions; it is located on the front of the camera between the finger grip and the viewfinder head. Whatever the intentions of the camera's design team were this feature is largely superfluous. Here are a few reasons why I suggest using CS-4 <AF Assist> to cancel operation of this lamp:

- The lamp only works if you have an autofocus lens attached to the camera, the focus mode is set to AF-S (single-servo), and autofocus area mode is set to either single-area AF, or auto-area AF (via CS-2), or when CS-2 is set to <Dynamic-area AF> and the central focus sensing area is selected. It is only usable with focal lengths between 24mm 200mm
- The operating range is restricted to between 1 foot 8 inches and 9 feet 10 inches (0.5 3.0 m).

- Due to its location many lenses obstruct its output, particularly if they have a lens hood attached. It is only usable with focal lengths between 24mm – 200mm, with the lens hood removed.
- The lamp overheats quite quickly (six to eight exposures in rapid succession is usually sufficient) and will automatically shut down to allow it to cool. Plus, at this level of use it also drains battery power faster.

Hint: Provided the conditions described above are met it is possible to use the built-in AF-Assist Illuminator lamp of either the SB-600 or SB-800 Speedlight, or SU-800 Speedlight commander unit (operation of the camera's lamp is disabled in these circumstances). If you want to use either the SB-600 or SB-800 off camera the SC-29 TTL flash lead has a built-in AF-assist lamp that attaches to the camera's accessory shoe.

Limitations of AF System

Although the autofocus system of the D80 is very effective there are some circumstances or conditions that limit its performance:

- Low light
- Low contrast
- Highly reflective surface
- Subject too small within the autofocus sensing area
- The autofocus sensing area covers a subject comprising fine detail
- The autofocus sensing area covers a regular geometric pattern
- The autofocus sensing area covers a region of high contrast

• The autofocus sensing area covers objects at different distances from the samera

If any of these conditions prevent the camera from attaining focus either switch to manual focus mode, or focus on another object at the same distance from the camera as the subject, and use the focus lock feature to lock focus before re-composing the picture.

Using Non-CPU Lenses

The introduction of electronic communication between the lens and camera for the purposes of exposure metering and autofocus has meant a number of changes have been introduced to the Nikon F lens mount, such that older non-CPU type lenses (i.e., those that lack any electrical contacts around their mounting bayonet) offer a very restricted level of compatibility with the D80. In this case, the camera can only be used in Manual exposure mode (if you select another exposure mode, the camera disables the shutter release automatically). The lens aperture must be set using the aperture ring on the lens, and the autofocus system, TTL metering system, electronic analogue exposure display, and TTL flash control do not function. However, the electronic range finder does operate, provided the maximum effective aperture is f/5.6 or larger (faster), unless otherwise stated (for full details and a list of compatible lenses, see pages 286-289).

Depth of Field

When a lens brings light to focus on a camera's sensor, there is only ever one plane of focus that is critically sharp. However, in the two dimensional picture produced by the camera, there is a zone in front of and behind the plane of focus that is perceived to be sharp. This area of apparent sharpness is usually referred to as the depth of field, and its extent is influenced by the camera-to-subject distance, together with the focal length and aperture of the lens in use. If the focal length and camera-to-subject distance are constant, depth of field will be shallower with large apertures (low f/numbers) and deeper with small apertures (high f/numbers). If the aperture and camera-to-subject distance are constant, depth of field will be shallower with long focal lengths (telephoto range) and deeper with shorter focal lengths (wideangle range). If the focal length and aperture are constant, depth of field will be greater at longer camera-to-subject distances and shallower at closer camera-to-subject distances. Depth of field is an important consideration when deciding on a particular composition, as it has a direct and fundamental effect on the final appearance of the picture.

Depth-of-Field Preview

In order that the viewfinder image is as bright as possible for composing, focusing, and metering, modern cameras such as the D80 operate with lenses automatically set to their maximum aperture. The iris in the lens does not close down to the shooting aperture until after the shutter release has been pressed and the reflex mirror has lifted, just a fraction of a second before the shutter opens. However, this means that the image you see in the viewfinder is as it would appear if the photograph were to be taken at the maximum aperture of the lens attached to the camera. To assess depth of field visually, you must close the lens iris down to the shooting aperture.

Note: Remember, as the size of the lens aperture decreases (higher f/number), the depth of field increases.

The D80 has a depth-of-field preview button (the lower of the two buttons on the right front of the camera between the finger grip and the lens mount) that, when pressed, stops the lens down to the selected shooting aperture, allowing you to see the effect the aperture has on the depth of field. The viewfinder image will become darker, as less light passes through the lens when the aperture iris in the lens is closed down.

The D80 has a depth-o-field preview button that is located on the camera front beside the lens mount.

Hint: At apertures of f/11 or smaller (higher f/numbers), the viewfinder image will become very dark and difficult to see, even with brightly lit scenes. It is often better to make a general assessment of depth-of-field at f/8, then change the aperture value to the one required for shooting.

Depth of Field Considerations

Probably the most important consideration concerning depth of field is that it is slightly less for images shot on a D80 than those shot on a 35mm film camera. This is due to the smaller size of the sensor compared with a 35mm film; the digital picture must be magnified by a greater amount compared with a frame of 35mm film to achieve any given print size. Therefore, at normal viewing distances, detail that appears to be sharp in a print (i.e., within the depth of field) made from a film-based image may no longer look sharp in a print of the same dimensions made from a digital file. If you use the depth-of-field values given in tables for 35mm lenses, you will find they do not correspond to images shot on the D80 (assuming the same camera-to-subject distance and focal length apply). To guarantee that the depth of field in pictures taken on the D80 is sufficient. use the values for the next larger lens aperture.

Apart from setting a small aperture (large f/number) to maximize depth of field in a landscape picture, it is worth remembering that at mid to long focus distances, the zone of apparent sharpness will extend about 1/3 in front of the point of focus and 2/3 behind it. Therefore, by placing the point of focus about a third of the way into your scene you will maximize the coverage of the depth of field of the shooting aperture.

In portrait photography, is often preferable to render the background out-of-focus so it does not distract from the subject. The simplest way to achieve this effect is to use a longer focal length lens; a short telephoto of 70-105mm is ideal in combination with a large aperture (low f/number). You can assess the effect using the camera's depth-of-field preview feature.

In close-up photography, depth of field is limited, so convention suggests you set the lens to its minimum aperture value (largest f/number). However, I strongly recommend that you avoid doing this because the effects of diffraction at (or near) the minimum aperture of a lens cause a significant loss of image sharpness. Generally, you will achieve superior results at an aperture around two-stops more (lower f/number) than the minimum value of the lens. Although it does vary slightly from lens to lens, I have found the effects of diffraction become apparent on the D80 somewhere between f/11 and f/16. It is likely that, even in good light, the shutter speed will be rather slow when shooting with a small lens aperture, so consider using a tripod or other camera support whenever possible.

Unlike the distribution of the depth-of-field zone for mid to long focus distances, at very short distances, the depth of field extends by an equal amount in front of and behind the plane of focus. By placing the plane of focus with care, you can use this fact to further maximize depth of field. Once again, the camera's depth-of-field preview button will allow you to preview the depth-of-field in your composition.

Digital Infrared Photography

Many digital cameras have the ability to record light beyond the limits of the spectrum visible to the human eye, particularly in the region of near infrared (IR) around a wavelength of 780 nm (one nanometer = one millionth of a millimeter). Camera designers work hard to exclude IR light from digital cameras because it adversely affects apparent sharpness, reduces the contrast in skies, and can reveal unappealing features of skin that would otherwise not be visible. The low-pass filter array in front of the CCD sensor in the D80 includes a layer designed to reduce the transmission of IR light; it is this filter that produces the green tint when you look at the surface of the filter array when inspecting or cleaning it. The IR blocking layer in the D80 is very effective and therefore the camera is not ideal for digital IR photography.

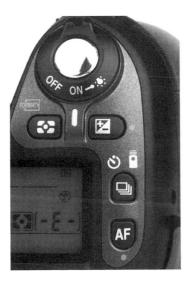

To perform a two-button reset press and hold (2) and buttons for approximately 2 seconds.

Two-Button Reset

If you want to restore settings on the D80 to their default values, press and hold the 2 and 4 buttons. The green dots beside each button are a reminder of their function for this feature.

Option	Default
Shooting mode	Single frame
Autofocus mode	AF-A (Auto-select)
Focus area mode	Center 1
Metering	Matrix
Flexible Program	Off
Exp. Comp	+/- 0
AE lock hold	Off
Bracketing	Off 2
Flash Sync mode	Front-curtain 3
Flash compensation	+/- 0
FV Lock	Off

- 1. Focus area not displayed if Auto-area AF is selected at CS-2.
- 2. Number of shots reset to zero, increment to 1 EV (exposure), or 1 (WB).
- 3. In 🛣 , 🛣), and 🐨 it is set to Auto front-curtain sync, and in 📓 it is set to Auto slow-sync mode.

Shooting Menu Options

Option	Default		
Image Quality	JPEG Normal		
Image Size	Large		
White Balance	Auto 4		
ISO	100 5		
Multiple exposure	Off		

Fine tuning set to 0.
 ISO Auto is set in modes.

and Digital Vari-program

Note: The two-button reset process does not affect options selected in the Custom Setting menu.

Image Review Options

One of the most useful features of a digital camera is the ability to get nearly instant feedback on photographs as you shoot. Using the playback functions on the D80 will allow you to see not only the images you have taken, but also a range of helpful and interesting information. Keep in mind though, that the small image displayed on the screen is not represented with sufficient precision to make any critical analysis of color or exposure; personally I believe that the image displayed in the playback modes should be considered no further than confirmation that an exposure has been recorded, the potential accuracy of the exposure based on the histogram display, whether the image is sharp, and the success or otherwise of the composition.

Immediately after taking an exposure on the D80, it will be displayed briefly on the LCD monitor (assuming <On> is selected for <Image Review> at CS-6 in the Custom Settings menu). A quick glance as to whether you have captured the image as intended is often all that is required. In singleframe and self-timer shooting modes, the image is displayed almost immediately after the exposure is made. In the continuous shooting mode, the camera must write the image data from the buffer memory to the memory card for each image recorded, so a short delay is induced; the camera then displays each image chronologically as soon as they have been saved.

Note: Select <Off> for the <Image Review> option at CS-6 in the Custom Settings menu if you do not want the camera to display the image automatically after shooting.

Single Image Playback

Pressing the
button just to the left of the LCD monitor on the camera back will display the most recent image taken by the camera. If you then wish to view other images saved on the memory card, simply multi select left or right to scroll through them. To return to shooting mode, press the
button again, or lightly touch the shutter release button halfway.

Note: If you want images shot in an upright (vertical) composition to be display in the correct orientation select <On> for the <Auto Image Rotation> option in the Setup menu.

Information Pages

A very useful feature of the image playback function on the D80 is the host of information that can be accessed while viewing the image on the monitor screen. This information can help you ensure that you have achieved a good exposure, as well as give you detailed information about how, when, and where the exposure was made. There are up to six different pages of information – Basic Information, Shooting Data page1, Shooting Data page 2, Image Data (only shown if the displayed image was created in the Retouch menu), Highlights, and RGB Histogram – that can be displayed for each image file displayed on the monitor screen.

To access these pages, either multi select up or rotate the sub-command dial toward the lens to scroll through each page in the following order: Histogram (composite), Basic Information, Shooting Data (1), Shooting Data (2), Image Data, Highlights, and RGB Histogram. Multi select down or turn the sub-command dial in the opposite direction to scroll though the pages in the reverse order.

Basic Information: This page provides minimal information for simple, uncluttered viewing of the image. It displays: Protect Status, Folder Number/File Number.

File Information: This page shows an unobstructed view of the image while providing additional information. It displays. Protect Status, Retouch Indicator, Prame Number/Total Number of Frames, Folder Name, File Name, Image Size, Image Quality, Date of Recording, Time of Recording, Folder Number/File Number.

Shooting Data Page 1: A block of information will be displayed superimposed over the center portion of the screen, obstructing the view of the image. This page displays: Protect Status, Retouch indicator, Camera Name, Metering Method, Shutter Speed, Aperture, Exposure Mode, Exposure Compensation, Focal Length, Flash Sync Mode, Frame Number/Total number of images.

Note: Shooting Data Page 1 can be particularly useful if you are trying to achieve similar results in a similar environment, learn about your shooting style, and learn what settings produce particular results.

Shooting Data Page 2: A block of information will be displayed superimposed over the center portion of the screen, obstructing the view of the image. This page displays: Protect Status, Retouch indicator, Image Optimization, ISO Sensitivity, White Balance/White Balance Adjustment, Image Size / Quality, Tone Compensation, Sharpening, Color Mode/Hue adjustment, Saturation, Image Comment, Frame Number/Total number of images.

Note: Shooting Data Page 2 can help you understand the effects of image settings and adjustments on the appearance of your picture.

Image Data: A block of information will be displayed superimposed over the center portion of the screen, obstructing the view of the image. This page displays: Protect Status, Retouch indicator, Retouch history (lists changes made to image using retouch menu options, with most recent change shown first), Frame Number/Total number of images. **Note:** The Image Data screen will only be displayed if the retouch menu has been used to create a modified version of a picture recorded by the D80, and saved to the installed memory card.

Highlights: Shows an unobstructed view of the image and displays: Protect Status, Retouch indicator, Image Highlights, Frame Number/Total number of images.

Note: The Highlights screen is very useful for checking if information may have been lost as a result of overexposure; any relevant areas that may be affected will flash alternately black and white.

RGB Histogram: Provides an individual histogram for each of the red, green, and blue channels, together with an RGB composite histogram and a thumbnail of the image file. It displays: Protect Status, Retouch indicator, Histogram – RGB composite, Histogram – Red Channel, Histogram – Green Channel, Histogram – Blue Channel, Frame Number/Total number of images.

Note: The histogram is a graphical display of the tonal values recorded by the camera. The horizontal axis represents brightness, with dark tones shown to the left and bright to the right. No data (i.e., pure black) is shown at the extreme left end of the axis and total saturation (i.e., pure white) is shown at the extreme right end of the axis. The vertical axis represents the number of pixels that have that specific brightness value.

Thumbnail Playback

If you wish to view multiple images at once on the monitor screen, press the
button; press once to view four at a time, or press it again to view nine images at a time. To view fewer images, press the
button. A yellow border surrounds the highlighted image. To scroll through the images, multi select left, right, up, or down. Once an image is highlighted, you can use the
button to show the image full-frame; press the
button to return to multiple image display, protect an image by pressing 6, or delete an image by pressing 6. To return to shooting mode press the 1 button or lightly press the shutter release button halfway.

Playback Zoom

The image displayed on the monitor screen is usually too small to check with any certainty that it is sharp; the playback zoom feature allows you to enlarge the image by up to 25x (equivalent to a 400% view on a computer screen). To zoom into the image displayed on the monitor screen, press the **Q** button. The image will appear slightly enlarged and a small thumbnail image with a vellow border indicating the sectional view of the displayed image is shown for a few seconds before turning off automatically. To increase the degree of magnification, press the **Q** button repeatedly until the required degree of magnification is achieved. You can navigate around the enlarged image by using the multi selector and pressing it in the direction you want to shift the view. If you rotate the main command dial, you can examine other images at the same location of the frame and the same degree of magnification. To zoom out, press the 🛽 🕮 button; to return to the full frame view press the OK button.

You can protect an image by pressing the ⁶⁶ button, and delete an image by pressing ⁶⁷ ; to return to shooting mode, press the ¹⁹ button or lightly press the shutter release button halfway.

Protecting Images

To protect an image against inadvertent deletion, display the image on the monitor screen in full-frame single image playback and press the solution. A small key icon will appear in the upper left corner, superimposed over the image. To remove the protection, open the image and press solution again and check that the key icon is no longer displayed.

Note: Paths to all images, including those designated as protected, will be deleted if the memory card is formatted.

Note: Protected images will retain their protected status even when the image file is transferred to a computer, or other storage device.

Deleting Images

Images can be deleted using one of two routes. The quickest and easiest is to press the button when the image to be deleted is displayed on the monitor screen. The first press of the button opens a warning dialog box that asks for confirmation of the delete command. To complete the process, press the button again. To cancel the delete process, press the button to return to viewing the image. Images can also be deleted via the Playback menu. There are two options: Delete images individually, or delete all images stored on the memory card.

Assessing the Histogram Display

The shape and position of the histogram curve indicates the range of tones that have been captured in the picture. Dark tones will be distributed to the left of the histogram graph and light tones to the right. In a picture of a scene containing an average distribution of tones, from a few dark shadows, through a wide number of mid-tones, to a few bright highlights, the curve will start in the bottom left corner, slope upwards, and then curve down to the bottom right corner. In this case, a wide range of tones will have been recorded.

Obviously not all scenes contain an even spread of tones because they have a natural predominance of light or dark areas. In these cases, the histogram curve will be biased to the right (light scenes) or the left (dark scenes); this is not necessarily an indication of over- or underexposure, respectively, but rather an indication of the limited range of tones in the scene. Hence there is no single "perfect" histogram curve for all scenes and subjects; the shape of the histogram curve will vary widely depending on the nature of the scene recorded. However, provided the histogram curve stops on the bottom axis before it reaches either end of the graph, the image should contain a full range of the available highlight and shadow tones in the subject or scene being pho-

Some scenes have a natural predominance of light or dark tones. In these cases, you can expect the histogram to be biased to the right or left, respectively.

tographed. If the curve begins at a point up the left or right side of the histogram display so the curve looks as though it has been cut off abruptly, the camera will not have recorded tones in either the shadows (left side) or highlights (right side). This is often an indication of under- or overexposure.

Generally, controlling exposure to ensure highlight detail is retained is more important than exposing for shadow areas. If the histogram curve is weighted heavily toward the right side of the graph and is cut-off at a point along the right-hand vertical axis, highlight data will probably have been compromised, or worse still, it may have been lost. In this case, reduce the exposure until the right-hand end of the curve stops on the bottom horizontal axis before it reaches the vertical one. Conversely, if shadow detail is important in a given scene, make sure the curve stops on the bottom horizontal axis before it reaches the left-hand vertical axis.

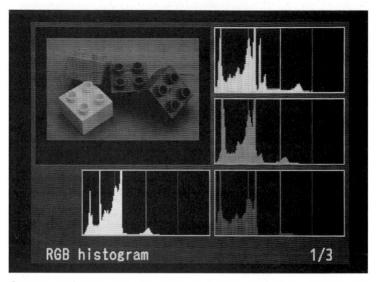

2-stops underexposed, the curve is heavily biased toward the left side of the graph with virtually no light tones recorded. In this case attempting to rescue the image is very likely to emphasize the effects of electronic noise, which will degrade the image quality.

Scenes that are low in contrast will have a curve that appears as a rather narrow spike, the ends of which fall short of either the left or right-hand extremities of the bottom axis. You have two choices as to how to deal with this situation: Either use the <Tone Compensation> function within the <Custom> option of the <Optimize Image> control (see pages 166-177) to have the contrast control performed by the camera, or adjust the contrast level at a later stage in an image-processing program.

Note: It is always preferable to err on the side of lower contrast, as it is easier to boost contrast than it is to try and reduce it.

The three pictures shown here represent a range of exposures of a scene that contains a wide range of tones from deep shadow to bright highlight.

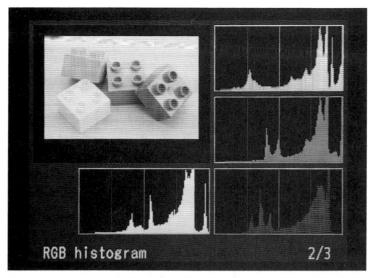

2-stops overexposed, the curve is biased to the right side of the graph and the curve is cut-off at a point up the right axis. In this case highlight detail is likely to have been lost, particularly in the red channel (top of the column of three histograms) due to total saturation. These areas will appear as featureless highlights in the picture.

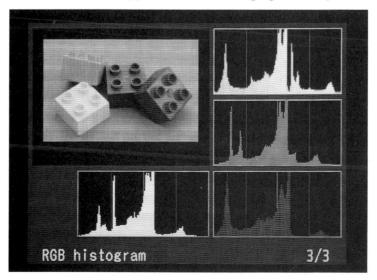

Properly exposed, the left and right-hand ends of the curve stop on the bottom axis before reaching either side of the graph, indicating that all tones have been recorded.

Optimizing Images

In addition to white balance, the D80 has several other controls that affect the appearance of your pictures. In an effort to make things easier for the user, Nikon has clustered these controls together in a series of preset options that can be applied to images shot in P, A, S, and M exposure modes.

The options available are: <Normal>, <Softer>, <Vivid>, <More Vivid>, <Portrait>, <Custom>, and <B&W>.

Option	Description
<normal></normal>	The default setting it tends to produce a slightly subdued looking image that benefits from slight enhancement of levels and contrast in post-processing. This is useful if you intend to deal with images individually using a computer
<softer></softer>	using a computer. As the title suggests, it produces images with slightly lower contrast and lower edge acuity. It is useful for portraits, or pictures shot with flash as the main light source.
<vivid></vivid>	This selection adds a little extra bite to images as color saturation and edge acuity is increased. It is useful if you expect to print images direct from the camera without any post-processing.
<more vivid=""></more>	An enhanced version of <vivid>, it pro- duces results akin to a high saturation color transparency film. Depending on how the images will be used subsequently, the level of sharpening applied in this option may be too high for many subjects.</vivid>
<portrait></portrait>	This option appears to produce results that are almost identical to the <normal> option, particularly in terms of the contrast.</normal>
<custom></custom>	The only option that provides full control to the user for each of the following image attributes: sharpness, contrast, color mode, saturation, and hue (see comments below).

<B&W> The <Standard> option appears to average out the red, green, blue values to produce a black and white image with a neutral tonal response. The <Custom> option offers the ability to adjust both the level of sharpening and tone (contrast), as well as filter effects that emulate the tonal response of using yellow, orange, red, or green contrast control filters with traditional panchromatic black-and-white film.

It is vitally important to understand that the <Custom> option is the only one that allows you to set all controls that affect sharpness, contrast, color mode, saturation, and hue, manually. If you select any of the other six options, with the exception of the <B&W> <Custom> sub-option, the camera will assign controls, as set out in the table below, automatically. However, that is not the whole story. The D80 will seek to optimize each individual image according to the shooting conditions that prevail at the time of exposure. In other words, even if you shoot a series of pictures of a similar scene, the values assigned in the <Normal>, <Softer>, <Vivid>, <More Vivid>, <Portrait>, and <B&W> <Standard> options may vary depending on the exposure and position of the subject within the frame area. To ensure consistent results, use the <Custom> option but avoid selecting <Auto> for <Sharpening>, <Tone Compensation>, and <Saturation>, as you relinquish control of these attributes by doing so.

Optimize	Color Mode	Tone	Hue	Saturation	Sharpness
<normal></normal>	la	Auto	0	Auto	Auto
<softer></softer>	la	Low (Less contrast)	0	Auto	Low
<vivid></vivid>	IIIa	Normal	0	Enhanced	Med. High
<more vivid=""></more>	IIIa	High (More contrast)	0	Enhanced	High
<portrait></portrait>	la	Auto	0	Auto	Med. Low
<b&w> <standard></standard></b&w>	la	Normal	0	Normal	Auto

D80 - Optimize Image Options

Hint: To maximize image quality, I recommend, strongly, that you use the <Custom> option. As described later no single level of sharpening or tone control is universally applicable.

Note: Unlike other recent Nikon cameras, such as the D2Xs and D200 in which the settings for Color Space and Color Mode can be selected separately, thereby increasing the combinations of settings available, these controls have been linked in the D80 so that in color modes Ia and IIIa, the color space is always sRGB; in color mode II, the color space is always Adobe RGB.

Note: A color space describes the range (gamut) of colors that can be recorded by the camera. The color mode defines how accurate the rendition of the recorded colors will be.

Note: Color mode II is only available when Adobe RGB, the color space that offers the widest range of colors, is selected as the working color space. Generally, it is often preferable to use color mode II (Adobe RGB) to ensure the highest level of color accuracy, which is particularly useful if the images will be subject to extensive work in post-processing, during which color shifts can be applied with a greater degree of control on either a global, or localized basis.

To select any of the <Optimize Image> controls, open the Shooting menu **and** navigate to the <Optimize Image> option. Multi select right to open the next menu page, which lists the options available. Use the multi selector to scroll to the required option then press it to right to select it.

Optimize Image – Custom Options

If you select $\bigcirc \bigcirc \bigcirc \bigcirc$ <Custom>, this action will open a further menu from which you can set each control option. Highlight the required option using the multi selector and press it to right; scroll to the setting you require and select it by pressing it to right again. Finally, navigate to <Done> and multi select right to confirm and save the selected settings; if you fail to carry out this last step the settings will not be saved. Likewise, if you select the <Custom> sub-option under the CBW <B&W> menu, this action will open a further menu from which you can set the level of sharpening and tone (contrast), together with a filter effect if desired. Highlight the required option using the multi selector and press it to right; scroll to the setting you require and select it by pressing it to right again. Finally, navigate to <Done> and multi select right to confirm and save the selected settings; if you fail to carry out this last step the settings will not be saved.

Sharpening

Sharpening is a process applied to digital data that can increases the apparent sharpness (acuity) of a picture.

Note: Sharpening is not a method for rescuing an out-of-focus picture.

Sharpening is used to correct the side effects of converting light in to digital data, which often causes distinct edges between colors, tones, and objects in a digital picture to look ill defined (fuzzy). The D80 uses a technique that identifies an edge by analyzing the differences between neighboring pixel values. Then the process lightens the pixels immediately adjacent to the brighter side of the edge, and darkens the pixels adjacent to the dark side of the edge. This causes a local increase of contrast around the edge that makes it look sharper; the higher the level of sharpening applied the greater the contrast at the edge.

The D80 offers seven levels of image sharpening:

Auto – The camera processing applies a level of sharpening that varies according to how the camera analyzes the image data.

Note: Nikon give no indication as to what the D80 does at this setting other than state that the level of sharpening can vary from image to image, even with subject / scenes of a similar type.

Normal – Apparently, the camera applies a moderate amount of sharpening at a consistent level. I say "apparently", because again Nikon do not provide specific values for the level of sharpening the camera applies.

Low – A lesser amount of sharpening is applied than with the Normal selection.

Medium low - Sharpening level is slightly higher than Low.

Medium High – Sharpening level is slightly higher than Normal.

High – The D80 applies an aggressive level of sharpening, which may not be appropriate for some subject /scenes.

None – No sharpening is applied to the image data.

Hint: No single level of sharpening is suitable for all pictures taking situations. Likewise the level of sharpening should also be based on your ultimate intentions for the image, (i.e., display on a web page, publication in a book or magazine, or producing a print for framing). Therefore, it is often preferable to apply sharpening in post-processing on a computer, particularly if you want to work on images for a range of different output purposes.

I would make the following suggestions with regard to incamera sharpening when shooting with the D80:

- For general photography, using JPEG format files set sharpening to Low or Medium Low if you intend to work on these images in post-processing.
- For general photography, using JPEG format files set sharpening to Normal if you intend to print pictures direct from the camera without any further post-processing.
- On those occasions when you need to expedite the output pictures for publishing on a web page, or in

newsprint, use the JPEG format and set the sharpening level to Normal or Medium High. In this specific case a slightly stronger degree of sharpening is probably bull more suitable as images will be viewed on computer monitor screens or at low reproduction resolutions, and prudent, as it will save valuable time in post-processing.

• If you shoot in the NEF file format set sharpening to None.

Note: Although the data in a NEF file is not sharpened by the in-camera processing, any sharpening level other than None that is set will be stored in the file's EXIF data, which means that sharpening can be applied when you convert the image in another application.

Tone Compensation

Tone compensation allows you to adjust the contrast of an image. It works by applying a curve control similar to those used in post processing applications that alter the distribution of tones from the sensor data to fit the selected contrast range as defined by the contrast curve.

Auto – The D80 uses its Matrix metering system to assess the differences between the levels of brightness in the scene. If these are significant the camera assumes the scene has high contrast and applies a compensation to lower it. Conversely if scene contrast is assessed to be low the camera will increase image contrast.

Normal – The D80 applies a "standard" contrast curve that produces images with contrast somewhere between the extremes of Less contrast and More contrast.

Less contrast – This setting produces images with noticeably less overall contrast, which can be a benefit when shooting a subject or scene that contains light tones that are well illuminated. However, it can also affect the density of very dark tones with the result that they lack "depth."

Note: If you expect to perform post processing on your picturor you may wish to consider setting Low contrast, as it is easier to increase contrast than reduce it at this stage.)

More contrast – Image contrast is boosted, which can be a benefit when shooting subjects, or scenes that lack contrast. However, this option should be used with care since there is an increased risk that highlight details may appear to be "burnt out."

Custom – This option is only applicable if you have access to Nikon Camera Control Pro software, because this allows you to write your own contrast curve and upload it to the camera. If no custom contrast curve is created and uploaded to the camera this option performs the same as Normal.

Color Mode

The D80 offers a choice of three color modes, which determine the accuracy of the colors recorded in an image. The color mode should be chosen based on the use to which the image will be put.

Mode I (sRGB only) – This is the default setting on the D80. Nikon recommends it for portrait pictures that will be used or printed without further modification, because the range of colors recorded by the camera is biased in favor of reproducing skin tones with a pleasant appearance (i.e., colors have a 'warm' appearance, due to increased levels of yellow/red).

Mode II (Adobe RGB only) – This color mode produces the most accurate rendition of colors recorded by the camera. Generally, it is the color mode used by many photographers in conjunction with the Adobe RGB color space, which renders a wider range of colors compared with the sRGB color space, thus providing a greater number options when it comes to the subsequent modification of an image.

Mode III (sRGB only) – This setting enhances the rendition of green and blue, especially, although yellow, orange, and red tend to look very strong as well. Nikon recommends that it should be used for "nature or landscape shots" that will be used or printed without further modification.

Unless you know your pictures will only ever be displayed on a computer monitor, for instance as part of a Web page, or you will use a direct printing method with no intention of carrying out any post-processing using a computer and additional imaging software yourself at any stage, I would recommend using the Adobe RGB color space, as it provides the widest range (gamut) of colors with a subtle rendition, and well-graduated tonal transitions, which increases the flexibility of an image that will be subject to post-processing.

Hint: It is essential that your image manipulation application be set to the same color space (i.e., you work with a color managed system) otherwise the application will more than likely assign its own default color space and you will lose control over the rendition of colors.)

Saturation

Adjusting the saturation changes the overall vividness (chroma) of color without affecting the brightness (luminance) of an image.

Auto – The D80 will adjust the level of saturation automatically according to the camera's assessment of the scene or subject.

Normal – This is the default setting and is probably the option to use for most situations, since the camera offers very limited control compared with a post-processing application.

Moderate – The vividness of colors is reduced but Nikon provide no information as to the level of adjustment that is applied.

Enhanced – The vividness of colors is increased but Nikon provide no information as to the level of adjustment that is applied.

Hue

The RGB color model (sRGB or Adobe RGB) used by the D80 to produce images is based on combinations of red, green, and blue light. By mixing two of these colors a variety of different colors can be produced. If the third color is introduced the hue of the final color is altered. For example if the level of red and green data is increased relative to the blue data the hue shifts (positive adjustment) to a "warmer" (red/yellow) rendition. If you apply a negative adjustment the hue shifts to a "cooler" (bluer) rendition, so for example red will shift toward purple. The control on the D80 allows you to set an adjustment of +/- 9° in increments of 3°.

Hint: Personally, I believe it is better to leave control of both color saturation and hue to the post-processing stage, as they can be controlled to a far greater degree using an image manipulation application on a computer. I would recommend that these controls be left set to Normal and 0° respectively.

Black and White

As mentioned above, the <B&W> option of the <Optimize image> menu offers two sub-options, either <Standard> or <Custom>. Nikon have not divulged the exact processes involved but if you select <Standard> the camera sets sharpening to Auto, and tone (contrast) to Normal, and appears to average out the red, green, blue values to produce a black and white image with a neutral tonal response to color, and saves the image as an RGB file.

If you select the <Custom> sub-option under the ØBW <B&W> menu this action will open a further menu from which you can set the level of sharpening and tone (contrast), together with a filter effect if desired. The options available for sharpening and tone (contrast) are exactly the same as those described above under the <Custom> option of the <Optimize Image> menu and work in an identical way. Therefore, my suggestions and recommendations for both apply here as well.

The D80 also offers the option to select a filter effect under the <Custom> sub-option of the <B&W> option. These filter effects emulate the effects of using contrast control filters with traditional black and white film to modify the tonal response of the film to certain wavelengths (colors) of light. The options available on the D80 are, <Off> (results as the same as the <Standard> sub-option), <Yellow>, <Orange>, <Red>, and <Green>. Just like their optical filter counterparts these filter effects reduce the amount of their complimentary color in the image. For example, the <Yellow>, <Orange>, and <Red> filter effects can be used to reduce the level of blue making a blue sky increasingly darker (the <Yellow> filter has the least effect and the <Red> filter the greatest effect). This results in an increase in the level of contrast between the blue sky and any white clouds, making the clouds more prominent. The <Green> filter effect reduces the amount of red making red and orange colored objects appear darker. This option can be useful for enhancing the range of skin tones in a portrait picture, making them appear more natural, and separating the tones of the various shades of green in landscape photograph.

Of course you can use the filters for creative purposes, for example, selecting the <Red> filter option and shooting a portrait of a person with a pale skin renders a result akin to taking the picture on black-and-white infrared film, which produces very light, almost white skin. The <Orange> and <Yellow> filter options have a lesser effect that can be useful for reducing the appearance of skin blemishes. My advice is to experiment with these options to determine, if, how, and when they will best suit your requirements.

Nikon considers the exact nature of the in-camera processing that the D80 applies to pictures recorded using these black-and-white options as commercially sensitive. However, it can best be described as being analogous to the Channel Mixer tool in Adobe Photoshop. The algorithm used is dedicated to this process and is not the same algorithm as is used in the Monochrome option of the Retouch menu (see pages 236-242).

Note: Like the other image attributes available under the <Custom> option of the <Optimize Image> menu, the effects of the options available under the <B&W> menu can all be achieved with a greater degree of control using digital imaging software, once the image file has been imported to a computer. However, for images that will be output direct from the camera this level of control can be useful.

Note: Regardless of the black-and-white option selected under the <Optimize Image> menu, the D80 always saves a black and white picture as an RGB file, using Color Mode Ia, with saturation set to Normal and Hue set to 0.

Camera Menus and Custom Settlings

The D80 makes extensive use of a sophisticated and comprehensive menu system that is displayed on the LCD monitor. It is divided into five main sections:

Playback Menu—is used for reviewing, editing, and managing the pictures stored on the memory card.

Shooting Menu—is used to select more sophisticated camera controls that have a direct influence on the quality and appearance of the images the D80 records. The menu also contains several specialized features, such as the noise reduction feature for long exposures, and the multiple exposure facility.

Custom Settings Menu—as the title of this menu suggests, the options available here allow the user to select and set specific controls to fine tune camera operations.

Setup Menu—is used to establish the basic configuration of the camera. Once the settings for the options in this menu are made, they are not changed that frequently.

Retouch Menu—offers useful features for performing a range of enhancements and modifications to images recorded and stored on the D80's memory card. The original image is always preserved, and with the exception of the <Image Overlay> and <Small Picture> options, any copies produced from NEF Raw files using the Retouch menu are saved as JPEG files at a quality of Fine; in most instances they are saved at an image size of Large (3,872 x 2,592 pixels).

The myriad of menu options will enable you to optimize the D80 for your style of shooting. **Note:** In my opinion, the items available in the Retouch menu cannot be considered anywhere near as sophisticated as their equivalents in any good digital imaging software application. They are intended to provide a quick, convenient, and largely automated method of producing a modified version of the original image, without the need to use a computer. However, they offer an unprecedented level of control with in-camera processing to produce a finished picture directly from the camera.

Note: Both the Setup and Custom Settings menu can be displayed showing either all the menu options or in abbreviated form. Also, the <My menu> option enables the user to select which options from all five menus are displayed, enabling the entire menu system to be customized to your specific needs.

Accessing the Menus

To access any menu push the use button and press multi selector button to the left to highlight one of the five tabs used to identify each menu (top to bottom):
E back Menu>. 🖸 <Shooting Menu>. 🖉 <Custom Set-<Setup Menu>, and 🗹 <Retouch Menu>. tings>. ٢ Highlight the required menu tab by using multi selector button; the first level of menu option will open. Press the multi selector to the right to highlight an option in the selected menu (navigate to the specific menu item by pressing the multi selector button up or down). To display the second level of options (sub-options) available for each menu item, press the multi selector to the right. Again, press the multi selector button up or down to highlight the sub-option. To select any highlighted item in any menu, press the OK button (pressing the multi selector switch to the right has the same effect and, in my opinion, is faster). To return to the previous menu level, press multi selector button to the left one time.

Note. Each menu has multiple options, so keep scrolling up or down using the multi selector button to access those options not shown on the monitor screen.

Note: If a menu item or sub-option is displayed in gray, it is not available at the current camera settings.

Note: The multi selector button can be used to navigate the menus even if its lock switch is set to "L" – locked.

To exit the menu system and return to the shooting mode, press the shutter release button lightly to the halfway position, or press button twice. Many of the options within the menu system can be set using buttons and dials located on the camera body. I would use this where it is available, as this will improve the efficiency of camera handling and reduce battery power consumption by avoiding use of the monitor screen.

Hint: If you need a reminder as to what a particular menu option does, press and hold the button to display a description of the function or feature. You may need to press the multi selector button up or down to scroll through the display.

In the following sections of this chapter, I will deal with those features and functions controlled by the various menus. I have given the page reference where these are discussed in more detail elsewhere in the book.

Playback Menu

The following items are displayed in the Playback menu. If the installed memory card contains no pictures, all items except <Playback folder> and <Rotate tall> will be gray.

Note: You can use the <My menu> option, selected under the <CSM/Setup menu> item to select which of the Playback menu items are displayed.

Delete

Use the <Delete> option in the Playback menu to erase individual images, a group of images, or all of the images on the card.

Hint: If you delete images one by one, it is faster to use the button on the rear of the camera. However, to erase a group of images the <Delete> function in the Playback menu will probably save you a lot of time (and button pushing!).

To delete a group of images:

- 1. Select <Delete> from the Playback menu.
- 2. Choose <Selected> from the Delete options list.
- 3. Thumbnails of the images stored in the active folder will be displayed on the monitor screen. Scroll through the images by pressing the multi selector button to the left or right. A yellow frame will form a border around the selected image. To see an enlarged view of the selected image, press and hold the substance.
- 4. To select the highlighted image for deletion, press the multi selector button up or down. A small icon of a trashcan will appear in the upper right corner of the thumbnail image.
- 5. Once all the files to be deleted have been selected, press the or button.
- 6. The total number of images to be deleted will be displayed, along with two options: <No> or <Yes>. Select the required option and press the or button to complete process (<Yes> to cancel; <No> to delete).

Note: If <All> is selected in the <Playback Folder> option (see below), you can view all images stored in all folders on the memory card, not just those in the active folder.

To delete all images:

- 1. Select <Delete> from the Playback menu.
- 2. Select <All> from the Delete options list, and press the multi selector button to the right. A warning message will display, "All images will be deleted. OK?"

Protected images cannot be erased using the <Delete> option.

- 3. Highlight either <Yes> or <No>.
- 4. Once you have selected the required option, press the button to either complete (<Yes>), or cancel (<No>) the process.

Note: This process cannot delete pictures that are protected. Images that are hidden are not displayed, and therefore cannot be selected for deletion.

Hint: If you want to delete a high volume of pictures, the deletion process can take a substantial amount of time (it could take 30 minutes or longer). To save draining the camera battery and placing additional wear and tear on the camera, it is better to eject the memory card and deal with the images on a computer.

Playback Folder

The <Playback Folder> option in the Playback menu allows you to determine which images from the memory card are displayed during playback. There are two options available:

- <Current> Only the images in the folder currently set for image storage, via the <Folders> option in the Setup menu (default).
- <All> All of the images stored on the card are displayed, regardless of which folder they are in.

To select the Playback Folder:

- 1. Select <Playback Folder> from the Playback menu and press the multi selector button to the right.
- 2. Highlight the required option.
- 3. Press **b** button to confirm your selection.

Rotate Tall

The <Rotate Tall> option allows pictures taken vertically to be displayed vertically on the monitor screen automatically. However, rotating an image to a vertical orientation for display on the monitor screen will decrease the overall size of the image to about 2/3 the size of an image viewed using the full viewing area of the screen.

Note: The <Auto Image Rotation> option in the Setup menu must be turned on for the <Rotate Tall> function to operate. Otherwise, all images will be displayed in a horizontal orientation regardless of the camera orientation at the time the images were recorded.

To set Rotate Tall:

- 1. Select <Rotate Tall> from the Playback menu and press the multi selector button to the right.
- 2. Highlight <On> or <Off>.
- 3. Press **ok** button to confirm your selection.

Slide Show

The <Slide Show> option in the Playback menu allows you to view all of the images stored on the current momory card in sequential order. This is a useful feature, especially if the camera is connected to a television for viewing.

To use Slide Show:

- 1. Select <Slide Show> from the Playback menu, and press the multi selector button to the right.
- 2. <Start> will be highlighted; to commence the slide show immediately, press the button (images will be displayed for approximately two seconds).
- 3. To pause the slideshow, press the DK button again. This displays a sub-menu of <Restart>, <Frame interval> (you can choose a duration of either 2, 3, 5, or 10 seconds), and <Exit> (to stop the slide show).

To select which pictures are included in the slide show:

- 1. Select <Slide Show> from the Playback menu and press the multi selector button to the right.
- 2. Highlight <Select picture>, and press the multi selector button to the right. Two options are shown in the submenu; <All pictures> and <Select pictures>.
- 3. Select <All pictures> to include all photographs in the active playback folder. Choose <Select pictures> to select up to 50 photographs for the slide show (only those pictures in the active folder can be selected). Repeat step 2 to commence the slide show.

To select the style in which the pictures will be played back:

- 1. Select <Slide Show> from the Playback menu and press the multi selector button to the right.
- 2. Highlight <Change settings> and press the multi selector button to the right. Three options are shown in the submenu; <Style>, <Frame Interval>, and <Background music>. Highlight the required option using the multi selector button and press the multi selector button to the right to display the sub-options:

- <Style> With the <Standard> option, images are played back at the selected interval without use of any transition effects or music. With the <Pictmotion> option, images are played back for a set time duration using a mix of zoom and panning effects. Background music can also be selected using the <Background music> option, but it is only audible if the D80 is connected to a television set.
- <Frame Interval> Select the duration of the display in <Style—Standard>; options include, 2, 3, 5, or 10 seconds (if <Style—Pictmotion> is selected this option is not available).
- <Background music> There are five different audio tracks to choose from. Use the multi selector button to highlight the required option, and press the button to confirm your choice (if <Style— Standard> is selected this option is not available).

There are a variety of control options when the Slide Show function is active:

- To return to previous image, press the multi selector button, or rotate the main command dial to the left (not available if <Pictmotion> is selected).
- To skip to next image, press the multi selector button, or rotate the main command dial to the right (not available if <Pictmotion> is selected).
- To change the display of image information, press the multi selector button up or down, or alternatively rotate the sub-command dial until the required page is displayed (not available if <Pictmotion> is selected).
- To pause the display, press **DB** button. A sub-menu with three options is displayed: <Restart>, <Frame Interval>, or <Exit>. Highlight the option you need and press the multi selector button to the right to select it.
- To exit to the playback menu, press the unit button.
- To exit to the playback mode, press the 🔳 button.
- To exit to the shooting mode, press the shutter release button halfway.

At the end of the display the same menu shown when the clide show is paused displays: <Restart>, <Frame Interval>, or <Exit>. Highlight the required option and press the button.

Note: Images that have been hidden do not appear during the <Slide Show> display.

Hint: The <Slide Show> function consumes a lot of battery power, especially if a large number of images are stored on the memory card. Ensure you use a fully charged battery, or the EH-5 mains AC adapter.

Note: Early versions of the Nikon instruction manual state that pressing the multi selector button left or right alters the display of information pages in a slide show; this is incorrect, the button should be pressed up or down.

Hide Image

The <Hide Image> option of the Playback menu enables the user to hide or reveal selected images. Images that are hidden cannot be viewed during normal image playback. These hidden images can only be seen in the <Hide Image> menu, and they are also protected against deletion; they can only be 'deleted' from the memory card if it is formatted.

Note: Remember, formatting does not actually delete the image file data; it merely overwrites the file directory on the memory card, so that the camera can no longer navigate to the image files stored on it. It is often possible to recover files from a card that has been formatted, but the chances of success diminish as more new data is saved on the card after the formatting process.

To use Hide Image:

- 1. Select <Hide Image> from the Playback menu and press the multi selector button to the right.
- 2. Highlight, <Select/Set>, and thumbnails of all of the images stored in the active folder will be displayed on the monitor screen. Scroll through the images using the

multi selector button. A yellow frame will form a border around the selected image. To see an enlarged view of the selected image, press and hold the sutton.

- 3. To hide the highlighted image, press the multi selector button up or down. A small icon of a frame with a diagonal line through it will appear in the upper right corner of the thumbnail image.
- 4. Once you have selected all images to be hidden, press the or button to hide all selected images.

To reveal selected images:

- 1. Select <Hide Image> from the Playback menu.
- 2. The next page shows <Select/Set>.
- 3. Thumbnails of all of the images stored in the active folder will be displayed on the monitor screen. Scroll through the images using the multi selector button. A yellow frame will form a border around the selected image. To see an enlarged view of the selected image, press and hold the substant.
- 4. To select a highlighted hidden image to be revealed press the multi selector button up or down. The small icon of a frame with a diagonal line through it, that denotes a hidden image, will disappear.
- 5. Once you have selected those hidden images that are to be revealed, press the **DK** button.

To reveal all images:

- 1. Select <Hide Image> from the Playback menu.
- 2. Select <Deselect All?>.
- 3. Press the *button*, or alternatively press the multi selector button to the right; a message stating "Deselect all done" is displayed once the deselect process is completed.

Note: Images can be protected by selecting them using the image review function and pressing the *button*.

Print Set

The <Print Set> option in the Playback menu enables the user to create and save a set of images to be printed by a compatible printing device. This "print order" will communicate which images should be printed, how many prints of each image, and the information that is to be included on each print. This information is saved, on the installed memory card, in the Digital Print Order Format (DPOF), to be read subsequently by DPOF compatible printing device. (See pages 321-323 for full details on DPOF.)

💐 Shooting Menu

Note: You can use the <My menu> option, selected under the <CSM/Setup menu> item, to select which of the Shooting menu items are displayed.

The Shooting menu contains the following items:

Optimize Image

The <Optimize Image> option in the Shooting menu allows you to make changes to sharpening, contrast, color mode, saturation, and hue based on the current shooting situation and/or the users preferences. It also allows you to select a variety of options for shooting pictures in the black-andwhite recording mode. See pages 166-177 for full details.

Image Quality

The <Image Quality> option in the Shooting menu allows the user to select the file format(s) to be used for images recorded by the camera. See pages 94-97 for full details.

Image Size

Image Size determines the file size, or resolution, of an image, and is expressed in pixels. (See pages 94-97 for full details.)

Note: Image size adjustments will only apply to images saved using the JPEG format. NEF Raw files are always saved at the camera's highest resolution.

White Balance

The <White Balance> option in the Shooting menu allows you to select the color temperature applied to the images you are shooting. There are nine options available when shooting in the P, S, A, and M exposure modes. See pages 97-108 for full details.

In addition to the direct measurement option for the preset white balance value described on pages 104-106, it is possible to copy the white balance value from an existing image file. However, the image file must have been recorded on a Nikon D80 and be stored on the memory card installed in the camera.

To use a previously recorded picture to set white balance:

- 1. Select <White balance> in the Shooting menu, highlight <White balance preset>, and press the multi selector button to the right.
- 2. Highlight <Use photo> and two options are displayed on the monitor screen: <This image> and <Select image>.
- 3. If a source picture is already selected, it is displayed on the monitor screen above these two options; if not a blank white frame will be displayed.
- 4. If you wish to use the previously selected picture as the source picture, select <This image> and press the multi selector button to the right, or press the button, to confirm your choice.
- 5. If no source image has been selected, or you wish to use an alternative source image, highlight <Select image> and press the multi selector button to the right, or press
 button to confirm your choice.
- 6. A list of available folders is shown on the monitor screen. Highlight a folder and press the multi selector button to the right, or press **OK** button to confirm your choice.

7. A thumbnail image of pictures stored in the folder is displayed (six per page) on the monitor screen. Use the multi selector to highlight the required picture and press button to confirm your choice. The white balance is then set to the same value as the selected photograph and the main Shooting menu is restored.

Note: If you have a preset white balance value selected via the <Use photo> option, and then use the preset options to obtain another value for the preset white balance value using the <Direct Measurement> option, the camera will use this measured value even though the <Use photo> option is selected in the preset white balance menu.

ISO Sensitivity

The <ISO sensitivity> feature is accessed through the Shooting menu. ISO sensitivity is the digital equivalent to film speed. It emulates the light sensitivity of film bearing the same ISO number. The higher the ISO number, the more sensitive a film is to light. In the D80, ISO sensitivity is a measure of the degree of amplification applied to the signal from the sensor, since the sensitivity of the sensor is fixed at its base level, which is approximately equivalent to ISO 100.

Long Exposure Noise Reduction

Images taken at shutter speeds of 8 seconds or longer often exhibit a higher level of electronic noise. Noise is the result of amplification processes applied to the data captured by the sensor. It manifests as irregularly placed bright, colored pixels that disrupt the appearance of an image, particularly in areas of even tonality. Long Exposure Noise Reduction, abbreviated to <Long Exp. NR> in the Shooting menu helps to reduce the appearance of noise when using long exposure times.

To set Long Exposure Noise Reduction:

- 1. Select <Long Exp. NR> from the Shooting menu and press the multi selector button to the right.
- 2. Highlight <On> or <Off> (default).
- 3. Press the **OK** button to confirm the choice.

If <On> is selected for Long Exposure Noise Reduction, the processing time for each recorded image will increase by 50-100%. While the image data is being processed "Job nr" appears, blinking, in place of the shutter speed and aperture value displays in the control panel. No other picture(s) can be taken while this is displayed.

Note: The process used by the D80 to perform the Long Exposure Noise Reduction involves the camera making a second "exposure" known as a "dark frame exposure" during which the shutter remains closed but the camera maps the sensor and records the values of each photosite (pixel). Sometimes a photosite can "lock-up" and retain a value that is erroneous; this often occurs if the sensor gets hot due to prolonged use, as occurs in a long exposure, or due to a high ambient atmospheric temperature. After 'mapping' the sensor for 'hot' (overly bright) photosites, the camera subtracts the 'dark frame' photosite values from the photosite values of the main exposure in an effort to reduce the effect of noise in the final image.

High ISO Noise Reduction

At high sensitivity (ISO) values the presence of electronic noise in an image increases due to the greater degree of signal amplification that takes place during in-camera processing. (It is analogous to the visible grain structure of high ISO film emulsions.) The <High ISO Noise Reduction> feature abbreviated to <High ISO NR> in the camera menus helps reduce the amount of noise in images taken at sensitivities (ISO) above 400. For a fuller description of sensitivity see pages 108-111.

To set High ISO Noise Reduction:

- 1. Select the <High ISO NR> option and press the multi selector button to the right.
- 2. Select <Normal> (default) to reduce the amount of noise in images taken at sensitivities (ISO) above 400, <Low> for less noise reduction, <High> for more noise reduction. Alternatively, select <Off> to prevent noise

reduction being performed at sensitivities of ISO 800 or less. At any sensitivity setting above 800 a minimal amount of noise reduction is always performed.

3. Press the **OK** button to confirm your selection.

Nikon D80 – The Noise Issue

During testing of my early production camera loaned by Nikon UK, I noticed that there was a significant level of noise produced by sensor signal amplification at high sensitivity (ISO) settings of ISO 1600 or above when used for time exposures of a minute or longer. The noise was particularly prevalent in the top corners of the frame and in an area about a third the way along the top edge of the frame (see the dark frame exposure example). Remember, in the camera these areas are at the bottom of the sensor as the image formed by the lens on the sensor is upside down.

The three arrows indicate the areas where noise, as a result of signal amplification, shows clearly in long exposures. This phenomenon appears to afflict early production D80 cameras in particular. This was a five-minute exposure made at ISO 1600.

At shorter exposure times (from 30 seconds to 1/60 second), and the same high setting of ISO 1600, the noise was not noticeable until I applied any significant amount of adjustment in post-production that increased the level of the photosite (pixel) value in these areas (e.g. a major shift using the levels tool), as I might do to recover an under uppoul abot, or restore some shadow detail to a dark area. Under these conditions, the same areas showed significant levels of noise as a result of signal amplification. Regardless of the exposure duration the High ISO Noise Reduction feature appears to have only a modest effect on the level of noise present in these areas of image.

Although less obvious, the combined efforts of the long exposure and high ISO noise reduction features still did not eliminate visible noise effects in the top corners and top edge in the five minute exposure at ISO 1600.

The good news appears to be that later D80 cameras (i.e. those that shipped during November 2006, or after) do not demonstrate the noise problems seen with earlier cameras when using exposure times of 30 seconds or less. However, it appears from the bodies I have tested that these later cameras can still show significant noise effects in the top corner areas of the frame at exposures of one minute or longer.

To summarize the above, if you use your D80 at high ISO settings (1600 or above) and set exposure duration of 30

seconds or longer, you will most likely see noticeable levels of noise in the top corners of the frame. If you have an early production D80, do not be surprised if you see noise effects in these areas and along the top edge of the frame with exposure times as brief at 1/30 to 1/60 second if you perform any post-processing that significantly raises the level of the photosites in these areas. The conclusion must be that the D80 is not usable for long exposures at high ISO settings, and even at shorter exposures times, again at high ISO levels, there is a risk of significant levels of noise affecting the image in these areas.

If you want to shoot long exposures, my advice is to keep the sensitivity setting as low as possible, preferably ISO 100.

Multiple Exposure

The D80 enables either two or three individual exposures to be combined into a single exposure using its <Multiple Exposure> feature. However, the images must be shot in consecutive order, and are not saved as individual files but as a single combined image. See pages 134-135 for full details.

Custom Settings Menu

Many of the default settings for the various functions and features of the D80 can be altered to suit your shooting style. This is achieved via the Custom Settings menu (CS) that has no less than thirty-two options.

At the camera's default setting it is necessary to scroll through the list of available options in the Custom Setting menu each time you want to make an adjustment to a particular one. In an effort to simplify and speed up this process, the D80 offers two different levels of the Custom Setting menu, Simple and Full, plus as a further refinement, a third option, known as My menu. My menu allows the user to select only those options from any of the five menus available on the camera—including the Custom Setting (CS) menu—that automatically display on the LCD monitor. All three levels of the Custom Setting display are set from the <CSM/Setup menu> option in the Setup menu.

Simple Menu

This is the default menu and only shows the first ten of the 32 available options. However, I find Nikon's idea of the ten most useful options is somewhat strange, because I consider items such the bracketing set, Function button operation, and self-timer delay to be more important than automatic ISO adjustment and increment size of exposure value steps. However, as I mentioned above, you can always configure the menu to your exact your requirements by using the <My menu> feature.

Detailed Menu

To enable access to the full list of Custom Setting options, select the Setup menu and scroll to <CSM / Setup menu>. Press the multi-selector to the right, highlight <Detailed>, and select it by pressing the multi-selector to the right again.

To view the selected menu, press the \bigcirc button and use the multi-selector to highlight the <CS menu tab> \bigcirc . Press the multi-selector to the right to enter the CS menu, and press it up or down to scroll through the menu.

Hint: To save time, it is helpful to know that both menus wrap around in a continuous loop in both directions as you scroll—just keep pressing the multi-selector either up or down.

To select a particular Custom Setting, use the multiselector. Then press the multi-selector button to the right to display the sub-options for that CS. Highlight the desired sub-option by pressing the multi-selector button up or down, and select it by pressing the multi-selector button to the right again.

Help Button

Rather than having to remember what each option does, or refer the camera's instruction manual for every Custom Set-

To restore the D80's Custom Settings menu to its default settings, select <Reset>, highlight <Yes>, then multi select right.

ting, Nikon has provided the help-function. It provides a brief description of each Custom Setting option on the LCD monitor. Whenever you have a Custom Setting displayed on the monitor, press and hold the button and the descriptive text will appear on the screen. (If necessary, press the multi-selector down to scroll through the text.)

Menu Reset

All of the Custom Setting (CS) menu options have a default value (see below), but if at anytime you wish to cancel all your user-set options and restore the camera to its default CS menu options, select <Reset>, highlight <Yes>, and press the multi-selector to the right.

Hint: This action only resets the CS menu. It does not restore default settings in other camera menus.

CS-1: Beep

- Operation: The D80 can emit an audible, electronic beep when the camera has performed certain functions: countdown during self-timer operation and delayed remote release mode; confirmation focus has been acquired in single-servo AF; and shutter operation activated with the ML-L3 infrared (IR) remote control in immediate release mode.
- Options: ON—The control panel shows a musical note icon (default)

OFF—The control panel shows the musical note icon with a strike through (camera is silent)

Suggestion: Set this option to OFF as the beep can be distracting in many shooting situations.

CS-2: AF-Area Mode

- Operation: The D80 has three different autofocus area modes: Single area, Dynamic area, and Auto-area AF. (See pages 145-149 for a full description of the autofocus area modes.)
- Options: Single area [1] —Only the single, preselected focus area is used to acquire focus (Default for P, S, A, M, and (icon 28) modes).

Dynamic area [♀] —Auto focus area shifts to follow a moving subject (Default for ★ mode).

Auto-area AF \square —The camera selects the auto focus area automatically. One or more areas may be highlighted depending on the nature of the scene (Default for \square , \square , \square and \square modes. Suggestion 1. Single area mode is probably the best option for many shooting situations since it is the most predictable method of autofocus. 2. When shooting a moving subject that shifts erratically, Dynamic area is more useful since it tracks the subject. It switches from the first auto focus area selected by the user and shifts focus to the next most appropriate area according to the movement of the subject as predicted by the D80.

3. Take care when using the Auto-area AF mode. This is a fully automated system, so you relinquish control of focus to the camera, and depending on the shooting conditions the camera may not focus on your intended subject.

Note: If the AF mode selector switch on the D80 is set to M (manual), or the AF mode switch on the lens is set to M (manual), CS-2 is disabled and you cannot select it.

CS-3: Center AF Area

Operation: This option determines the size of the center focus area. The D80 has two configurations for the coverage of the central auto focus sensing area.

- Options: Normal zone—The central auto focus sensing area has a similar coverage to the ten outer auto focus sensing areas (default). Wide zone—The coverage of the central auto focus sensing area is increased horizontally and vertically. This option can be useful when photographing moving subjects. (It is not available if Auto-area AF option in CS-2 is selected.)
- Suggestion: Although the Wide zone option does provide an increase in the focusing performance with moving subjects, it requires that they be placed at the center of the frame,

which is often not where you want the subject to be.

CS-4: AF Assist

- Operation: The AF-assist lamp will light automatically when the D80 determines that light levels are low and there is a risk that the autofocus system will not acquire focus. However, there are all sorts of limitations depending on the type of lens in use (for example, it is only effective with focal lengths between 24 and 200mm) and any lens hood should be removed. Additionally, it has a maximum effective range of only 9' 10" (3m).
- Options: ON—AF-assist lamp will light automatically when the D80 is set to Single-servo AF, and when either Single-area or Auto-area AF are selected at CS-2; or when Dynamic-area AF is selected for CS-2 and the center focus area is used (default). OFF—Regardless of the lighting conditions the lamp will not operate.
- Suggestion: This is strictly a personal preference, but I keep the lamp option set to OFF for several reasons. First, it drains battery power; second, it can be distracting to the subject; and third, it has a limited range means and therefore is of no value with many of the subjects I shoot.

CS-5: No Memory Card?

Operation: If there is no CF card in the D80, it will disable the shutter release button to prevent you from thinking the camera is recording an image. This can be overridden to allow the camera to save pictures directly to a computer using appropriate Nikon software. Options: Release locked—The shutter will not operate if a memory card is not installed (default). Enable release—The shutter release will operate normally even with no memory card installed in the camera. The photograph is displayed on the LCD monitor but it is NOT saved.

Suggestion: Leave this option set to Release lock (default). Otherwise, like a film camera with no film, the D80 will appear to be operating normally but will not save pictures.

CS-6: Image Review

- Operation: The D80 can display a picture on the LCD monitor as soon as an exposure is made.
- Options: ON—Pictures are shown almost immediately on the LCD monitor after an exposure is made (default).

OFF—Pictures are not displayed on the LCD monitor after an exposure is made. You can press **D** to display the image.

Suggestion: Unless you need to conserve battery power, I suggest you set this option to ON (default). The image review is confirmation that an exposure has been made. You can also configure the histogram to display at the same time. As soon as you have finished looking at the picture/histogram you can switch the monitor off by lightly pressing the shutter release button.

CS-7: ISO Auto

Operation: The camera can automatically shift the ISO sensitivity if an optimal exposure cannot be made at the selected value. Although the camera displays ISO AUTO in the control panel and viewfinder when the ON option is selected, and the icon flashes as a warning that the camera has altered the ISO setting, there is no indication as to what ISO setting is in use, unless you tie up the Function button operation for this purpose (see CS-16 options). The operation of this function is also dependent on the exposure mode you select.

- Options: OFF—The camera retains the ISO setting selected by the user and will not alter it (default). ON—The D80 will alter the ISO setting to compensate if an optimal exposure cannot be made (the flash output is adjusted appropriately). The maximum ISO setting can be set using the <Max. Sensitivity> option. In the P and A exposure modes, ISO sensitivity is only adjusted if under-exposure would occur at the lowest shutter speed selected by the user at the <Min, shutter speed> option.
- Suggestion: 1. I recommend you leave it set to OFF (default) if you want to be sure of what sensitivity level is used. This gives you control over ISO "noise" levels. Granted, you can assign the Function button to show the sensitivity level that the D80 sets automatically, but it means you cannot use the Function button for more useful purposes. 2. If you do want to use ISO Auto, I recom-

2. If you do want to use ISO Auto, I recommend you set the <Max. Sensitivity> option to ISO 800.

CS-8: Grid Display

Operation: The D80 can display a set of grid lines superimposed on the focusing screen to aid composition and alignment of the camera (for example, to ensure a horizon line is level).

- Options: OFF—No grid lines are displayed (default). ON—Three horizontal and vertical lines bisect the focusing screen area.
- Suggestion: Again, this is a matter of personal preference. I find this a very useful feature and have this option set to ON at all times, although I know some people find the lines distracting.

CS-9: Viewfinder Warning

- Operation: When set to ON, the viewfinder displays several warnings.
- Options: ON—Warning signs are displayed in the viewfinder to notify the user when: Blackand-white is selected in the <Optimize image> option of the Shooting menu; battery charge is low; or no memory card is installed in the camera (default). OFF—No warning signs are displayed.
- Suggestion: This option is useful if you use the Blackand-white shooting option, since it is easy to forget if you have set it until you review the image on the monitor screen. If you set CS-5 to Release locked, the lack of a memory card is not an issue, and the battery status is always displayed in the control panel.

CS-10: EV Step

- Operation: This determines the step increments for adjustments pertaining to exposure value. The selected increment, 1/3 EV or 1/2 EV steps, is used for all exposure settings on the D80 (shutter speed, lens aperture, exposure compensation factor, and exposure bracketing).
- Options: 1/3 step—The camera shifts exposure in increments of 1/3 EV (1/3-stop) (default).

1/2 step—The camera shifts exposure in increments of 1/2 FV (1/2-stop).

Suggestion: For the finest level of exposure control, use the 1/3 step option.

CS-11: Exposure Compensation

- Operation: This option allows the user to activate exposure compensation in a variety of ways other than pushing and holding the exposure compensation button and turning the Main-command dial.
- Options: OFF—Push and hold the Exposure compensation button 😰 to set exposure compensation (default). ON—Turn one of the command dials to set exposure compensation. There is no need to push the 😰 . However, choice of exposure mode and setting the CS-15 option dictates which command dial you can use.

CS-15 status	Exposure mode	Exposure Compensation set by
Off	А	Main-command dial
Off	S, P	Sub-command dial
On	Α, Ρ	Sub-command dial
On	S	Main-command dial

Suggestion: In my opinion, this option adds needless complication to controlling the D80, and has the potential to confuse the user. Personally, I leave this option set to OFF.

CS-12: Center-Weighted

Operation: The Center-weighted metering pattern takes 75% of its evaluation from the central, circular area of the frame. At the default setting, the diameter of this area is 8mm, the size of the central circle, but you can select an alternative diameter if you wish.

- Options: 6mm diameter 8mm diameter (default) 10mm diameter
- Suggestion: I consider center-weighted metering the least useful of the three TTL metering options available on the D80. I simply leave this option set to its default value, and instead use the more specific Spot metering function.

CS-13: Auto BKT Set

- Operation: Exposure bracketing is available for ambient light exposure by altering either the shutter speed or aperture; for flash exposure using flash output compensation; or a combination of both. It is also possible to bracket the white balance setting. This option allows you to choose the routine a D80 uses to perform exposure bracketing. (Only available in P, S, A, and M exposure modes.)
- Options: AE & flash—If you are using a Speedlight flash unit (internal or external), this option adjusts the shutter speed/aperture values for the ambient exposure and the flash output level (default).

AE only—This option adjusts the shutter speed (in S & M modes), or aperture value (in A mode), and either the shutter speed or aperture (in P mode) based on prevailing light conditions (i.e. only the ambient light exposure is affected).

Flash only—Exposure is bracketed using only flash exposure compensation (i.e. only the flash output is affected).

WB bracketing-White balance values are

bracketed for JPEG files. This option does not bracket exposure values, and it is not available for NEF Kaw, or INLETIPEG file options.

Suggestion: Since changing exposure by varying the shutter speed or aperture produces a very different appearance compared with changing the flash exposure level, think carefully about this feature. If you use fully automated 3D Automatic Balanced Fill-Flash, the default may be worthwhile. However, if you prefer to set your own flash compensation level using Standard TTL flash control, I suggest setting this option to <AE only>.

Note: If you use the <Flash only> option, the D80 will only support this function in i-TTL flash exposure control. The only compatible external flash units are the SB-800 (including its Auto Aperture mode), SB-600, SB-400, and SB-R200 Speedlights.

CS-14: Auto BKT Order

Operation:	This option allows you to select the order in which the D80 makes exposures in a brack- eting sequence (available only in P, S, A, and M exposure modes).	
Options:	MTR>Under>Over—The "correct" exposure is followed by an underexposed, and over- exposed frame (default). Under>MTR>Over—An underexposed frame is taken first, followed by the 'correct' expo- sure, and then an overexposed frame.	
Suggestion:	These options are a matter of personal preference.	

CS-15: Command Dials

- Operation: The D80 can be configured so that the each command dial can control either the shutter speed or lens aperture.
- Options: Default—The main (rear) command dial controls shutter speed, and the sub (front) command dial controls the lens aperture. Reversed—The main (rear) command dial controls lens aperture, and the sub (front) command dial controls shutter speed.
- Suggestion: Although a matter of personal preference, if you use or have used any other Nikon camera(s) in which this option is not available, I recommend the default option; this prevents confusion if you switch between different camera models.

CS-16: FUNC. Button

- Operation: The Function button (located on the front of the camera between the finger grip and the lens) offers a quick and convenient way to activate one of nine useful camera functions.
- Options: ISO display—Whenever ISO Auto CS-7 is active, pressing the function button will display the modified ISO value in both the viewfinder and control panel (default).

Framing grid—Press the function button and rotate the main command dial to turn the viewfinder grid line display on or off.

AF-area mode—Press the Function button and rotate the main command dial to select the autofocus area mode, (displayed in the control panel).

Center AF area—Press the function button and rotate the main command dial to select between normal or wide coverage for the central auto focus sensing area.

FV lock—Activates the FV lock function, which helps to improve flash exposure accuracy for off-center subjects when using the built-in or an external Speedlight (SB-800, SB-400, SB-600, or SB-R200). Position the subject at the center of the frame and press the function button to fire a monitor pre-flash (no exposure is made). The D80 assesses the required flash output and locks this value. You can then re-compose the picture with the subject located off-center as required, and press the shutter release to take the picture.

Note: The flash output value is locked until the function button is pressed again, or the exposure meter switches off automatically.

Flash off—When using the built-in or an external Speedlight (SB-800, SB-600, SB-400 or SB-R200), pressing the function button cancels the flash operation.

Matrix metering—Press the function button to activate Matrix metering in P, S, A, and M exposure modes.

Center-weighted metering—Press the function button to activate center-weighted metering in P, S, A, and M exposure modes. Spot metering—Press the function button to activate spot metering in P, S, A, and M exposure modes.

Suggestion: Function button operation depends on the shooting situation and specific user requirements. For what it is worth, I generally have my camera set to <Matrix metering> for normal shooting and select the <Spot metering> option for the function button so I can switch between the two metering options at will. If I am shooting with flash, I usually select the <FV lock> option to be activated by the function button.

CS-17: Illumination

- Operation: This CS controls the control panel illumination.
- Options: OFF—The backlight of the control panel will only operate when the power switch is rotated past the ON position to the light bulb icon * (default). ON—The backlight of the control panel will remain on while the exposure meter is active.
- Suggestion: There may be some shooting situations when it is desirable to have the backlight on all the time, although none come to mind immediately! I recommend that you leave this option at its default to conserve battery power.

CS-18: AE-L/AF-L

Operation: The autoexposure lock button can be set to a variety of functions.

Options: AE/AF lock—Exposure value and autofocus are locked when the button is pressed and held down (default).

AE lock only—Exposure value is locked, but autofocus continues to operate, when () is pressed and held down.

AF lock— Autofocus is locked, but the exposure value can change, when (B) is pressed and held down.

AE lock hold—Exposure value is locked when (1) is pressed once and remains locked until it is pressed again.

AF-ON-The D80 will only autofocus when

is pressed; pressing the shutter release button does not activate autofocus. FV lock—Replicates the same functionality as the <FV lock> option under CS-16 (see CS-16).

Focus area selection—Press (#) and rotate the sub command dial to select the focus area.

AE-L/AF-L/AF area—Press (B) to lock exposure value and autofocus, and rotate the sub command dial to select the focus area.

AE-L/AF area—Press (B) to lock exposure value, and rotate the sub (front) command dial to select the active auto focus sensing area.

AF-L/AF area—Press (B) to lock autofocus, and rotate the sub command dial to select the focus area.

AF-ON/AF area—Press (B) to activate autofocus, and rotate the sub command dial to select the focus area.

Suggestion: 1. <AF lock only> is useful when you know where the subject is going to be but want autoexposure to operate right up to the moment you make the exposure.

2. <AE lock only> is probably the most useful option, since you can take a reading from your chosen area, lock it, and then re-compose the shot before releasing the shutter.

3. <AF-ON> has two distinct ways of being used. First, it can be considered an extension of the AF lock feature. Pressing (in Single Servo AF mode) operates AF using the active AF sensing area without having to press the shutter release button. If you hold the button down, you can recompose the shot as many times as you wish before releasing the shutter. Second, it can be used

to release the shutter when the subject reaches a pre-focused distance. Set the camera to Single-servo/Single-area AF modes and select <AF-ON>. Set the lens to autofocus mode and select an appropriate AF sensor area for your shot. Pre-focus by selecting a point through which the subject will move, align this with the AF sensor area bracket, then press and release AFL Recompose the shot and press and hold the shutter release button down all the way (focus is now locked). The shutter will release as soon as the selected AF sensor area bracket detects an in-focus subject. For example, say you are photographing a hurdle race. Pre-focus on the bar of a hurdle and then recompose so the AF bracket covers an area just above the bar where the athlete will pass through. As the runner approaches the hurdle, press and hold the shutter release down, while keeping the active AF bracket centered on the subject. As soon as the camera detects the hurdler is in focus, the shutter operates.

4. Personally, I leave the <FV lock> operation to CS-16, as there are other options I would prefer to have available via the button.

5. Maybe it is me, but I feel the last four options under this CS menu are control overkill, and the selection of the active autofocus sensing area by way of having to press a button and rotate a dial is much slower, as each area is selected in a fixed sequence. It seems far more cumbersome than using the multi-selector button on the back of the camera.

CS-19: AE Lock

- Operation: This option determines how and when the D80 locks an autoexposure value.
- Options: OFF—The exposure is not locked when you press the shutter release button halfway (default). ON—The exposure value is locked when the shutter release button is pressed halfway.
- Suggestion: I set this option to ON because I find it much faster and easier to lock exposure by pressing the shutter release button halfway.

CS-20: Focus Area

- Operation: The multi-selector button is used to select an AF sensing area. At the default setting, repeated pressing of the button shifts selection in the chosen direction to the furthermost sensor, which forms the boundary of the autofocus coverage.
- Options: No wrap—Sensor selection stops at the boundary of the 11-sensor array, regardless of the direction in which you press the multi-selector (default). Wrap— Pressing the multi-selector button repeatedly continues selection in the same direction but 'wraps' around to the other side of the display.
- Suggestion: In my opinion, <Wrap> offers a much faster method of sensor selection, but I do suggest you try these two options for yourself before deciding which is for you.

CS-21: AF Area Illumination

- Operation: The selected AF area is indicated either by a solid black line, or is initially highlighted in red before changing to solid black.
- Options: Auto—The camera decides which method to use based on its assessment of the scene's brightness; red is used in low light conditions to help make the AF bracket stand out against a dark background (default).

Off—The selected AF area is indicated in black only.

On—The selected AF area is always indicated in red, initially, before turning black.

Suggestion: The <Auto> option is probably the best compromise. It is useful in low light, but conserves battery power in brighter conditions.

CS-22: Flash Mode

- Operations: This option sets the flash mode for the builtin Speedlight. It does not affect external Speedlight units.
- Options: TTL—The built-in flash operates in the i-TTL mode and always emits monitor pre-flashes (default).

Manual—The flash output is fixed at a predetermined level selected from the submenu.

Repeating flash—The flash fires repeatedly during the shutter opening. A sub-menu allows the user to select the output level, number of flashes and frequency of flash outputs.

Commander mode—The built-in Speedlight can be used in either its commander mode, (where it does not contribute to the flash exposure but controls remote flash units only in one or two independent groups) or as a master flash, when it contributes light to the flash exposure as well as controls remote flash units in one or two independent groups. Both functions form part of Nikon's Advanced Wireless Lighting system, which requires use of the SB-800, SB-600, or SB-R200 Speedlights.

Built-in flash—This can be set to operate in i-TTL mode (it always operates in Automatic Balanced Fill-flash mode; it is not possible to select Standard i-TTL mode when using multiple Speedlights in the Advanced Wireless Lighting system), Manual flash (flash output level is selected by the user), or flash output can be cancelled, so only the monitor preflashes and control signals are emitted.

Group A/Group B—Up to two remote groups of Speedlights can be set to operate independently from each other and the master/commander flash. Each group can be set to operate in i-TTL mode, Auto Aperture (SB-800 only), manual flash (output level selected by the user), or flash output can be cancelled. It is also necessary to select one of four operating channels, and ensure that each flash unit is set to the same channel.

Suggestion: 1. If you use either the built-in Speedlight, or a single optional external Speedlight (currently only the SB-800, SB600, SB-R200 units are compatible), you will probably want to use the TTL setting, as it offers the most sophisticated level of TTL flash exposure control.

2. The Advanced Wireless Lighting system sounds complicated, but in truth it is relatively straightforward to set up and use effectively; currently only the SB-800, SB600, SB-R200 units are compatible.

CS-23: Flash Warning

- Operation: In P, S, A, and M exposure modes, the builtin Speedlight does not pop-up automatically if the camera decides additional light is required to make a good exposure. Instead, at the default setting, the thunderbolt flash icon f blinks as a warning whenever the camera determines that flash should be used.
- Options: ON—The thunderbolt icon **4** flashes in the viewfinder to recommend using the built-in Speedlight, or an optional external Speedlight (default). OFF—No warning is displayed.
- Suggestion: If you are making informed decisions about exposure control, the last thing you will want is the D80 telling you when to use flash! I set this option to OFF. All things aside, it keeps the viewfinder information as clear and uncluttered as possible.

CS-24: Flash Shutter Speed

- Operation: In P and A exposure modes, the D80 allows the user to set a lower limit on the shutter speed that can be used when either the built-in, or an external Speedlight flash is used. In both modes, the default is 1/60 second. However, this can be adjusted to any shutter speed, in one-stop steps between 1/60 second and 30 seconds.
- Suggestion: In order for the low level of ambient light in interiors to appear in an exposure for a more a balanced background when using flash as the primary light, you will want to select a slower speed than the default value of this option. Generally, I set a 1/15 second speed when using focal lengths of 55mm or

less as I am reasonably confident of my ability to hold the camera steady at such a shutter speed. Consider using a tripod at shutter speeds slower than 1/60 second to attain the best sharpness in an exposure.

CS-25: Auto FP

- Operation: Normally, the fastest shutter speed available when using a flash unit is the maximum flash synchronization speed. On the D80 this speed is 1/200 second. This can restrict the range of usable apertures, particularly when using fill-flash in bright conditions, even at the lower ISO settings. The Auto Focal Plane (FP) flash mode enables an external Speedlight (SB-800, SB-600, SB-400, or SB-R200) to synchronize at shutter speeds with a duration shorter than 1/200 second (this feature is not available with the built-in Speedlight of the D80).
- Options: ON—Auto FP mode is activated. OFF—Auto FP mode does not operate. Flash synchronization is automatically limited to 1/200 second (default).
- Suggestion: Auto FP mode can be very useful, particularly for fill-flash work in bright conditions where you want to use a wide aperture (low f/number) to limit the depth of field. However, it is important to understand that its use does reduce the flash shooting range progressively as the shutter speed is raised above 1/200 second. Always check the flash shooting range displayed in the control panel of the SB-800 / SB-600 Speedlight.

CS-26: Modeling Flash

- Operation: To assist in the assessment of flash lighting, the built-in flash or an external Speedlight (SB-800, SB-600, or SB-R200) will emit a series of very rapid flash pulses for approximately one second when the depth-of-field preview button on the camera is pressed.
- Options: ON—Modeling flash operates. OFF—Modeling flash does not function (default).
- Suggestion: This can be a useful feature at short shooting ranges, but it does increase battery drain.

CS-27: Monitor-Off

- Operation: This option sets the duration of the display on the LCD monitor assuming no other function/action is activated that would otherwise turn it off. The duration can be chosen from the following times:
- Options: 5s (five seconds), 10s (ten seconds), 20s (twenty seconds, the default), 1 min (one minute), 5 min (five minutes), and 10 min (ten minutes)
- Suggestion: 1. The monitor consumes a relatively high level of power. Therefore, I recommend selecting a shorter duration than the default <20s>. You can always switch off the LCD display by pressing the shutter release button lightly.

2. If you connect the D80 to the Nikon EH-5 main AC adapter, the duration is automatically set to <10min>. This cannot be altered.

CS-28: Auto Meter-off

Operation: The metering display remains active when you depress the shutter release button halfway. Assuming no other camera function is performed, the meter display will automatically turn off 6 seconds after you release the shutter button, or make an exposure.

The duration of the TTL meter display can be changed to the following values:

- Options: 4s (four-seconds), 6s (default) (six-seconds), 8s (eight-seconds), 16s (sixteen-seconds), and 30 min (thirty-minutes)
- Suggestion: You may find <6s> not quite long enough but a duration of <8s> is generally sufficient to view exposure data; any longer and battery drain is significant, especially over the course of an extended shooting session.

CS-29: Self-timer

- Operation: You can select one of four different durations for the delay between pressing the shutter release button and the exposure being made via the self-timer function as follows:
- Options: 2s (two seconds), 5s (five seconds), 10s (default) (ten seconds), and 20s (twenty seconds)
- Suggestion: A delay of <2s> is ideal for releasing the shutter when you want to minimize camera vibration without touching it. The ML-L3 IR remote release is probably a more practical option, since you do not need to press the camera's shutter release button to initiate the shutter action. This also allows you to release the shutter some distance from the camera.

CS-30: Remote on Duration

- Operation: This option allows you to determine the duration of the period in which the D80 can receive the infrared (IR) control signal from the ML-L3 remote control before it automatically cancels the remote release function. The following delays are available:
- Options: 1 min (default) (one-minute), 5 min (fiveminutes), 10 min (ten-minutes), and 15 min (fifteen-minutes)
- Suggestion: The camera draws more power than usual when it remains active awaiting the IR signal. Therefore, I recommend you set the shortest duration according to the shooting conditions.

CS-31 Exposure Delay Mode

- Operation: This option introduces a brief (0.4 second) delay between pressing the shutter release button down fully to make an exposure and the operation of the shutter. Its purpose is to help reduce the level of vibration of the camera, which is particularly important when shooting at high magnification, or with long focal lengths.
- Options: OFF—The shutter operation occurs as soon as the shutter release button is depressed fully (default). ON—The shutter operation is delayed for approximately 0.4 second after the shutter release button is depressed fully.
- Suggestion: This is a very useful feature; it helps to reduce the effects of the reflex mirror movement and the internal vibration this can cause when the shutter operates. By locking the reflex mirror in its raised position just

before the shutter blades open, it allows uny vibration to dissipate. I use this option often, particularly when shooting at high magnifications and long focal length lenses, or in close-up and macro photography.

CS-32: MB-D80 Batteries

- Operation: The optional MB-D80 battery grip allows the use of AA size batteries in place of the Lithium-ion rechargeable EN-EI3e battery used normally to power the D80. To ensure proper operation use this menu option to match the type of battery inserted in the battery holder to the MD-D80. Four battery types can be used:
- Options: LR6 Alkaline type, FR6 Lithium type, HR6 – Ni-MH type, and ZR6 – Ni-Mn type.
- Suggestion: I find that high capacity (2500 mAh) rechargeable Ni-MH batteries offer the best balance of power and performance in the MB-D80, but the option of using AA size batteries should only be considered as a last resort. Use the EN-EL3e battery to guarantee the best camera performance.

Setup Menu

The Setup menu is used to establish the basic configuration of the camera. Once the settings for the items in this menu are made, they are usually not changed very frequently. It is divided in to a simple menu that contains seven items, and a full menu that contains a further eight items.

CSM/Setup Menu

This option is used to determine whether the camera displays an abbreviated list of all the options available in both the Setup menu and the Custom Settings menu. (It does not affect the display of options in the other three camera menus, which are always shown in full, unless of course you have configured the menu display differently using the <My menu> option).

To select which options are displayed in the menu system:

- 1. Select <CSM/Setup> from the Setup menu.
- 2. Highlight <Simple> to display only the abbreviated form of the Setup and Custom Settings menu; <Full> to display all the options in all menus; or <My menu> to display only those menu items from the five main menus that you require the camera to show on the monitor screen.
- 3. Press the Simple> or <Full>.
- 4. If you select <My menu>, it is then necessary to select which menu items you require to be displayed. Highlight <My menu> and press the multi selector to the right to display a list of the five menus. Select a menu by highlighting it and pressing the button. A list of all items in the menu will be shown with a check box to the left of each one. Use the multi selector button to scroll through the menu items and press it to the right to select or deselect each item (a check mark is shown in the box for each item that is selected). Once you have finished making your selections for the menu, highlight <Done> and press the button to confirm them and return to the list of main menus. Repeat this process for each main menu. Finally, highlight <Done> in the list of main

menus and press the *button* to confirm the settings and return to the Setup menu.

Format Memory Card

A new memory card should always be formatted when it is first placed into the D80. It is also good practice to format any memory card whenever you insert it in to the camera. This is particularly important if you use your memory cards between different camera bodies.

To format a memory card:

- 1. Select <Format> from the Setup menu.
- 2. Select <Yes> or <No>.
- 3. Press the **DK** button to confirm your selection.

To prevent accidental deletion of image files, the <No> option is highlighted when the sub-menu of options is displayed. If you select <Yes>, the camera will display the following message on the monitor screen: "WARNING ALL IMAGES WILL BE DELETED OK?" During the formatting process "FOR-MATTING" will be displayed on the monitor screen.

Note: Make certain that the power to the camera is not interrupted during formatting. A loss of power could damage the card, so ensure the battery is fully charged, or use the optional EH-5 mains AC adapter.

Note: The D80 supports the SDHC version 2.00 standard, which allows it to use a memory cards with a capacity in excess of 2GB.

Note: The Nikon instruction states that formatting a memory card "permanently deletes all photographs and any other data the card may contain". This is not true; the formatting process actually only overwrites the file directory on the memory card, so that it is no longer possible to access any image files stored on it. If you should format a card inadvertently, it is often possible to recover the image files using appropriate data recovery software, provided no further data is written to the card.

Note: The most convenient way to format a card is to use the two-button method. Press and hold and to buttons until **[For**] appears, blinking, in the control panel screen. Then press and buttons again until **[For**] appears continuously in the frame count brackets.

World Time

World Time enables you to set and change the date and time recorded by the D80's internal clock, and also how it is displayed. Once you have selected <World Time> from the Setup menu, four options are displayed: <Time Zone>, <Date>, <Date Format>, and <Daylight Savings Time>. Each one requires the user to input information.

To set Time Zone:

- 1. Select <Time Zone> from the options list.
- 2. Scroll right or left through the world map using the multi selector button until the relevant time zone is high-lighted.
- 3. Press the **DK** button to select it.

To set Date:

- 1. Select <Date> from the options list.
- 2. Scroll through the settings by pressing the multi selector button to the left or right, and press it up or down to set each value for the date and time settings.
- 3. Press the Solution to confirm the date/time.

To set Date Format:

- 1. Select <Date Format> from the options list and press the multi selector button to the right.
- 2. Highlight the desired configuration for the date display.
- 3. Press the **OK** button to confirm the selection.

To set Daylight Savings Time:

- 1. Select <Daylight Saving Time> from the options list and press the multi selector button to the right.
- 2. Highlight either <ON> or <OFF>, depending on the time of year or location where the camera is to be used.
- 3. Press the **ov** button to confirm the selection.

LCD Brightness

The brightness of the LCD monitor on the back of the camera is set to a default value. However, this can be adjusted to help improve the visibility of any displayed image, or page of information. The feature can be particularly helpful when trying to review images in bright outdoor light.

To adjust LCD Brightness:

- 1. Select the <LCD Brightness> option from the Setup menu, and press the multi selector button to the right.
- 2. Adjust the brightness value press the multi selector button up or down.
- 3. Press the **D** button to set the brightness value you have chosen.

Note: A negative adjustment will darken the screen while a positive adjustment will brighten it. The screen displays a grayscale to help you judge the brightness effect on the full tonal range present in your images.

Note: I recommend you only use the image review function to check composition of the picture, and view the histogram display to make a broad assessment of overall exposure accuracy. Any attempt to judge color or tonal graduation is fruitless due to the limitations of the screen. It is better to judge the quality of the image on a computer monitor.

Video Mode

Video Mode allows you to select the type of signal used by any video equipment, such as a VCR or television, to which you may connect your camera. This should be set before connecting your camera to the device with the supplied A/V cord.

To set Video Mode:

- 1. Select <Video Mode> from the Setup menu, and press the multi selector button to the right.
- 2. Use the multi selector button to highlight either <NTSC> or <PAL>.
- 3. Press the **D** button to confirm your selection.

Language

The Language option on the D80 allows you to select one of 15 languages for the camera to use when displaying menus and messages.

To set the Language:

- 1. Select <Language> from the Setup menu and press the multi selector button to the right.
- 2. Highlight the desired language from the list displayed by pressing the multi selector button up or down.
- 3. Press the **b** button to confirm the selection.

USB

This menu item allows you to select the correct USB interface option for the type of operating system used by the computer the camera is connected to for image transfer from the camera using Nikon software, or controlling the camera using Nikon Camera Control Pro software.

Note: The selection for the USB option should be made before connecting your camera to your computer using the supplied USB cable.

To select USB:

- 1. Select <USB> from the Setup menu and press the multi selector button to the right.
- 2. Highlight either <Mass Storage> or <PTP> (Picture Transfer Protocol).
- 3. Press the or button to confirm the selection.
- Mass storage (default)—In this configuration, the D80 acts like a card reader and the computer sees the memory card in the camera as an external storage device; it only allows the computer to read the data on the memory card. Use this option if computer is running Windows 2000 Professional.
- **Picture Transfer Protocol (PTP)**—In this configuration the D80 acts like another device on a computer network and the computer can communicate and control camera

operations. Use this option if the computer is running, Windows XP (Home or Professional), or Macintosh OS X.

Note: If you use the <Mass Storage> option, ensure the camera is un-mounted from the computer system in accordance with the correct procedure for the operating system in use, before the camera is switched off and disconnected from the USB cord.

Note: You must select <PTP> to control the camera using the optional Nikon Camera Control Pro software. When Camera Control Pro software is running the camera will display "PC" in place of the number of exposures remaining.

Note: <Mass storage> can also be selected with Windows XP (Home or Professional), or Macintosh OS X.

Note: The following eight menu items will only be displayed if the <Full> option is selected under the <CSM/Setup menu> item, or they are included in the user defined <My menu> list (see pages 222-223).

Image Comment

The <Image Comment> feature in the Setup menu allows you to attach a short note or reference to an image file. Comments can be up to 36 characters long and may contain letters and/or numbers. Since the process requires each character to be input individually, this is not a feature you will use for each separate picture. However, as a way of assigning a general comment (e.g. the name of a location/venue/event) or identifying your pictures with a note as to their authorship or a copyright notice, it is a very useful feature.

Note: The keyboard used for inputting an <lmage Comment> is the same one used for file and folder naming.

To attach an Image Comment:

- 1. Select <Image Comment> from the Setup menu and press the multi selector button to the right.
- 2. Select <Input Comment> from the options list.
- 3. To enter your comment, highlight the character you wish to input by using the multi selector button and press the sutton to select it. If you accidentally enter the wrong character press the button to erase it. To move the cursor position, press and press the multi selector button in the required direction.
- 4. Press the button to save the comment and return to the <Image Comment> options list.
- 5. To actually attach the comment to your photographs, scroll down to the <Attach Comment> option and select <Set>. A small check mark will appear in the box to the left of the option. If you fail to select <Set> and place a check mark in the box, the image comment will not be attached to the image file.
- 6. Once you have completed this process highlight <Done>, and press the button to confirm the selection.

If you wish to exit this process at any time without changing an existing comment or attaching the comment, prior to step 5, simply press the work button.

When the check mark is present in the <Attach Comment> option in the <Image Comment> menu, the saved comment will be attached to all subsequent images shot on the camera. To prevent the comment from being attached to an image, simply return to the <Image Comment> menu and uncheck the <Attach Comment> box. The <Image Comment> will remain stored in the camera's memory and can be attached to future images by rechecking the <Attach Comment> box.

The first 13 characters of the comment will be displayed on the second page of the shooting information available via the <Image playback> option. The full comment can be viewed when using the supplied Picture Project software or Nikon Capture NX.

Folders

The D80 uses a folder system to organize images stoted on the memory card installed in the camera. The <Folders> option in the Setup menu allows you to select which folder the images you are currently recording will be saved in, and it enables you to create new folders.

If you do not use any of the options pertaining to folders, the D80 automatically creates a folder named "NCD80", where the first 999 pictures recorded are stored on the memory card. The folder will be assigned a three-digit prefix folder number, so the title of the default folder will be "100NCD80". When you exceed 999 pictures, the D80 creates a new folder named "101NCD80", and so on for each set of 999 pictures.

You can create your own folder(s); the folder title is always prefixed by a three digit number between 100 and 999, which can be assigned by the user. The suffix, NCD80, remains the same.

If you use multiple folders, you must select one as the active folder to which all images will be stored until an alternative folder is chosen, or the maximum capacity of 999 pictures in the active folder is exceeded. In this case, the D80 creates a new folder using the same five-character suffix and assigns a three-digit prefix with an incremental increase of one (e.g. if folder "100NCD80" is full the D80 creates folder "101NCD80" and pictures are now stored in this new folder).

Note: If the folder that has reached full capacity is folder number "999NCD80", the D80 disables the shutter release button and prevents you from making an exposure. You must create a new folder with a lower number, or choose another folder on the card that still has space to hold new images.

To create a new folder:

1. Select <Folders> from the Setup menu and press the multi selector button to the right.

- 2. Select <New> from the Folders options list.
- 3. Designate the number of the new folder by highlighting the required letter or number using the multi selector button until the number desired is displayed, and press
 to select it. Repeat up to four times to set the new folder name.
- 4. Press the **ov** button to confirm the new folder title.

To select an existing folder:

- 1. Select <Folders> from the Setup menu and press the multi selector button to the right.
- 2. Select <Select Folder> from the Folders options list and press the multi selector button to the right.
- 3. Highlight the folder you wish to use by pressing the multi selector button up or down.
- 4. Press the **OK** button to confirm the folder where the pictures will be stored, and return to the Setup menu.

Hint: Folders may be useful if you expect to take pictures of a variety of subjects (e.g. you go away on a touring vacation and want to file your images on the memory card(s) location-by-location. You can create a folder for each location and select this as the active folder accordingly).

Hint: Personally, I find using multiple folders time consuming, potentially confusing, and fraught with danger! If you have more than one Nikon digital camera and move cards between them, the individual cameras will not be able to handle images in folders created by another camera. If the second camera then creates a new folder, it will have a higher prefix number than the folder created by the first camera. Even multiple folders created by the D80 can present problems, as images will be saved to the currently selected folder with the highest prefix number. I would rather use a browser application such as PictureProject, Nikon Capture NX, or Nikon View Pro to browse and organize my images after they have been transferred to a computer.

File Number Sequence

The file names of all images you take with the D80 contain three letters, a four-digit number, and the three-letter file extension (.JPG or .NEF). The three letters shown in the name are DSC, and depending on the selected color mode, they have an underscore mark either as a prefix to denote Adobe RGB, or as a suffix to denote the sRGB color space (e.g. _DSC0001.JPG denotes a JPEG file, number 0001, saved in the Adobe RGB color space). The <File No. Sequence> option in the Setup menu allows the user to select whether file numbering is reset to 0001 whenever a new folder is created, the memory card is formatted in camera, or a new memory card is inserted.

To use File No. Sequence:

- 1. Select <File No Sequence> from the Setup menu and press the multi selector button to the right.
- 2. Highlight <Off> (default) to instruct the camera to reset the file number to 0001 whenever a new folder is created, the memory card is formatted in-camera, or a new memory card is inserted.
- 3. Select <On> to instruct the camera to continue numbering from the last number used after a new folder is created, the memory card is formatted in-camera, or a new memory card is inserted.
- 4. Select <Reset> to number the next image file 0001 and continue numbering as if the <On> option is selected (i.e. file numbering will run consecutively from the last number used after a new folder is created, the memory card is formatted in-camera, or a new memory card is inserted).
- 5. Press the or button to confirm the selection and return to the Setup menu.

Mirror Lock-Up

This feature in the Setup menu is for cleaning or inspecting the low pass filter. (It cannot be used to lock the reflex mirror in its raised position to reduce camera vibration while shooting.) It is essential that the power supply to the camera is not disconnected or interrupted in some way when the <Mirror Lock-up> function is active, particularly if you have any cleaning utensils in the camera at the time, as the reflex mirror will drop to its normal position with potentially dire consequences. Make sure the camera battery is fully charged, or use the optional EH-5 mains AC adapter.

Note: This option will not function if the battery charge indicator displayed in the control panel shows a level of three bars or less.

To use Mirror Lock-up:

- 1. Select <Mirror Lock-up> from the Setup menu and press the multi selector button to the right.
- 2. Highlight <On> and press the multi selector button to the right to select <Start>.
- (A message with instructions on how to proceed will be displayed on the monitor screen and a series of dashes will appear in the control panel.)
- 3. Press the shutter release button fully; the mirror lifts and the shutter opens. Proceed with any necessary inspection/cleaning.
- 4. To return the reflex mirror to its normal position, turn the power switch to OFF.
- 5. If you wish to cancel the function, select <OFF> at step 2, and press the button.

Note: Exceptional care should be taken whenever the Mirror Lock-up function is in use, as the low pass filter is exposed. There is an increased risk that unwanted material, such as dust or moisture, might enter the camera, so always keep the camera facing down. In this situation, gravity is your best friend or your worst enemy!

Dust Off Reference Photo

The <Dust Off Ref Photo> option on the D80 is specifically designed for use with the Image Dust Off function in Nikon Capture NX. The image file created by this function creates a mask that is electronically 'overlaid' on a NEF Raw file to

enable the software to reduce or remove the effects of shadows that are cast by dust particles on the surface of the low pass filter.

Note: This function can only be used with NEF Raw files. It is not available for JPEG files.

Note: To obtain a reference image for the Dust Off Ref Photo function, you must use a CPU-type lens, and Nikon recommends using a lens with a focal length of 50mm or more.

To use Dust Off Reference Photo:

- 1. Select <Dust Off Ref Photo> from the Setup menu and press the multi selector button to the right.
- 2. Highlight <On> and press the **D** button. A message instructing you to "Take a picture of a featureless white object 10cm from the lens. Focus will be set to infinity", is displayed in the monitor screen.
- 3. Point your camera at a well and evenly lit, white featureless subject approximately 4 inches (10 cm) from the front of the lens, ensuring the viewfinder frame is filled with it.
- 4. Press the shutter release button halfway; focus is automatically set to infinity. If you are in manual focus mode, set the lens to infinity focus.
- 5. Fully depress the shutter release button to acquire the Image Dust Off reference frame.

Note: If the lighting conditions for your subject are too bright or too dark, the camera will display the error message "EXPOSURE SETTINGS NOT APPROPRIATE" on the monitor screen. In these conditions it is not possible to complete the process, so it is necessary to increase or decrease the level of illumination or chose an alternative test target.

Once you have recorded the Dust Off Reference Photo it is displayed in the camera. It appears as a grid pattern with Image Dust Off Data shown within the image area. These files cannot be view using a computer. *Note:* You can identify the Dust Off Reference Photo file by its file extension, which is .NDF.

Battery Info

The EN-EL3e rechargeable battery has an electronic chip in its circuitry that allows the D80 to report detailed information regarding the status of the battery. To access this information, select <Battery Info> from the Setup menu, and three parameters concerning the battery will be displayed on the monitor screen (see the table below).

Parameter	Description
Bat. Meter	Current level of battery charge expressed as a percentage
Pic. Meter	Number of times the shutter has been released with the current battery since it was last charged. This number will include shutter release actions when no picture is recorded (e.g. to record an Image Dust Off reference frame, or measure color tempera- ture for a preset white balance value)
Charg. Life	Displays the condition of the battery as one of five levels (0 -4); level 0 indicates the battery is new, and level 4 indicates the bat- tery has reached the end of its charging life and should be replaced.

Note: If the MB-D80 battery pack is fitted to the D80 and has two EN-EL3e batteries inserted, the <Battery Info> display shows information for each battery separately; it is listed as L Slot for the battery in the left chamber, and R Slot for the battery in the right chamber. If AA sized batteries are inserted in the MS-D200 battery holder and it is used in the MB-D80, no information about the batteries is available.

Note: Batteries charged in low temperatures may report a reduced charging life. If in doubt, recharge the battery at normal room temperature (68°F, or 20°C) and check battery status again.

Firmware Version

When <Firmware Version> is selected from the Setup menu, the current version (A & B) of the firmware installed on the camera is displayed on the monitor screen. It is worthwhile checking periodically on the various Nikon technical support web sites to see if any firmware updates have been released for the D80. The initial firmware version issued for the D80 was A – 1.00 / B – 1.00.

Auto Image Rotation

The D80 automatically recognizes the orientation the camera is in as it records an image (i.e. horizontal, vertical rotated 90° clockwise, or vertical—rotated 90° counterclockwise). At its default setting, the camera stores this information so the image can be automatically rotated during image playback, or when viewing images on the computer with compatible software, such as Nikon Picture Project, or Nikon Capture NX.

How to set Auto Image Rotation:

- 1. Select <Auto Image Rotation> from the Setup menu and press the multi selector button to the right.
- 2. Highlight <On> (default) or <Off>.
- 3. Press the **b** button to confirm the selection.

Note: If you do not wish the camera to record its orientation, or if you shoot with the camera pointed up or down, which will usually render this feature unnecessary, select <Off>.

Note: The <Rotate Tall> option must be turned on in the Playback menu for the image to be viewed in the orientation in which it was originally taken.

Retouch Menu

This menu contains a range of items that, when applied, create copies of image files stored on the memory card in the camera. The options available enable you to create retouched (modified), trimmed (cropped), or resized versions of the original image file, which are then saved to the memory card.

Note: You can use the <My menu> option, selected under the <CSM/Setup menu> item, to select which of the Retouch menu items are displayed.

Note: With the exception of the options available in the <Small Picture> item, the other options in all the Retouch menu items can also be applied to a copy image created with the Retouch menu already saved to the memory card. However, this may result in a loss of image quality, depending on the option used, and each option can only be applied once.

Note: The following Retouch menu items are not available if the original image was recorded with the black-and-white option in the <Optimize image> menu: <D-Lighting>, <Red-eye correction>, <Monochrome>, and <Filter effects>.

Note: While I feel Nikon should be commended for including the options available in the Retouch menu, I believe it is important to put them in perspective. The items available in this menu cannot be considered anywhere near as sophisticated as their equivalents in any good digital imaging software applications. They are intended to provide a quick, convenient, and largely automated method of producing a modified version of the original image, without the need to use a computer. However, they offer an unprecedented level of control, using in-camera processing, to produce a finished picture direct from the camera.

Selecting Images

Images can be selected for processing by the items in the Retouch menu from either the full-frame playback of the image review function, or from the Retouch menu itself. To select and produce a copy of an image from the full-frame playback function, display the required image and open the Retouch menu by pressing the solution. Press the multi selector button up or down to highlight the required menu item, and then press it to the right to display any options within the selected item. Again, press the multi selector button up or down to highlight the required option, and press it to the right to apply the option. You can return to the full-frame playback mode, at anytime, without creating a copy image, by pressing the solution.

Note: It is not possible to use the <Image overlay> item during full-frame playback.

To select and produce a copy of an image directly from the Retouch menu, open the menu and highlight the required item by pressing the multi selector button up or down. Press the IN button to display up to six thumbnail images on the monitor screen. A yellow border frames the selected picture; press the multi selector button to the left or right to scroll through the pictures. To view an enlarged version of the selected picture press and hold the IN button. Once you have selected the picture to be modified and copied press the IN button. You can return to the fullframe playback mode, at anytime, without creating a copy image, by pressing the IN button.

Note: It is also possible to use the command dials to scroll through the images saved on the memory card; to scroll left or right rotate the main command dial in the same direction, to scroll up or down rotate the sub-command dial.

Image Quality and Size

The image quality and size of the copy image created by the Retouch menu will depend on the quality and size of the original image file(s), and the option within the Retouch menu that is used, as follows:

- Using the small picture option always creates a copy that is saved as a JPEG file at the Fine (1:4 compression ratio) guality level.
- Using the image overlay option always creates a copy that is saved at the image quality and size set currently on the camera, regardless of the fact that this option is only available with NEF Raw images (i.e. if you wish to save the copy image as a NEF Raw file ensure the image quality is set to NEF Raw before you apply this option).
- All other options in the Retouch menu copy NEF raw files and save them as a JPEG file at the Fine (1:4 compression ratio); unless noted otherwise below these copies produced from NEF Raw originals are sized to 3,872 x 2,592 pixels.

D-Lighting

The <D-Lighting> feature brightens shadow areas, to reveal more detail. It is not a simple global brightness control but its application is selective, and only affects the shadow areas of the recorded image. Highlight the option in the Retouch menu and press the Solution to display two thumbnail images, one unmodified and the other modified). You can select three levels of <D-Lighting>: moderate, normal, or enhanced, which increases the effect respectively. Once you have decided which level is most appropriate press the

ok button to apply it and create the copy image.

Red-Eye Correction

This option is only available with pictures taken using either the built-in, or an external Speedlight (if the option is graved out in the menu no flash was used for that exposure). First, examine the picture in full-frame play back mode and use

the Subtton to zoom in the image, and the Subtton to zoom out of the image. You can navigate around the image using the multi selector button (a navigation window is display while these buttons are pressed).

If you see red-eye in the image return to the full-frame playback by pressing the @ button. Then press the button to display the Retouch menu and highlight the <Red-eve correction> item. Press the button again; the D80 will then analyze the original image data and assess it for potential red-eye effect. If none is detected, a message to that effect is displayed and the fullframe Playback/Retouch menu display is restored. If the camera determines that red-eye is present, the camera creates a copy image using image data that is processed automatically to reduce the red-eye effect (since this is a completely automated process it is possible for the camera to apply the red-eve correction to areas of an image that are not affected by red-eve, which is why it is prudent to check the preview image before selecting this item).

Trim

This item enables you to crop the original image to exclude unwanted areas. The selected image is displayed along with a navigation window to show the location of the border that marks the crop area (you can navigate around the image using the multi selector button). As you use the and

buttons to zoom in and out of the full frame image the crop size is displayed in the top left corner of the image and shows the pixel dimensions (width x height) of the crop area. Once you have decided on the size and location of the crop area, press the button to create a cropped copy of the original picture and return to the full-frame playback, or Retouch menu display.

Monochrome

This item allows you to save the copied image in one of three monochrome effects: black-and-white (grayscale), sepia (brown tones), and cyanotype (blue tones). In all three cases the image data is converted to black and white using an algorithm dedicated to this feature (it is different to the algorithm used for the black-and-white options in the <Optimize Image> menu). Once converted to black-and-white the image data is still saved as an RGB file (i.e., it retains its color information). If you select either the sepia, or cyanotype options the appropriate color shift is applied after the copy picture is converted to black and white; you can press the multi selector button up to increase, or down to decrease the degree of color shift. Once you are satisfied with the preview image, which is displayed next to a thumbnail of the original for the purposes of comparison, you press the **OK** button to save the copy picture.

Filter Effects

The filter effects menu offer three options: two that emulate a skylight and color correction ("warm") filter respectively, as used for color photography, and a color balance option, which allows you adjust the amount or red, green, blue, and magenta in the image.

Open the Retouch menu and use the multi selector button to highlight Filter effects. Press the multi-selector button to the right to display the three options, highlight the required one and press the multi selector button to the right again. If you select either <Skylight> or <Warm tone>, a preview image is displayed. To apply the effect and save a copy image press the button.

- Skylight Nikon describe this option as providing a "cold" blue cast but in fact the effect is very subtle reducing the amount of red in the image by a modest amount.
- Warm tone This effect increases the amount of red in the image and produces a result similar to the use of a Wratten 81-series color correction filter. Again the effect is subtle and proper control of the white balance should obviate the need to use it.

Selecting the <Customize colors option causes a thumbnail image to be display alongside histograms for the red, green, and blue channels. Below the thumbnail is a color space map with a cross hair aligned on its center. You press the multi selector up to increase the level of green, and down to increase the level of magenta. Pressing to the left increases the level of blue and right to increase the level of red. The center point of the cross hair will shift accordingly, and the thumbnail image can be used to preview the effect. Once you are satisfied with the adjustment press the button to apply the color shift and save a copy of the image.

Hint: The color balance provides you with a two-dimensional CIE color space (a method of describing all possible colors that can be made by mixing red, green, and blue) to adjust to your requirements, and in my opinion is a far more useful and controllable method of modifying color in camera compared with the hue control option found in the custom option of the <Optimize Image> menu.

Small Picture

The <Small picture> item offers options to reduce the resolution of the original image to create a copy image that has a far smaller file size suited to specific use of the image.

The three size options are as follows:

- 640 x 480 pixels suitable for playback on a television set
- 320 x 240 pixels suitable for display on Web pages
- 160 x 120 pixels suitable for sending as an attachment to an e-mail

The selection of a picture for this item from the full-frame playback is as described above. However, the method of selecting a picture from the Retouch menu after choosing the small picture item differs from the method described previously. It is necessary to select the image size as the first step and then select the picture(s) to which the process is to be applied.

Open the Retouch menu and highlight the <Small picture> item. Press the multi selector button to the right to display two options: <Select picture> and <Choose size> (the latter is highlighted). Press the multi selector button to the right to display the three size options, and highlight the required size, before pressing the multi selector button to the right to confirm your choice and return to the previous page. Highlight the <Select picture> option and press the multi selector button to the right to display up to six thumbnail images. The currently selected image is shown framed by a vellow border. Use the multi selector button to highlight the required image (the yellow border will shift accordingly), and press the multi selector button up or down to select the image (a small icon appears in the top right corner of the thumbnail to indicate it has been selected). Once you have selected all the images to which the <Small picture> effect is to be applied press the **DK** button. A confirmation page will be displayed indicating how many images will be processed. Select either <Yes> to proceed with the process or <No> to return to the previous page. If you select <Yes>, press the or button to apply the effect and save the copy picture(s).

Note: Images saved using the Small picture item are displayed with a grey border during full-frame playback, and the zoom function is disabled

Image Overlay

<Image Overlay> is one of two methods available on the D80 that enable the user to combine multiple images. In the case of this feature it is limited to using a pair of NEF Raw files and combining them to form a single, new image (the original image files are not affected by this process). The images do not have to be taken in consecutive order but must have been recorded by a D80 and be stored on the same memory card. (See pages 136-137 for more details.)

Nikon Flach Photography

Before we take a look at the flash capabilities for the D80 it is important that you understand a couple of basic principles of flash photography. Light from a flash unit falls off, as it does from any other light source, by what is known as the Inverse Square Law. Put simply, if you double the distance from the light, its intensity drops by a factor of four. This is because as it travels, light spreads out, in this case, to an area four times the size. Since a flash unit emits a precise level of light, it will only light the subject correctly at a specific distance. This depends on the intensity of the light. If the flash correctly exposes the subject, anything closer to the flash will be overexposed, and anything further away will be increasingly underexposed. So, to produce a balanced exposure between the subject and its surroundings you need to balance the light from the flash with the ambient light in the scene.

When the D80 is used with a D or G-type Nikkor lens and its built-in Speedlight, or an external SB-400, SB-600 or SB-800 Speedlight, and the camera is set to Matrix metering, it will perform 3D Multi-sensor Automatic Balanced Fill-flash (i.e. the camera attempts to balance the ambient light to the flash output). The system used in the D80 is Nikon's third generation of TTL flash exposure control, which is known as i-TTL (intelligent TTL), and it represents Nikon's most sophisticated flash exposure control system to date. It is part of a wider set of flash features and functions that Nikon refer as the Creative Lighting System (CLS).

The i-TTL flash control used in the D80 is Nikon's most sophisticated flash system to date.

Note: Currently the internal Speedlight of the D200, D80, D70-series, D50, D40, and the SB-800, SB-600, SB-400, and SB-R200 external Speedlights are the only Nikon flash units to support CLS. If any other external Nikon Speedlight is attached to the D80 no form of TTL flash exposure control is supported.

The Creative Lighting System

During 2003 Nikon raised the bar a considerable distance for photography with portable, camera mounted, flash units by introducing the SB-800 Speedlight and D2H digital SLR camera-the first two components of their Creative Lighting System (CLS). The CLS encompasses a range of features and functions that are as much a part of the cameras that support it, such as the D80, as the Speedlight units themselves. These features include: i-TTL, Advanced Wireless Lighting that provides wireless control of control multiple Speedlights using i-TTL flash exposure control, Flash Value (FV) Lock, Flash Color Information Communication, Auto FP High-Speed Sync, and Wide-Area AF-Assist Illuminator. The CLS has expanded and, at present compatibility, extends to the D2-series, D200, D80, D70-series, D50, D40, and F6 cameras, with the SB-800, SB-600, SB-400, SB-R200 Speed-SU-800 Wireless Speedlight Commander, lights. and although the D70-series, D50, and D40 camera models do not support all of the features of the CLS.

i-TTL (Intelligent TTL) Flash Exposure Control

Intelligent TTL, or i-TTL, offers an enhanced and refined method of flash exposure control using only one or two preflash pulses that have a shorter duration and higher intensity than those used for the TTL and D-TTL methods performed by previous Nikon cameras and Speedlights. Currently, the D80 supports i-TTL with compatible Speedlights (its built-in Speedlight, SB-800, SB-600, SB-400 and SB-R200) at sensitivity settings between ISO 100 and ISO 1600. **Note:** Due to its design the SB-R200 cannot be mounted on the accessory shoe of a camera, It can be used only as a remote flash controlled, wirelessly, by either the SU-800 Commander unit, an SB-800 Speedlight, or the built-in Speedlight of the D200, D80, and D70-series camera models.

There are several key differences between the i-TTL system and the earlier TTL and D-TTL systems. In respect of the D80 these include:

- i-TTL uses fewer monitor pre-flashes but they have a higher intensity. The greater intensity of the pre-flash pulses improves the efficiency of obtaining a measurement from the TTL flash sensor, and by using fewer pulses the amount of time taken to perform the assessment is reduced.
- The D80 uses its 420-pixel RGB sensor to assess and control the output of flash, regardless of whether you use a single Speedlight attached to the camera (directly or via a dedicated TTL flash cord such as the SC-28), or multiple Speedlights in a wireless TTL configuration.
- Monitor pre-flashes are always emitted before the reflex mirror is raised regardless of whether the camera is used with a single, or multiple compatible Speedlights; if you look carefully you can often observe the pre-flash emission a fraction of a second before the viewfinder blacks out due to the reflex mirror being raised.

The following is a summary of the sequence of events used to calculate flash exposure in the D80, when used with one or more compatible Speedlights (the built-in unit, SB-800, SB-600, SB-400, or SB-R200) and a D, or G-type Nikkor lens:

- 1. Once the shutter release is pressed, the camera reads the focus distance from the D or G-type lens
- 2. The camera sends a signal to the Speedlight to initiate the pre-flash system, which then emits one or two pulses of light from the Speedlight(s).

- 3. The light from these pre flashes is bounced back from the scene, through the lens on to the 420-pixel RGB sensor housed in the camera's viewfinder head, via the reflex mirror.
- 4. The information from the pre-flash analysis is then combined with information from the 420-pixel sensor regarding the prevailing ambient light and focus information. The camera's microprocessors determine the amount of light required from the Speedlight(s) and set the duration of the flash discharge accordingly.
- 5. The reflex mirror lifts up out of the light path to the shutter, and the shutter opens.
- 6. The camera sends a signal to the Speedlight(s) to initiate the main flash discharge, which is quenched the instant the amount of light pre-determined in Step 4 has been emitted.
- 7. The shutter will close at the end of the predetermined shutter speed duration, and the reflex mirror returns to its normal position.

Note: The SB-400 does not support the Advanced Wireless Lighting system that provides wireless control of control multiple Speedlights using i-TTL flash exposure control

Flash Output Assessment

The crucial phase in the sequence described above is step 4, which is the point when the required output from the flash is calculated. I understand from the Nikon technicians and engineers to whom I have spoken that in addition to the amount of light detected by the 420-pixel RGB sensor, three distinct elements are considered during this process when the camera is in Matrix metering mode:

Brightness – In Matrix metering mode the camera will assess the overall level of brightness, using its 420-pixel RGB sensor.

The D80 is programmed to recognize patterns of light and dark when determining how to meter a scene.

Contrast – The camera compares the relative brightness of each pixel in its 420-pixel RGB sensor. The camera is preprogrammed to recognize specific patterns of light and dark across the metering segment array. For example, if outer segments record a high level of brightness and the central segment detects a lower level of brightness, this indicates a strongly backlit subject at the center of the frame.

The camera then compares the detected pattern with patterns pre-stored in its database of example exposures. If the first comparison generates conflicting assessments the segment pattern maybe re-configured and further analysis is performed. Finally, if any segment reports an abnormally high level of brightness in comparison to the others, which might occur if there is a highly reflective surface in part of the scene, such as glass or a mirror, the camera will usually ignore this information in its flash exposure calculations. **Focus Information** – Focus information is provided in two forms; camera-to-subject distance, and the level of focus/defocus at each focus sensor. Compatible cameras use both forms in tandem not only to assess how far away the subject is likely to be but also its approximate location within the frame area.

Generally the focus distance information will influence which segment(s) of the Matrix metering sensor affect the overall exposure calculations. For example, assuming the subject is positioned in the center of the frame and the lens is focused at a short range, the camera will place more emphasis on the outer metering segments and less on the central ones. An exception to this occurs if the camera detects a very high level of contrast between the central and outer sensors. In this case, it may reverse the emphasis and weight the exposure according to the information received from the central sensors. Conversely, if the subject is positioned in the center of the frame and the lens is focused at a mid-to-long range, the camera will place more emphasis on the central metering segments and less on the outer ones. Essentially, what the camera is trying to do in both cases is prevent over exposure of the subject, which it assumes is in the center or the frame.

Note: The focus distance information requires a D, or G-type lens to be mounted on the camera distance.

Individual focus sensor information is integrated with focus distance information, as each AF sensor is checked for its degree of focus. This provides the camera with information about the probable location of the subject within the frame area. Using the examples given in the previous paragraph, the camera notes that the central AF sensor has acquired focus while the outer AF sensors each report defocus. Therefore, exposure is calculated on the assumption that the subject is in the center of the frame and the camera biases its computations according to the focus distance information it receives from the lens, as described. It is important, however, to understand that other twists occur in this interaction between exposure calculation and focus information. For example, if you acquire and lock focus on a subject using the center AF sensor and then recompose the shot so that the subject is located elsewhere in the frame (so that the central AF sensor no longer detects focus), the camera will, generally, use the exposure value it calculated when it first acquired focus. However, if it detects that the level of brightness detected by the central metering segment has subsequently changed significantly from the point when focus was acquired with the subject in the center of the frame, the camera can, and often does, adjust its exposure calculations but not necessarily for the better!

Note: To help improve flash exposure accuracy in situations when the photographer wishes to recompose the picture after acquiring focus Nikon introduced the Flash Value (FV) lock feature on CLS compatible cameras (see below for a full description).

The Built-In Speedlight

The D80 has a built-in Speedlight (Nikon's proprietary name for a flash unit) that has an ISO 100 Guide Number of 42 in feet (13 meters). It can synchronize with the shutter at speeds up to 1/200 second (assuming that FP High-speed Sync mode is not selected). It has a minimum range of 2 feet (0.6 m) below which the camera will not necessarily calculate a correct flash exposure.

If the D80 determines that the ambient light level is low, or the subject is backlit strongly, the built-in Speedlight is raised automatically in the $\overset{\text{MB}}{\longrightarrow}$, $\overset{\text{MB}}{\swarrow}$, and $\overset{\text{MB}}{\Longrightarrow}$ Digital Vari-program modes. However, in P, S, A, and M exposure modes it must be activated manually by pressing the O button, which causes the flash head to lift.

The built-in Speedlight of the D80 has a Guide Number of 42/13 (ISO100, ft/m).

The built-in Speedlight draws its power from the camera's main battery so extended use of the flash will have a direct effect of battery life. As soon as the flash unit pops up it begins to charge. The flash ready symbol \clubsuit appears in the viewfinder to indicate charging is complete and the flash is ready to fire. If the flash fires at its maximum output the same flash ready symbol will flash for approximately three seconds after the exposure has been made, as a warning of potential under-exposure.

Note: The flash ready symbol operates in the same way when an external Speedlight is attached and switched on.

Note: The built-in Speedlight will only support FV Lock if the TTL option is selected at CS-22 <Built-in flash>.

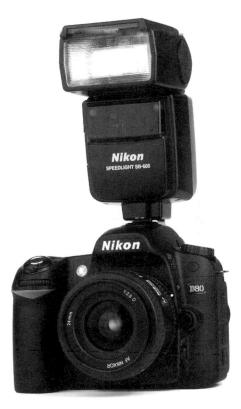

The D80 with SB-600 Speedlight.

Nikon External Speedlights

In addition to the built-in Speedlight the D80 offers full i-TTL flash exposure control with three external Speedlights that are compatible with the CLS:

- SB-400 ISO100 Guide number 69 in feet (21 m) at the 18mm
- SB-600 ISO100 Guide number 98 in feet (30 m) at the 35mm zoom head setting.
- SB-800 ISO100 Guide number 125 in feet (38) at the 35mm zoom head setting.

All three models can be attached to the camera directly, or via a dedicated TTL remote flash cord, such as the SC-28, or SC-29.

Note: The D80 does not support TTL flash exposure control with any other Nikon Speedlight designed to be attached to a camera's accessory shoe (hot-shoe).

Note: The SB-R200 can only be controlled as part of a wireless flash system.

SB-400

This lightweight 4.5 oz. (127 g) Speedlight is fully compatible with the i-TTL flash exposure control. It offers a fixed angle of coverage equivalent to a focal length of 18mm (when used on the D80 with its DX-format size sensor), and the flash head can be tilted in four positions; horizontal, 60, 75, and 90 degrees to facilitate bounce flash but there is no option to swivel the flash head.

Used with the D80 the SB-400 supports the following flash sync modes: Slow Sync, Red-eye reduction, Red-eye reduction with Slow-sync, Rear-curtain sync, plus additional support for FV Lock, and flash output compensation, all of which are set from the camera, but it is not compatible with manual flash exposure control.

SB-600 and SB-800

Apart from being more powerful, the SB-600 and SB-800 Speedlights are considerably more versatile than the D80's built-in flash or the SB-400. This is mainly because the flash heads on these two units can be tilted and swiveled for bounce flash. They also have an adjustable auto zoom-head (SB-800, 24-105mm) (SB-600, 24-85mm) that controls the angle-of-coverage of the flash beam, and a wide-angle diffuser for a focal length of 14mm.

Hint: Unlike earlier Nikon Speedlights, which cancelled monitor pre-flashes if the flash head was tilted or swiveled for bounce flash photography, the SB-800 and SB-600 emit pre-flashes regardless of the flash head orientation.

Hint: The focal lengths used by the SB-600 and SB-800 Speedlights in their zoom head assume the unit is attached to a film camera, and not a digital SLR, such as the D80 with its reduced angle-of-view due to the smaller sensor size. Therefore, the flash will be illuminating a greater area than is necessary when used on the D80, which means you will be restricting your shooting range and squandering flash power. Use the following table to maximize the performance of an external Speedlight:

Focal length of lens (mm)	Zoom head position (mm)
14	20
18	24
20	28
24	35
28	50
35	50
50	70
70	85
85	105 1

TTL Flash Modes (for Built-In and External Speedlights)

The D80 supports the following methods for i-TTL control flash exposure with either its built-in Speedlight, or a compatible external Speedlight.

• **i-TTL 3D Automatic Balanced Fill-flash** – The most sophisticated version of Nikon's i-TTL flash exposure control system, i-TTL is only available when a D or G-type lens is attached to the D80 camera body. The camera takes the following factors in to consideration when calculating the required flash output: focus distance

If you attach an autofocus lens other than D- or G-type to the D80, flash exposure control will default to Automatic Balanced Fill-flash.

information from the lens (hence the "3D" designation), information from the camera's TTL light metering system, and information based on the assessment of the monitor pre-flashes emitted immediately prior to the exposure. This system is particularly effective at detecting situations where the background is abnormally light (e.g. sky) or dark (e.g. dimly lit interior), or there are highly reflective surfaces in the scene (e.g. glass or a mirror), and generally does not consider them in flash exposure computations, since these would have an adverse affect on exposure accuracy.

 i-TTL Automatic Balanced Fill-flash – Essentially the same as 3D Multi-sensor Balance Fill-flash except focus distance information is not taken in to consideration during flash exposure calculations. The icons displayed on Nikon Speedlights to Indicate you are in either 3D Automatic Balanced Fill-flash, or Automatic Balanced Fill-flash are identical! The only way to determine which mode the camera/flash is using to calculate flash exposure is to be aware of which mode is supported by the camera with which lenses. For example, if you attach a non-D or non-G type autofocus lens to the D80, flash exposure control will default to Automatic Balanced Fill-flash.

• Standard i-TTL Flash – This differs from the automatic balanced flash control methods described above because the 420-pixel sensor exclusively determines the output of the flash. Any measurement of the ambient light performed by the camera's TTL metering system remains wholly independent; it is not integrated in any way with the flash exposure calculations.

Note: Standard i-TTL Flash has very important implications when mixing ambient light with light from a Speedlight for the fill-flash technique, as any compensation factor selected for either the ambient exposure, the flash exposure, or both will be applied at the level pre-determined by the photographer. In either of the Automatic Balanced Fill-flash options the camera can, and often does, override any flash output compensation applied, which make achieving consistent, repeatable results impossible (see below).

Note: Selecting Spot metering on the D80 will cause the flash exposure control to default to Standard i-TTL flash, which can also be selected on the SB-600 and SB-800 Speedlights; in all other situations the camera performs i-TTL automatic balanced fill-flash.

Understanding Nikon's Terminology

Many photographers fail to understand how their choice of exposure mode can affect the appearance of a photograph made with a mix of ambient light and flash. All too often they assume that because the camera is performing Automatic Balanced Fill-flash that both the subject and background will be rendered properly. Their frustration deepens when they realize that any exposure compensation factor that they apply on the camera, Speedlight, or both, is often either overridden or ignored completely!

So what is going on? The first clue to this conundrum is quite obvious – read the title again – Automatic Balanced Fill-flash.

The photographer is not the one in control here – it is the camera that is responsible for all exposure decisions in the Automatic Balanced Fill-flash options when the camera is set to any of the automatic exposure modes (P, A, and S), and all flash exposure decisions in the Balanced Fill-flash options when the camera is set to manual exposure mode.

Furthermore, if you select either Aperture-priority (A), or Programmed-automatic (P) exposure modes, the available shutter speed range is restricted to between 1/200 and 1/60 second. If the level of ambient light requires a shutter speed outside of this range, (as is usually the case when shooting in low-light conditions such as a dimly lit interior), the areas of the scene lit predominantly by ambient light will be underexposed.

Hint: If you use Aperture-priority (A) exposure mode habitually with flash consider setting Slow-sync flash mode (do not confuse this with Rear-sync mode) as it overrides this restriction on shutter speed range, and allows the full range of speeds available on the camera, between the maximum flash sync speed and the slowest shutter speed to be used, so areas lit by ambient light appear more balanced with those lit by flash.

Note: Alternatively, on the D80 it is possible to select the slowest shutter speed to be used with flash when the camera is set to either Aperture-priority (A) or Programmed-automatic (P) exposure modes; this option is found in the custom settings menu CS-24 <Flash shutter speed> (see pages 216-217).

me second clue is the word balanced," which means that the camera is attempting to combine the flash and ambient light to create roughly equal exposures from both. For example, a background lit by ambient light, and the subject in the foreground lit by the flash, are each exposed at a similar level. The camera achieves this, more often than not, by compensating the exposure for either the ambient light, the flash, or sometimes both. As mentioned above any exposure compensation factor applied by the photographer is frequently overridden or even ignored, because in all the Automatic Balanced Fill-flash options the camera and flash operate automatically, which makes consistent repeatable results difficult to accomplish.

The third part of this generic term Automatic Balanced Fill-flash just serves to confuse users even further! Fill-flash is a recognized lighting technique in which the flash is used to provide a supplementary light to the main ambient light source, and as such its output is always set at a level below that of the ambient light. Generally, the purpose of this fill light from the flash is to provide additional illumination in the shadows and other less well-lit areas of a scene to help reduce the overall contrast range, although many photographers also use the technique to put a small catch light in their subject's eyes.

Nikon's use of the term fill-flash is misleading on two counts in the context of the title Automatic Balanced Fillflash: first, depending on the prevailing light conditions, generally when the level of ambient light is very low, using one of the Automatic Balanced Fill-flash options will often cause the Speedlight to become the principal light source for illuminating the scene, and second, as discussed above balanced implies that the exposure for the ambient light and flash comprise equal proportions. **Note:** Whenever you see the term Automatic Balanced Fillflash remember that existing ambient light and flash will be mixed to produce the final exposure; how the two light sources are mixed and in what proportion will depend on the combination of camera, lens, exposure mode, and selected flash exposure control option. In my opinion a more accurate term for this system would be Automatic Balanced Flash.

The D80 lacks a standard PC flash sync terminal; the AS-15 adapter that attaches to the hot shoe provides one

Non-TTL Flash Modes (SB-800 Speedlight)

When using the SB-800 external Speedlight with the D80 there are two additional non-TTL flash modes available.

(AA) Auto Aperture – in this mode the SB-800 reads the sensitivity (ISO) setting and lens aperture from the D80 automatically, and receives the "fire flash" signal from the camera as well. It can be used in A and M exposure modes. When the flash is fired, the system uses a sensor on the front panel of the Speedlight to monitor the flash exposure and, as soon as this sensor detects that the flash output has been sufficient, the flash pulse is quenched. If, between exposures, you decide to alter the focal length or change the lens aperture the Speedlight will adjust its output accordingly to maintain a correct flash exposure. The problem with this option is that the sensor does not necessarily "see" the same scene as the lens, which can lead to inaccuracies in flash exposure.

(A) Automatic (non-TTL) – this is the only automatic (non-TTL) flash mode available with the earlier DX-type, and non-DX type Speedlights, as well as the SB-800. It can be used in A and M exposure modes. Similar to the AA mode, in this case, a sensor of the front of the SB-800 monitors flash levels and shuts of the flash when the Speedlight calculates sufficient light has been emitted. However, the lens aperture and sensitivity (ISO) values must be set manually on the Speedlight to ensure the subject is within the flash shooting range. As with the AA mode the sensor does not necessarily "see" the same scene as the lens, which can lead to inaccuracies in flash exposure.

Manual Flash Mode (Built-In Speedlight)

In Manual flash mode the user sets the output of the Speedlight (built-in or external) to a fixed level. It is necessary to calculate the correct lens aperture as determined by the flash to subject distance and the Guide Number (GN) of the Speedlight.

At ISO100, the built-in Speedlight of the D80 has a Guide Number (GN) of 42 in feet (13 m). The output level of the built-in Speedlight is determined by CS-22, where a value between 1/1 and 1/128 can be selected (available in P,S, A, and M exposure modes only).

Since there is only one specific exposure value for any given level of sensitivity at a particular flash-to-subject distance, you must calculate the lens aperture for proper exposure. Use the following equation:

Aperture = GN / Distance

So, for example, using the built-in Speedlight of the D80 set to its full output (1/1), at a shooting distance of exactly 7.5 ft (2.286 m), the lens aperture for a correct exposure of the subject will be f/5.6. (5.6 = 42/7.5). In meters this would be calculated (5.6 = 13/2.286).

Note: Similar calculations will have to be performed when using an external Speedlight in Manual flash mode. Check the Guide Number for the Speedlight model and be sure that you are using the same unit of distance throughout.

Repeating Flash (Built-In Speedlight)

This mode is accessed via CS-22 <Built-in Flash>. The flash will fire repeatedly while the shutter is open to produce a strobe-lighting effect.

Press the multi selector button left or right to select one of the three values that must be set, and press it up or down to select the required value. Press **or** to return to the Custom Setting menu once all the required settings have been made.

Option	Description
Output	Select the required flash output (it is expressed as a fraction of the maximum output)
Times	Select the number of times the flash will fire at the selected output level. Depending on the shutter speed used, and the frequency selected at the Interval option, the number of frames may be less than selected.
Freq.	Select the frequency at which the flash fires (per second – Hz)

Output	Times (Number of times the flash will tire,
1/4	2
1/8	2-5
1/16	2-10
1/32	2-10, 15
1/64	2-10, 15, 20, 25
1/128	2-10. 15. 20. 25, 30, 35

Flash Sync Modes

Not to be confused with Flash Modes available with the D80 (described above), the Flash Sync (synchronization) Modes determine when the flash is fired and how it combines with the shutter speed. These apply to the built-in Speedlight, and the external Speedlights.

To set a flash sync mode on the D80 press and hold the button, and rotate the main command dial to scroll through the various options until the icon for the required flash sync mode appears in the control panel.

Flash Synchronization in P, S, A, and M Exposure Modes

4 Front-curtain sync – The flash fires as soon as the shutter has fully opened. In P and A exposure modes this will be combined with a shutter speed between 1/60 and 1/200 second, unless a lower speed has been selected via CS-24 (Flash Shutter Speed). In S and M exposure modes the Speedlight synchronizes at shutter speed between 30 seconds and 1/200 second.

4 () Front-curtain sync with red-eye reduction – The D80's AF-assist lamp on the front right side of the camera body lights for approximately one second before the main exposure in an effort to reduce the size of a subject's pupils. Shutter speed synchronization is the same as for Front –curtain sync. The D80 offers a range of flash sync modes when used with an external Nikon Speedlight, such as the SB-600.

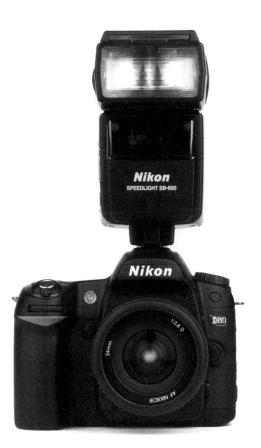

Hint: This mode creates a delay in the firing of the shutter, by which time the critical moment has often passed and you have missed the shot! Personally, I never bother with this feature.

SLOW Slow-sync – Only available in P and A exposure modes, the flash fires as soon as the shutter has fully opened at all shutter speeds between 30 seconds and 1/200 second. It is useful for recording low-level ambient light as well as those areas of the scene or subject illuminated by flash.

SLOW () Slow sync with red eye reduction Thin is the same as Slow-sync mode except the Red-eye reduction lamp is fired for approximately one second before the shutter opens as stated above under Red-eye reduction.

Hint: The same advice applies – avoid this mode!

REAR Rear-curtain – In S and M exposure modes, the flash fires just before the shutter closes at all shutter speeds between 30 seconds and 1/200 second. An image of a moving subject recorded by the ambient light exposure will appear to be behind the parts of the subject illuminated by the flash output, giving the photo a natural appearance.

SLOW REAR Slow rear-curtain sync – In P and A exposure modes, the flash fires just before the shutter closes at all shutter speeds between 30 seconds and 1/200 second. Any image of a moving subject recorded by ambient the ambient light exposure will appear to be behind the parts of the subject illuminated by the flash output.

Flash Synchronization with Digital Vari-Program Modes

As stated above, to set a flash sync mode on the D80 press and hold the \bigcirc button, and rotate the main command dial to scroll through the various options until the icon for the required flash sync mode appears in the control panel.

Using the built-in flash with the 🍟 , 💈 , ♥ , and ☑ Digital Vari-program modes provides the following flash sync modes:

4 AUTO Auto Flash – In $\stackrel{\text{AUT}}{\sim}$, $\stackrel{\text{auto}}{\sim}$, $\stackrel{\text{auto}}{\sim}$ modes only. The flash fires as soon as the shutter has fully opened; the camera selects a shutter speed between 1/60 and 1/200 second (1/125 – 1/200 second in $\stackrel{\text{auto}}{\sim}$ mode), automatically.

 effort to reduce the size of a subject's pupils. Shutter speed synchronization is the same as for Auto flash sync.

4 AUTO SLOW Auto Flash with Slow-sync – In mode only. The flash fires as soon as the shutter has fully opened; the camera selects a shutter speed between 1 second and 1/200 second, automatically.

4 AUTO SLOW **()** Auto Flash with Slow-sync and red-eye reduction – In **(2)** only. The D80 uses the AF-assist lamp on the front right side of the camera body to light for approximately one second before the main exposure in an effort to reduce the size of a subject's pupils. Shutter speed synchronization is the same as for Auto flash with Slow-sync.

• **Flash off** – the flash will not operate even if the camera detects the ambient light has a low level, or the subject is backlit.

Note: If you attach an external Speedlight to the D80 when the camera is set to any of the Digital Vari-program mode options, except the mode, the only flash sync modes available are front curtain sync or front curtain sync with red-eye reduction. If mode is selected, the only flash sync modes available are slow-sync or slow-sync with redeye reduction.

Slow Synchronization Flash

Attaching a Speedlight directly to the accessory shoe, or via a dedicated TTL flash cord such as the SC-17 or SC-28, to the D80 when the camera is used in either Programmed automatic, or Aperture-priority automatic exposure mode will cause the camera to set a shutter speed in the range of 1/60 to 1/200 second, depending on the level of ambient light (the brighter the conditions the shorter the shutter speed that is chosen within this narrow range), as soon as you switch the Speedlight to ON.

Use slow-sync flash mode to add creative motion blur to your flash photos.

The restriction imposed on the range of available of shutter speeds when using flash in P and A modes can have a significant affect on the overall exposure. For example, in situations when you photograph a subject outside at night, or in a dark interior, any area of the scene that will be illuminated by ambient light alone will be lit dimly compared with those areas that will be illuminated by the flash. It is more than likely that the level of ambient light will not be sufficient for a proper exposure with this restricted range of shutter speeds. Consequently, these areas of the scene will be underexposed. A typical photograph taken under these conditions has a well-exposed subject set against a very dark, featureless background. To prevent this, select **SLOW** Slow-synchronization flash mode (abbreviated to Slow-sync), which enables the camera to use all shutter speeds below 1/60 second to the longest shutter speed available on the camera, 30 seconds. (To set a flash sync mode on the D80 press and hold the O button, and rotate the main command dial to scroll through the various options until the icon for the required flash sync mode appears in the control panel.)

With Slow-sync activated, the camera will be able to select an appropriate shutter speed for the low level ambient light, so the correct exposure can be achieved for the background (remember the flash output will have little if any effect in this region as the intensity of light from the flash will diminish according to the inverse square law), and the flash output will be controlled for a proper exposure of the subject and foreground.

Flash Exposure Compensation

In P, S, A, and M exposure modes flash output compensation can be set on the D80 by pressing and holding the ● button whilst turning the sub-command dial. Compensation can be set in increments of either 1/3EV, 1/2EV (subject to the setting at CS-10 EV Step) over a range of +1 to -3EV (stops).

Hint: If you use the default i-TTL Balanced Fill-flash mode it will automatically set a flash compensation based on scene brightness, contrast, focus distance, and a variety of other factors. The level of automatic adjustment applied by the D80 will often cancel out any compensation factor entered manually by the user. Since there is no way of telling what the camera is doing you will never have control of the flash exposure. To regain control set the flash mode to Standard i-TTL by selecting spot metering when using the built-in or an external Speedlight, or selecting Standard i-TTL mode directly on an external Speedlight.

Flash Value (FV) Lock

Flash Value (FV) Lock allows you to use the camera and Speedlight to estimate the required flash output for a subject and then retain this value temporarily, before making the main exposure (only available in P,S, A, and M exposure modes). This is a very useful feature if your want to compose so that the main subject is located toward the edge of the frame area, particularly if the background is very bright or dark. Under these circumstances, using TTL, D-TTL and normal i-TTL flash modes, there is a risk that the camera may calculate an incorrect level of flash output, and cause the main subject to be either under, or over exposed.

On the D80 the EV lock feature must first be activated via the CS-16 FUNC button: select the <FV Lock> option (see pages 208-210). Activate the built-in flash by pressing the button. A two-stage process follows that requires you Ð to compose the picture, initially with the main subject in the center of the viewfinder area, acquire focus by half-depressing the shutter release, before pressing the FUNC button on the camera. This causes the pre-flash pulses to be emitted by the Speedlight, which are used to assess the required amount of flash output. The camera stores the required output value of the flash and the FV lock warning + L θ appears in the viewfinder, as a reminder that the function is active. Now you can recompose the picture and make the exposure by fully depressing the shutter release button. The flash will fire at the predetermined level. If you alter the focal length of a zoom lens, or adjust the lens aperture, the FV function will compensate the flash output automatically.

Note: FV lock is available on the D80 in the following flash modes: i-TTL, or Commander Mode, set via CS-22. Using the SB-800 FV Lock can also function in Auto Aperture (AA) and non-TTL (A) automatic flash modes.

Note: The camera-to-subject distance must not change during the use of the FV lock function otherwise the flash exposure may be inaccurate.

Flash Color Information Communication

Used with D80, the built-in Speedlight, and external SB-800 and SB-600 Speedlights automatically transmit information about the color temperature of the light they emit to the camera. Provided the camera is set to Automatic white balance control it will then use this information to adjust its final white balance setting in an attempt to match the color temperature of the flash output.

Note: This function only operates when Auto white balance has been selected and set on the camera.

The Auto FP High-speed sync mode enables the camera to synchronize with an external Speedlight such as the SB-600, at all shutter speeds up to 1/4000 second.

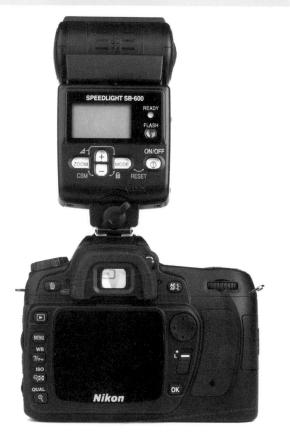

Auto FP High-Speed Sync

Available with the SB-800, SB-600, and SB-600 Speedlights, this feature is set from the D80, via CS-25 (Auto FP).

One of the limitations of using daylight fill-flash is the maximum flash sync speed of the camera, which is limited to 1/200 second. When working in bright lighting conditions it is often not possible to open the lens aperture very far, due to the restriction of the maximum shutter speed imposed by the use of flash. The Auto FP High-Speed Sync function, allows you to use the full range of high shutter speeds available on camera whilst adjusting the flash output automatically, which makes using fillflash far more flexible. To achieve this the flash emits a very rapid series of pulses instead of a single continuous pulse but the downside is that at shutter speeds above the normal maximum sync speed flash output is reduced significantly, which reduces the operational range of the Speedlight.

Wide-Area AF-Assist Illuminator

The purpose of the AF-assist lamp built-in to the SB-600 and SB-800 is to facilitate autofocus in low light situations. With these two units the illumination from the lamp covers a much wider area compared with previous Speedlights. This is particularly useful with cameras such as the D80, with is array of eleven AF-sensor areas, which covers a greater proportion of the frame area.

. The effective range of the wide-area AF-assist lamp varies according to the focal length of the lens in use and the location within the viewfinder area of the selected AF sensor. For example, using a 50mm lens and AF sensor areas in the central portion of the viewfinder area the effective range of the lamp is between 1 m and 10 m but this is reduced at shorter focal lengths. Shooting with a 50mm lens and AF sensor areas at the periphery of the viewfinder area the effective range is reduced to between 1 m and 7 m, but again, this is reduced at shorter focal lengths.

Note: Wide-Area AF-Assist Illuminator feature requires an AF lens to be mounted and the camera to be set to Single-servo AF with focus priority selected.

Note: The AF-assist function can be used in isolation on the SB-800 by selecting Cancel for the flash FIRE option in the custom setting on the Speedlight.

Shutter Speeds Available with the Built-In Flash

In P and A exposure modes the slowest shutter speed at which the flash will be used can be set using CS-24 (Flash Shutter Speed). The flash will fire at shutter speeds as slow as 30 seconds if Slow-sync is selected.

1/200 - 1/60s
1/200 – 1/125s
1/200 – 1s
1/200 – 1/30s

slow sync.

Flash Range, Aperture, and Sensitivity (ISO)

The flash shooting range will vary depending on the values set for the lens aperture and sensitivity (ISO).

	Aperture at ISO equivalent of										Range			
100	125	160	200	250	320	400	500	640	800	1000	1200	1600	m	ft.
1.4	1.6	1.8	2	2.2	2.5	2.8	3.2	3.5	4	4.5	5	5.6	1.0-9.2	3 ft. 3 in30 ft. 2in.
2	2.2	2.5	2.8	3.2	3.5	4	4.5	5	5.6	6.3	7.1	8	0.7-6.5	2 ft. 4 in21 ft. 4in.
2.8	3.2	3.5	4	4.5	5	5.6	6.3	7.1	8	9	10	11	0.6-4.6	2 ft15 ft. 1in.
4	4.5	5	5.6	6.3	7.1	8	9	10	11	13	14	16	0.6-3.2	2 ft10 ft. 6in.
5.6	6.3	7.1	8	9	10	11	13	14	16	18	20	22	0.6-2.3	2 ft7 ft. 7in.
7	9	10	11	13	14	16	18	20	22	25	29	32	0.6-1.6	2 ft5 ft. 3in.
11	13	14	16	18	20	22	25	29	32	-	-	-	0.6-1.1	2 ft3 ft. 7in.
16	18	20	22	25	29	32					_		0.6-0.8	2 ft2 ft. 7in.

Maximum Aperture Limitations

In P (programmed auto) exposure mode, the maximum aperture (smallest f/number) is limited according to the sensitivity (ISO).

	Maximum aperture at ISO sensitivity of												
Mode	100	125	160	200	250	320	400	500	640	800	1000	1250	1600
P, 10, 2,	4	4.2	4.5	4.8	5	5.3	5.6	6	6.3	6.7	7.1	7.6	8
	5.6	6	6.3	6.7	7.1	7.6	8	8.5	9	9.5	10	11	11

Limitations of the Built-In Speedlight

While the built-in Speedlight of the D80 is not as powerful as an external Speedlight it can still provide a useful level of illumination at short ranges, especially for the purpose of fill-flash, since it supports flash output level compensation. However, if you want to use this built-in Speedlights as the main light source you should be aware of the following:

- The built-in Speedlight of the D80 has an ISO 100 Guide Number (GN) of 42 in feet (13 m), so at an aperture of f/5.6 this unit provides its full output at a range of a little less than just 7.5 ft (2.2 m). (The maximum flash shooting distance is equal to the GN divided by the lens aperture.)
- The proximity of the flash head of the built-in Speedlights is much closer to the central lens axis compared with an external flash; hence the likelihood of red-eye occurring is increased significantly.
- Again, the proximity of the built-in Speedlight to the central lens axis often means that the lens obscures the output of the flash, especially if a lens hood is fitted. If the camera is held in a horizontal orientation the obstruction of the light from the flash will cause a shadow to appear on the bottom edge of the picture.
- The angle of coverage achieved by the built-in Speedlight is limited, and only extends to cover the field of view of a 18mm lens. Using of a shorter focal length, the flash will not be able to illuminate the corners of the frame

and these areas will appear underexposed. Even at the widest limit of coverage it is not uncommon to see a slight fall off of illumination in the extreme corners of the full frame.

Note: Any flash unit places a high demand on the batteries used to power it; the built-in Speedlight draws its power from the camera's battery, so extended use will exhaust the battery quite quickly.

Lens Compatibility with the Built-In Speedlight

Due to the proximity of the built-in Speedlight to the central lens axis, when the lenses mentioned in the table below are used at the focal lengths and shooting ranges given, there is a possibility that they will obscure some light from the flash, and cause uneven exposure.

Lens	Zoom position	Mm. range
AF-S DX ED 12-24mm f/4G	20mm 24mm	2.0m/6ft. 7in. 1.0m/3ft. 3in.
AF-S ED 17-35 mm f/2.8D	24mm 28 mm, 35 mm	2.0m/6ft. 7in. 1.0m/3ft. 3in.
AF-S DX IF ED 17-55 mm f/2.8G	28 mm	1.5m/4ft. 11in.
	35 mm	1.0m/3ft. 3in.
AF ED 18-35 mm f/3.5-4.5D	24mm	1.0m/3ft. 3in.
AF 20-35 mm f/2.8D	20 mm 24mm	1.5m/4ft. 11in. 1.0m/3ft. 3in.
AF-S DX ED 18-70 mm f/3.5-4.5G	18 mm	1.0m/3ft. 3in.
AF-S DX ED 18-135 nim f/3.5-5.6G	18 mm	1.5m/4ft. 11in.
AF-S DX VR ED 18-200 mm f/3.5-5.6G	24 mm, 35 mm	1.0m/3ft. 3in.
AF-S ED 28-70 mm f/2.8D	35 mm 50 mm	1.5m/4ft. 11in. 1.0m/3ft. 3in.
AF-S VR ED 24-120 mm f/3.5-5.6G	24mm	1.0m/3ft. 3in.
AF-S VR ED 200-400 mm f/4G	200 mm 250 mm, 300 mm	3.0m/9ft. 10in. 2.5m/8ft. 2in.

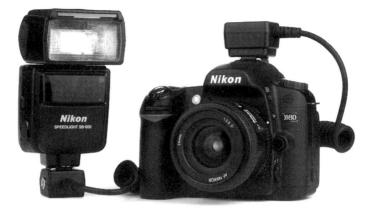

The SC-28 TTL flash cord allows you to take an external Speedlight off-camera but retain full control.

Using a Single Speedlight Off-Camera

When you work with a single external Speedlight it is often desirable to take the flash off the camera. Nikon produces a number of dedicated TTL cords for this purpose: the SC-17, SC-28, and SC-29. All three cords are 4.9 feet (1.5m) long: up to three, SC-17, or SC-28 cords can be connected together to extend the operating range away from the camera.

The benefits of taking a Speedlight off camera include:

- Increasing the angle between the central axis of the lens and the line between the flash head and a subject's eyes. This will reduce, significantly, the risk of the red-eye effect with humans or eye-shine with animals.
- In situations when it is not practicable to use bounce flash, moving the flash off camera will usually improve the quality of the lighting. This is especially true for the

degree of modeling it provides, compared with the rather flat, frontal lighting produced by a flash close to the central lens axis of the lens.

- By taking the flash off camera, and directing the light from the Speedlight accordingly, it is often possible to control the position of shadows so that they become less distracting.
- When using fill-flash it is often desirable to direct light to a specific part of the scene to help reduce the level of contrast locally.

Hint: Whenever you take a Speedlight off camera and use any flash mode that incorporates focus distance information in the flash output computations, take care as to where you position the flash. If the Speedlight is moved closer or further away by a significant amount (compared with the camera-to-subject distance), the accuracy of the flash output may be compromised, as the TTL flash control system works on the assumption that the flash is located at the same distance from the subject as the camera.

Note: Compatible with either the SB-800 or SB-600 Speedlights, the SC-29 has a built-in AF-assist lamp built-in its terminal block that attaches to the camera accessory shoe. Using this to position an AF-assist lamp immediately above the central axis of the lens can help improve the accuracy of autofocus compared with using the AF-assist lamp built-in to the Speedlight when it is used off the camera. This is because the light emitted by the Speedlight's AF-assist lamp may not be reflected properly or with sufficient strength if it strikes the subject at an oblique angle.

Note: A Speedlight connected to the camera via one of Nikon's dedicated TTL cords can be used as the master flash to control multiple Speedlights off camera, using the Advanced Wireless Lighting system (see below).

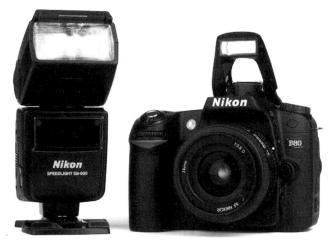

Used as a master or commander unit, the built-in Speedlight of the D80 can control two independent groups of remote flash units.

D80 Built-In Speedlight (Commander Mode)

In addition to its own output for flash photography the built-in Speedlight of the D80 camera can be set to control one or more remote Speedlights, wirelessly, in P, A, S, and M exposure modes; this feature is compatible with the SB-800, SB-600, and SB-R200. The remote Speedlights can be controlled in a variety of flash modes: TTL, Auto Aperture (for use with remote SB-800 Speedlights only), or Manual. Control is limited to two groups; group A and B, using any one of four channels (1 to 4).

To use the built-in Speedlight of the Nikon D80 camera as a master flash:

- 1. Open the Custom Setting menu and navigate to CS-22 <Built-in flash>.
- 2. Highlight the <Commander Mode> option and press the multi selector button to the right to open a sub-menu of flash mode, flash output level, and control channel options.

- 3. Highlight <Built-in / Mode> to set the required flash mode and use the multi selector button to select <TTL>, <M>, or < - -> (flash cancelled). If <TTL>, or <M> is selected press the multi selector button to the right to highlight <Comp.> (flash output level compensation) and use it to select the required value. Press the multi selector button to the right to set and confirm the value, and highlight <Group A / Mode>.
- 4. Set the required flash mode for group A by using the multi selector button to select <TTL>, <AA> (SB-800 only), <M>, or < -> (flash cancelled). If <TTL>, <AA>, or <M> is selected, and you want to set a flash output compensation level repeat the procedure from Step 3, otherwise press the multi-selector switch to the right to highlight <Group B / Mode>. Repeat Steps 3 and 4 to set flash mode and flash exposure compensation.
- 5. Highlight <Channel> and use the up and down buttons on the multi-selector switch to select the required channel number.
- 6. Finally, press the **OK** button to confirm and lock the settings made in Steps 3 5 above.
- 7. Check that the remote Speedlight(s) are set to operate in the remote flash mode, and that the ready light is lit. The system is now ready to be used.

Effective Range of the Advanced Wireless Lighting System

When the following units are used as the master flash or commander unit, when the flash is only used to emit the control signals to the remote flash units and does not contribute to the flash exposure, for wireless control of compatible remote Speedlights (SB-800, SB-600, and SB-R200) the effective range of operation is:

- **SB-800** When the SB-800 is used as a master flash Nikon states that the maximum effective operating range between it and the remote Speedlights is 33 ft (10 m) along the central axis of the lens, and 16 ft (5 m) to 23 ft (7 m) within 30° of the central axis of the lens.
- **SU-800** The SU-800 is a dedicated IR transmitter (i.e. unlike the SB-800 and built-in Speedlights that emit the control signals as part of a full spectrum emission when used as a master flash, the SU-800 only emits IR light). It is a more powerful unit compared with the Speedlights that can perform the master flash role, and as such Nikon state that it is capable of controlling remote SB-800 and SB-600 Speedlights up to a maximum range of 66 ft (20 m).
- **SU-800** / **SB-R200** When the SU-800 is used as the commander unit Nikon state that the maximum effective operating range between it and remote SB-R200 Speedlights is 13 ft (4 m) along the central axis of the lens, and 9.8 ft (3 m) within 30° of the central axis of the lens.
- **D80 Built-in Speedlight** The built-in Speedlight of the D80 camera used as the master flash can control remote Speedlights placed within 30° of the central axis of the lens up to a maximum range of 33 ft (10 m), between 30° and 60° from the central axis of the lens the maximum range is 16 ft (5 m)

Note: I have found Nikon's quoted maximum operating ranges for the components of the Advanced Wireless Lighting system to be very conservative. For example, I have used SB-800 Speedlights as master and remote units at ranges outdoors of 100 ft (30 m) or more, particularly in situations where there have been reflective surfaces such as walls and follage close by. This is three times greater than Nikon's suggested maximum range. However, in bright sunlight, which will contain a high level of naturally occurring IR light you may find the practical limit of the operating range is reduced.

Note: Nikon states that communication between the master and remote flash units cannot be performed properly if there is an obstruction between them. In practice I have used remote flash units very successfully without line-of-sight between the master flash and the sensor on the remote Speedlight(s). However, every shooting situation is different, so my advice is to set up the lighting system to your requirements and always take test shots to ensure it works as you intended. If not, adjust the location of the remote Speedlights.

Note: For full details of Nikon's contemporary flash system, see my book The Nikon AF Speedlight Flash System: Master the Creative Lighting System (ISBN:1-57990-588-9), published by Lark Books, as part of the Magic Lantern Guide series.

Nikon Lenses and Accessories

Nikon's F mount for Nikkor lenses is legendary, and has been used on all 35mm film and digital SLR cameras, virtually unchanged, since the introduction of the original Nikon F camera in 1959. Consequently, a great many of the lenses produced by Nikon over four decades can be mounted on the D80. However, the level of compatibility is restricted severely if a non-CPU type lens (see definition below) is attached to the camera.

DX-Format Sensor

All Nikon digital SLR cameras produced to date have the same size sensor, which Nikon calls the DX-format (also referred to as an APS-C sized sensor). At 15.6 x 23.7mm it is smaller than a 35mm film frame, which reduces the field-of-view seen by the D80 by about 1.5x compared with that seen by 35mm film camera.

This diagram represents the total area covered by the image circle projected from anv 35mm format lens. The pale grey rectangle represents the image area of the 35mm film frame (24 x 36 mm), and the dark grey rectangle represents the area covered by the DX-format (15.6 x 23.7 mm) sensor used in the D80. (Diagram not shown to scale.)

Many older Nikon lenses can be used with the D80, though compatibility is limited with non-CPU type lenses.

However, marketing people do not like to talk in terms of negative aspects; they much prefer positives! Hence, advertisement copyrighters' hype such as "it's like getting a free 1.4x teleconverter", or "the 1.5x magnification of focal length", has instilled a notion, that still persists even among those who should know better, that the focal length of a 35mm format lens increases by 1.5x in some way, as if by magic, when attached to a DX-format Nikon digital SLR camera such as the D80. Wrong - a 300mm lens on a Nikon 35mm film camera is still a 300mm lens on the D80—no ifs, no buts! Furthermore, a teleconverter generally reduces image sharpness and contrast but since no extra glass is required to achieve the magnified image recorded by the D80 these issues are irrelevant.

What changes is the field-of-view, which is decreased (there's that negative aspect!), in other words the view seen through the camera with a DX-format sensor becomes narrower. Consequently, a 35mm lens on the D80 "sees" a field-of-view equivalent to a focal length about 1.5x greater (the actual factor is closer to 1.52x). If you where to shoot two pictures, one on a D80 and the other on a Nikon 35mm film body, mounted side-by-side pointing at exactly the same scene with the same focal length lens, and then cropped the film image to the same area as the sensor in the D80 you would end up with identical pictures.

The following table gives the approximate effective focal length equivalent for a lens used with a 35mm format camera when the same focal length is used with the D80:

Focal length with 35mm format	12	14	17	18	20	24	28	35	50	60
Effective focal length – DX-format	18	21	25.5	27	30	36	42	52.5	75	90

Focal length with 35mm format	70	85	105	135				400	500	600
Effective focal length – DX-format	105	127.5	157.5	202.5	270	300	450	600	750	900

Choosing a Lens

There is a beneficial side effect of this reduced angle-ofview. Since the sensor of the D80 is only using the central portion of the total image projected by those lenses designed for 35mm format film cameras the effects of optical aberrations and defects are kept to a minimum, as these are generally more prevalent toward the edge of the image circle. Using many of the Nikkor lenses designed for 35mm film cameras some or all of the following can be reduced significantly, if not eliminated altogether:

- Reduced light fall-off toward the edge and corners of the image area (vignetting)
- Reduced chromatic aberration
- Linear distortion both barrel and pin-cushion
- Flat field focus
- Vignetting with filters

Wide-angle lenses offer a large field-of-view. Typically, they are associated with landscape photography where they can be used to capture a sweeping vista, but wide-angles are great for many subjects. Their close focusing ability, extended depth-of-field and angle-of-view can be combined to create some dynamic compositions if the subject is placed close to the lens, so it dominates the foreground and is set against an expansive backdrop, accentuating the perspective between the two elements. Telephoto lenses provide a narrower angle-of-view that magnifies a subject, making them good for sport, action, and wildlife photography. They are useful anytime that it is difficult to be close to the subject. The optical effects of a telephoto can be used in many other areas of photography such a portrait and landscape as they can help isolate a subject from its background due to their limited depth-of-field, particularly at large apertures, and the flattened perspective that they tend to produce.

Zoom lenses allow you to adjust the focal length, the range can be exclusively wide-angle, telephoto, or span both. Speaking strictly, most modern lenses described as a "zooms" are in fact vari-focal lenses; a true zoom lens maintains focus throughout the zoom range, which cannot be said of many lenses produced currently. These lenses are extremely versatile, as you have several focal lengths available in one lens, which reduces the amount of lenses you need to carry and you spend less time changing lenses. However, convenience comes at a price; many zoom lenses have smaller (larger f/ number) maximum apertures, often two-stops less than fixed-focal length types, which can be a critical when shooting in low light. Zoom lenses with large maximum apertures (smaller f/ numbers) tend to be expensive due to the complexity of their optical engineering. For general photography with the D80, a lens or lenses that offer focal lengths between say 18mm and 200mm will cover most shooting situations; for the greatest level of compatibility and functionality you should use either D-type, or G-type Nikkor lenses (see descriptions below).

Nikon makes a huge range of lenses known by their proprietary name, Nikkor. The following table provides details of the compatibility of the various types available:

Lens Compatibility

The following table indicates the compatibility of Nikkor lenses with the D80:

Camera setting		Focus		Mode	Metering	
Lono/accoccory	AF	M (with electronic rango findor)	м	Digital Vari Program, P, S, A	м	[·] , (), (•)
Type G or D AF Nikkor ² ; AF-S, AF-I Nikkor		• ⁶	•6	• ⁶	•6	•
PC-Micro Nikkor 85 mm f/1.8D 3	-	• 4	•		•6	•
AF-S/AF-I Teleconverter 5	•6	• ⁶	•6	• ⁶	• 6	•
Other AF Nikkor (except lenses for F3AF)	•7	• 7	•6	•6	• 6	•
AI-P Nikkor	-	• 8	•6	•6	• 6	•

- 1. Spot metering meters selected focus area.
- 2. Vibration Reduction (VR) supported with VR lenses.
- 3. Camera exposure metering and flash control may not function when lens is shifted and/or tilted or aperture is not at maximum.
- 4. Electronic range finder can not be used when shifting or tilting lens.
- 5. Compatible with AF I Nikkor lenses and with all AF S lenses except:
 - DX ED: 12 24 mm f/4G, 17 55 mm f/2.8G, 18 55 mm f3.5 5.6G, 18 70 mm f/3.5 4G, 55 200 mm f/4 5.6G
 - DXVR ED: 18 200 mm f/3.5 5.6G
 - ED: 17 35 mm f/2.8D, 24 85 mm f/3.5 4.5G, 28 70 mm f/2.8D
 - VR ED: 24 120 mm f/3.5 5.6G
- 6. With maximum effective aperture of f/5.6 or faster.
- 7. If AF 80 200 mm f/2.8S, 35 70 mm f/2.8S, new model 28 85 mm f/3.5 4.5S, or 28 85 mm f/3.5 4.5S is zoomed while focusing at mini¬mum range, image on matter screen in viewfinder may not be in focus when in focus indicator is displayed. Focus manually using image in viewfinder as guide.
- 8. With maximum aperture of f/5.6 or faster.

Using Non-CPU Lenses

Although the Nikon F mount has remained unchanged, largely, for almost fifty years, the design of modern cameras has progressed considerably! The introduction of electronic communication between the lens and camera for the purposes of exposure metering and auto focus has necessitated number of changes. Because of this, older non-CPU type lenses offer a very restricted level of compatibility with the D80. Often, the camera can only be used in Manual (M) exposure mode (if you select another exposure mode the camera automatically disables the shutter release). The lens aperture must be set using the aperture ring on the lens, and the autofocus system, TTL metering system, electronic analog exposure display, and TTL flash control do not function. However, the electronic rangefinder does operate, provided the maximum effective aperture is f/5.6 or larger (faster), unless otherwise stated, with the following non-CPU type lenses.

The following non-CPU type lenses can be used as described with the D80:

- Ai-modified, Ai, Ai-S, and E-series Nikkor lenses
- Medical Nikkor 120mm f/4 (only shutter speeds slower than 1/180 second can be used)
- Reflex Nikkor lenses (electronic rangefinder does not operate)
- PC Nikkor lenses (electronic rangefinder does not operate if lens is shifted)
- Ai-type teleconverters (electronic rangefinder requires an effective aperture of f/5.6, or larger to operate).
- PB-6 Bellows focusing attachment
- Extension rings PK-11A, PK-12, PK-13, and PN-11

Incompatible Lenses and Accessories

The following accessories and lenses are incompatible with the D80. If you attempt to use them it may damage the equipment.

- K2 extension rings
- TC-16A AF Teleconveter
- All pre Ai-type Nikkor lenses (Ai-types introduced from 1977 onwards)
- Lenses that require the AU-1 focusing unit (400mm f4.5, 600mm f/5.6, 800mm f/8, 1200mm f/11)
- Fisheye-Nikkor (6mm f/5.6, 8mm f/8, OP 10mm f/5.6)
- 21mm f/4 (first type with protruding rear element)
- 180-600mm f/8ED (serial numbers 174041 1744127)
- 360-1200mm f/11 (serial numbers 174041 174127)
- 200-600mm f/9.5 (serial numbers 280001 300490)
- AF 80mm f/2.8, AF200mm f/3.5, TC-16 teleconverter (for F3AF camera)
- PC 28mm f/4 (serial numbers 180900 or earlier)
- PC 35mm f/2.8 (serial numbers 851001 906200)

If you have non-CPU lenses, refer to the lists included here to see if they are compatible with the D80.

- PC 35mm f/3.5 (early type)
- Reflex 1000mm f/6.3
- Reflex 1000mm f/11 (serial numbers 142361 143000)
- Reflex 2000mm f/11 (serial numbers 200111 200310)

Features of Nikkor Lenses

The designation of Nikkor lenses is peppered with initials. Here is an explanation as to what some of these stand for:

• **D-type** – These lenses have a conventional aperture ring and an electronic chip that communicates information about lens aperture and focus distance between the lens and the camera body. The 'D' designation appears on the lens barrel.

- **G-type** These lenses have no aperture ring and are only compatible with Nikon cameras that allow the aperture value to be set from the camera body. They do contain an electronic chip that communicates information about lens aperture and focus distance between the lens and the camera body, similar to the D-type lenses. The 'G' designation appears on the lens barrel.
- **AF-type** These lenses are the predecessors to the later D, and G-type designs. They have a conventional aperture ring but do not communicate focus distance information to the camera. Used with the D80 the camera can only perform standard Color Matrix metering, not 3D Color Matrix metering.
- **DX** Lenses in the DX-Nikkor range have been especially designed for use on Nikon digital SLR cameras. They project a smaller image circle compared with lenses designed for the 35mm format cameras but the light exiting their rear element is more collimated to improve the efficiency of the photo sites (pixels) on the camera's sensor.
- **CPU Lens** A CPU lens can be identified easily by the array of small electrical contact pins set around the lens mount bayonet.
- Non-CPU Nikon uses the term non-CPU lens type to describe any Nikkor lens that lacks the electrical connections and electronic components, which enable CPU-type lenses to communicate information about the lens to the camera (with the exception of the 85mm PC-Micro lens and Ai-P type Nikkor lenses all manual focus Nikkor lenses are non-CPU types).
- **AF-I** These lenses are predecessors to the AF-S type lenses that contain a silent-wave motor (SWM) for driving the focusing action. These lenses also have an internal focusing motor.

- AF-S Not to be confused with <u>Bligle some auto</u> focus, AF-S denotes the lens has a silent-wave motor (SWM) used for focusing; it uses alternating magnetic fields to drive the motor, which moves lenses elements to shift focus. This system offers the fastest auto focusing of all AF Nikkor lenses. Most AF-S lenses have an additional feature that allows the photographer to switch between auto focus and manual focus, without adjusting any camera controls, by just taking hold of the focus ring.
- **ED** To reduce the effect of chromatic aberration Nikon developed a special type of glass to bring various wavelengths of light to a common point of focus.
- **IF** To speed up focusing, particularly with long focal length lenses, Nikon developed their internal focusing (IF) system. This moves a group of elements within the lens so that it does not alter length during focusing, and prevents the front filter mount from rotating, which facilitates use of filters such as a polarizer.
- VR Vibration Reduction is Nikon's name for a sophisticated technology that enables a lens to counter the effects of camera shake / vibration by using a set of builtin motion sensors that cause micro-motors to shift a dedicated set of lens elements to improve the sharpness of pictures.

Filters

Most of the time, the white balance control of the D80 obviates the need to carry color correction or color compensating filters that you would normally need when shooting on film. However, there are a few filter effects that you simply cannot replicate using a computer; the good news is you do not need that many! I would recommend that you consider the three filter types mentioned below:

Polarizing Filters

The most useful, and probably best-known, filter is a polarizer. Often associated with its ability to deepen the color of a blue sky, a polarizer has many other uses. The unique effect of this filter type is one that makes it essential for film or digital photography; for example, it can remove reflections from non-metallic surfaces, including water, so the polarizer is a favorite of landscape photographers. Even on a dull, overcast day a polarizer can help reduce the glare from foliage, caused by the reflection of the sky, thereby intensifying its color.

Hint: The automatic focusing and TTL metering systems of the D80 will not function properly if you use a linear-type polarizing filter. Thus, you use a circular-type polarizer, such as the Nikon Circular Polarizer II.

Neutral Density (ND) Filters

Even at the D80 sensor's base sensitivity of ISO100, it may not possible to set a lens aperture or shutter speed that will achieve the required results when shooting in very bright light. Continuous tone neutral density filters help to reduce the overall exposure by lowering the amount of light that reaches the camera's sensor, making it possible to use longer shutter speeds and/or wider apertures in very bright conditions. Nikon no longer produces continuous neutral density filters but many independent companies do. Any wellstocked camera store should have this filter.

Graduated Neutral Density Filters

Coping with excessive contrast is one of the most difficult aspects of digital photography. For example, when shooting landscapes, the sky is often much brighter than the land, even at each end of the day, which can make shooting landscapes tricky. If you set the exposure in to record the darker portion of the scene, the lighter portion will often be too bright to be recorded properly and ends up being overexposed. Graduated neutral density filters that are clear at one and become progressively denser toward the other are the ideal solution. They come in a variety of strengths and rates of change. If you use a slot-in type of filter system (such as manufactured by Cokin, Lee, or Singh Ray), it is easy to adjust the position of the graduated filter so the dense area darkens the sky and the clear portion is over the foreground area, which is unaffected. Nikon does not produce graduated neutral density filters but many independent companies do

No doubt someone will point out that another way to solve this exposure problem is to make two exposures of the same scene, one for the shadow areas and the other for the highlight areas and then combine the two shots in to one using software and a computer. Yes, this can often work well but sometimes an element in the scene will move between the recording of the two exposures, and the technique is revealed! I would always advocate trying to get as much right in the camera, apart from anything else, it means you spend less time in front of a computer; time you can spend using your camera.

Hint: Nikon advises that the D80's 3D Color Matrix and Matrix metering is not recommended when using for any filter with a filter factor over 1x. The filter factor is the amount of exposure compensation necessary to compensate for the reduction in light transmission caused by the filter. For example, a filter factor of 2x is equivalent to one-stop, a factor of 8x is equivalent to three-stops. So this does apply to polarizing and neutral density filters—in these situations switch to center-weighted or spot metering.

General Nikon Accessories

• **BF-1A** – a body cap that will help prevent dust from entering the camera. Keep it in place at all times when a lens is not mounted on the camera.

Note: The earlier BF-1 type body cap cannot be used; it may damage the lens mount of the D80

- **DG-2** a viewfinder eyepiece magnifier, which provides an approximate 2x magnification of the central area of the viewfinder field. (Note: requires the eyepiece adapter to be fitted.)
- **DK-3** a circular rubber eyecup for the Nikon FM3A that can be attached via the square-to-circular viewfinder accessory Eyepiece Adapter, it also requires the viewfinder eyepiece filter for the FM3A camera to hold it in place. The circular eyecup provides a better light seal when held up to the photographer's eye than the DK-21 square eyecup fitted as standard to the D80.
- **DK-5** the cover for the viewfinder eyepiece; it is essential to use it when the D80 is operated remotely (not held to the eye) in automatic exposure modes, to prevent light entering the viewfinder from affecting the exposure measurement.
- **DK-21** the standard, square profile rubber eyecup supplied with the D80.
- DK-21M this replaces the standard DK-21 eyecup, providing a modestly enhanced viewfinder magnification of 1.2x.
- **DK-22** square to circular eyepiece adapter. It allows viewfinder accessories with a round attachment thread, such as the DG-2, to be mounted on the square frame of the viewfinder eyepiece on the D80.
- **DR-6** a right-angle viewer that can attach directly to the square frame of the D80 viewfinder eyepiece. It is

useful when the camera 15 at a low shooting position but is disproportionately expensive compared with the D80 camera!

- **EC-AD1** an adapter that accepts Type I CompactFlash memory cards for connection to PCMCIA card slot.
- **EH-5** a multi-voltage, AC adapter for powering the D80; it is ideal for use during extended periods of shooting.
- EN-EL3e the lithium-ion rechargeable battery for the D80; it is also compatible with D200, D100, D70-series, D50, and D40 cameras (one battery is supplied with the camera).
- MB-D80 –a battery pack for the D80; it accepts up to two EN-EL3e or six AA-size batteries in the MS-D200 battery holder.
- **MC-DC1** the standard 30 inch (0.8 m) remote shutter release cord it has a locking shutter release button to facilitate making long time exposures, and connects to the dedicated remote cord terminal on the D80.
- **MH-18a** a multi-voltage AC charger for a single EN-EL3e battery (supplied with the camera).
- MH-19 a multiple battery charger it can charge two EN-EL3e batteries, and supports either a multi-voltage AC supply or 12V DC motor vehicle supply.
- ML-L3 Remote Control a wireless infrared remote release for the D80 it requires one CR2025 (3V) battery.
- **MS-D200** a battery holder for six AA sized batteries that can be used as an alternative power supply for the D80 when fitted with the MB-D80 battery pack.

Working Digitally

Digital Workflow

Using film for photography is familiar to most people; load the camera, take the pictures, then have someone else do the processing and printing for you. Shooting digitally, on the other hand, brings many new aspects to your photography, and provides a far greater level of user control. Therefore, regardless of whether you have experience of shooting on film cameras or you began shooting with a digital camera from the outset of your photography, it is essential to develop a routine to make sure you work in an efficient and effective way. You may wish to consider the following 7point workflow as a general guide to establishing your own.

Preparation

- Familiarize yourself with the camera. The more intuitive you become with your equipment, the more time you can spend concentrating on the scene/subject being photographed.
- Make sure the camera battery is charged and always carry a spare.
- Rather than save all your pictures to a single high capacity memory card, reduce the chance of a catastrophic loss due to card failure / loss by spreading the risk over several memory cards.
- Always clean the low-pass filter array in front of the sensor to reduce the level of post-processing work.
- Always format the memory card in the camera in which it will be used each time you insert a card.

Establishing a workflow for shooting and processing images will help you to make the most of your time.

Shooting

- Adjust camera settings to match the requirements of your shoot; choose an appropriate image quality, size, ISO, color space, and white balance.
- Set other camera controls such as metering and autofocus according to the shooting conditions.
- Use the <Image Comment> feature (see pages 227-228) to assign a note about the authorship/copyright of the images you shoot.
- Review images and make any adjustments you deem necessary. The histogram display is extremely useful for checking on exposure values.
- Do not be in too much of a hurry to delete pictures unless they are obvious failures. It is often better to edit after shooting rather than "on the fly."

Transfer

- Before transferring images to your computer, designate a specific folder or folders in which the images will be stored so you know where to find them.
- Use a card reader rather than connecting the camera directly to the computer. It is much faster, more reliable, reduces wear and tear on the camera, and doesn't drain the battery.
- If your browser application permits you to assign general information to the image files during transfer (i.e., DNPR (IPTC) metadata), make sure you complete appropriate fields for image authorship and copyright.
- Consider renaming files and assigning further information and key words to facilitate searching for images at a later date.

I don't recommend using the JPEG format for image processing. Work in TIFF, or use your processing program's native image file, such as Adobe Photoshop's PSD.

Edit and File

- Use a browsing application to sort through your pictures. Again, do not be in too much of a hurry to edit out pictures. It is often best to take a second look at images a few days or even weeks after they were shot, as your opinions about images will often change.
- Print a contact sheet of small thumbnail images to help you decide which images to retain.

Processing

- Make copies of NEF files and save them to a working file format such as TIFF or PSD (Adobe Photoshop).
- Do not use the JPEG format for processing.

- Make adjustments in an orderly and logical sequence starting with overall brightness, contrast, and color. Then make more local adjustments to correct problems or enhance the image.
- Save your adjusted file as a master copy to which you can then apply a crop, resizing, unsharp mask, and any other finishing touches appropriate to your output requirements.

Archive

- Data can become lost or corrupted at any time for a variety of reasons so always make multiple backup copies of your original files and the edited master copies.
- CDs have a limited capacity, so consider DVDs or an external hard disk drive. No electronic storage media is guaranteed 100% safe, nor does it have an infinite lifespan, so always check your backup copies regularly and repeat the backup process as required.

Display

- We all shoot pictures for others to see and enjoy. Digital technology has expanded the possibilities of image display considerably; we can email pictures to family, friends, colleagues, and clients, prepare digital "slideshows," or post images to a web site for pleasure or profit.
- Home printing in full color is now reliable, cost effective and, above all, achievable. Spend some time to set up your system properly and work methodically; calibrate your monitor and printer, use an appropriate resolution for the print size you require, and choose paper type and finish accordingly.
- Once you have a high-quality print, ensure that you present it in a manner befitting its status; frame it, or mount it securely. This will also help to protect it from the effects of light and atmospheric pollutants.

Caring for Your D80

Obviously, keeping your camera and lenses in a clean and dry environment is very important, but regardless of how scrupulous you about doing this, dust and dirt will eventually accumulate on or inside your equipment. Since prevention is better than cure, always keep body and lens caps in place when not using your equipment. Always switch the D80 off before attaching or detaching a lens to prevent particles from being attracted to the low-pass filter by the electrical charge of the sensor. And remember, gravity is your friend. Whenever you change lenses, get into the habit of holding the camera body with the lens mount facing downwards. For the same reason, do not carry or store your D80 on its back, as particles already inside the camera will settle on the low-pass filter. Periodically vacuum-clean the interior of your camera bag/case; it is amazing how much debris can collect there. Sealing you camera body in a clear plastic bag, which you then keep within your camera case, will add another valuable layer of protection in very dusty or damp conditions. In the latter situations, keep some sachets of silica gel inside the bag, as they will absorb any moisture.

In putting together a basic cleaning kit, you should consider the following: a soft 1/2-inch (12 mm) artist's paint brush with soft sable hair for general cleaning, a micro-fiber lens cloth for cleaning lens elements, a micro-fiber towel (available from any good outdoors store) for absorbing moisture when working in damp conditions (I find these towels invaluable in all sorts of conditions, and they are soft enough to use for cleaning lenses and filters), and a rubber bulb blower (either from a traditional blower brush, or a dedicated blower for use in cleaning lenses and the low-pass filter).

Always brush or blow as much material off of the equipment before wiping it with a cloth. For lens elements and filters, use a micro-fiber cloth and wipe surfaces in short strokes, not a sweeping circular motion. Turning the cloth frequently to prevent depositing the dirt you have just removed back on the same surface. For any residue that cannot be removed with a dry cloth, you will need to resort to a lens cleaning fluid suitable for photographic lenses. Apply the fluid sparingly to the cloth, not directly to the lens, as it may seep inside and cause damage. Wipe the residue away and then buff the glass with a dry area of the cloth. Any lens cloth should be washed on a regular basis to keep it clean.

Cleaning the Low-Pass Filter

Dust and any other material that settles on the low-pass filter array in front of the CCD sensor will often appear as dark spots in your pictures because they cast a shadow on the CCD sensor that is located behind the filter array. The exact nature of their appearance will depend on their size and the lens aperture you use. At very large apertures (i.e., f/1.4), it is likely that most very small dust specks will not be visible. However, at small apertures (i.e., f/22), they will probably show up as well defined black spots.

Nikon expressly recommends that you should have the low-pass filter cleaned by an authorized service center. However, in recognition of the fact that this is likely to be impractical for a variety of reasons, Nikon has provided the D80 with a facility to lock up the reflex mirror to access the lowpass filter array for cleaning. However, they state that under no circumstances should you touch or wipe the filter array.

To inspect and/or clean the low-pass filter you need to access the <Mirror Lock-up> feature via the Setup menu. Open the menu and scroll to <Mirror Lock-up>, then press the multi selector switch to the right to display the options <On> or <Off>; <On> is the default option. Press the multi-selector switch to the right again. A dialog box will appear with the following instruction: "When shutter button is pressed, mirror lifts and shutter opens. To lower mirror, turn camera off."

Once the shutter is pressed the mirror will lift and remain in its raised position. The control panel display will show a series of dashes that flash, and all other information will disappear. Keep the camera facing down so any debris falls away from the filter look up in to the lens mount to inspect the low-pass filter surface (it is probably helpful to shine a light on to it) but remember the photo-sites on the CCD of the D80 are just 5.9-microns square (one micron = one thousandth of a millimeter), so offending particles are often very, very small, and it is unlikely you will be able to resolve them by eye.

Note: If the battery level of the camera drops to **CPP** or below, or the camera is powered using AA size batteries in the MS-D80 with the MB-D80 battery pack you will not be able to access the <Mirror Lock-up> (cleaning) option in the Setup menu.

Note: If the mirror is locked up for cleaning, and the battery power drains too low the camera emits an audible warning and the AF-assist lamp will begin to flash, to indicate the mirror will be lowered, automatically, in approximately two minutes.

To clean the low-pass filter your self, keep the camera facing down, and use a rubber bulb blower to gently 'puff' air towards the filter array surface. Take care that you do not enter any part of the blower into the camera. Never use an ordinary brush with bristles, or compressed air canister type blower to clean the filter array as they can easily leave a residue, or damage its surface. Once you have finished cleaning, switch the camera OFF to return the mirror to its down-position. If the blower bulb method fails to remove any stubborn material I recommend you do have the sensor cleaned professionally.

For users with plenty of confidence there is range of proprietary sensor cleaning materials available from photographic suppliers that can be used to clean the filter array. It must be stressed that you do this entirely at your own risk, and it is essential that the camera's battery be fully charged before you attempt any of these procedures (preferably, use the EH-5 AC adapter to ensure a continuous power supply). If the power supply fails during the cleaning process the shutter will close and the mirror will return to its down-position, with potentially dire consequences if you have any cleaning utensils in the camera!

Finally, if you have Nikon Capture NX software you can use the Dust Reference Photo feature with NEF (Raw) files shot using the D80 to help remove the effects of dust particles on the low-pass filter by masking their shadows electronically. This feature is reasonably effective but since the dust particles can be dislodged and shift between shots there is no guarantee that this technique will be successful if you save only one reference file during the course of a shoot.

Troubleshooting

On occasions the D80 camera may not operate as you expect. This may be due to an alternative setting(s) having been made (often inadvertently), or for some other reason. Many of the reasons for these problems are common and the solutions are set out in the table below:

Problem	Solution
Camera takes longer than expected to turn on	Delete files / folders
Viewfinder appears out of focus	Adjust viewfinder focusUse diopter adjustment lens
Viewfinder display is dark	Battery not insertedBattery exhausted
Displays turn off unexpectedly	Set longer delay for monitor off / meter off
Displays in LCD panels appear slow to react and are dimmed	Affect of high or low temperature
Fine lines appear in vicinity of active focus area on focusing screen	Normal – this is not a fault
Viewfinder display appears red	Normal – this is not a fault
Playback menu cannot be accessed	No memory card inserted

Problem

Image size cannot be altered Menu item not displayed Menu item cannot be selected

Shutter release will not operate

Metering cannot be changed

Unable to select focus area

AF-assist lamp does not light

No picture taken when release button of ML-L3 remote release is pressed

Range of shutter speeds is limited Focus does not lock when shutter release is depressed halfway

Final pictures shows more than viewfinder Pictures out of focus

Solution

NEF (Raw) selected for image quality Select Detailed for CSM / Setup menu

Turn mode dial to another setting, or insert memory card, or ensure lens set to autofocus

- Aperture not set to minimum value
- Memory card not installed or full
- Flash charging
- Focus not acquired
- **bulb** selected in S exposure mode
- Digital Vari-program mode selected
- Auto-exposure lock active
- Unlock focus area selector
- Monitor is on: camera in Playback mode
- Camera in AF-C focus mode
- Mode dial set to

 , or
 , select an alternative mode
 CS-2 (AF-area mode) set to Auto-area
 AF, or Dynamic select center focus area.
- <OFF> selected at CS-4
- Lamp has shut down automatically to cool down
- Replace battery in ML-L3
- Select remote control mode
- Flash is charging
- Time selected for remote delay (CS-30) has elapsed; reset
- Bright light is interfering with remote signal

Flash in use - sync speed imposed

- Camera in AF-C focus mode: use AF-L/AE-L button
- AF-A mode used to photograph a moving subject

Viewfinder coverage is limited to approx. 95% of full frame area

- Select S or C focus mode
- AF unable to operate; use manual focus

Problem

Recording time is unusually long Random bright pixels appear in image

Areas with a red tint appear in pictures

Dark spots / blotches appear in pictures

Colors appear unnatural

Continuous shooting mode unavailable

Unable to obtain WB measurement in Preset WB

Source image cannot be selected for setting WB

WB bracketing not available

Results with <Optimize Image> vary from image to image

Exposure compensation cannot be used

Pictures shots in upright orientation (tall) displayed in horizontal (wide) orientation

Unable to delete image

Not all images displayed in Playback mode, or message stating note <Current> will be selected no images are available in Playback mode

Solution

Noise reduction in operation

- Use lower ISO setting
- Use High ISO noise reduction
- Shutter speed exceeds 8 seconds; use long exposure noise reduction

Long time exposure used; turn on long exposure noise reduction in Shooting menu

- Dirt on lens
- Dirt on low-pass filter
- Inappropriate WB set
- Adjust <Optimize Image> settings
- In P, A, S, and M modes lower built-in flash unit
- Turn flash off in Digital Vari-program modes

Illumination of test target too dark or too bright

Image not created with D80

- NEF (Raw) or NEF (Raw) + JPEG selected for image quality
 - **K** selected for white balance
- Multiple exposure sequence in progress

Use <Custom> setting. Avoid <Auto> for <Sharpening>, <Tone Compensation>, and <Saturation> options

Select P, A, or S exposure modes

- Select <ON> for <Rotate Tall>
- <OFF> selected for <Auto Image Rotation>
- Camera orientation was altered while shooting in continuous mode
- Camera was pointed up / down when shooting

Image protection set; remove protection Select <All> for <Playback Folder>; automatically when next picture is taken

Use the trouble shooting guide provided here as a first step to problem-solving with your D80.

Proble	m
--------	---

NEF image is not played back Cannot change print order Unable to print direct from camera via USB connection Unable to select image for direct printing Unable to display image on TV Unable to transfer images to computer Unable to use Camera Control Pro Set <USB> to <PTP> Date of recording image is incorrect

Solution

Image quality set to NEF + JEPG Memory card is full: delete images Set <USB> to <PTP>

Image saved as NEF file

Select correct video mode Select correct <USB> option

Set camera clock accordingly

Error Messages and Displays

The D80 is a sophisticated electronic device capable of reporting a range malfunctions and problems by way of indicators and error messages that appear in the displays of the viewfinder, control panel, and monitor screen. The following table will assist you in finding a solution should one of these indicators or messages be displayed.

Indicator				
Control panel			Solution	
F E E			Lock ring at minimum aperture	
(blinks)		minimum aperture.	(highest f/-number).	
(blin	lic)	No lens attached.	Attach lens (IX Nikkor excluded).	
		Non-CPU lens attached.	Select mode M.	
هـ ـــه		Low battery.	Ready fully-charged spare battery	
		 Battery is exhausted. 	Recharge or replace with fully	
(blinks)	(blinks)	Batteny information not avail	charged spare battery.Battery can not be used in came	
(DIINKS) (DIINKS)		able.	 Battery can not be used in cam- era. 	
CLOCK (blinks)		Camera clock not set.	Set camera clock.	
(- E -)	[🛃 /]	No memory card.	Insert memory card.	
FULL	Ful	No memory for further photos at		
(blinks)	(blinks)	current settings, or camera has	 Delete photographs. 	
(01111(3)	(DITINS)	run out of file or folder numbers.	 Insert new memory card. 	
	•		Recompose photo or focus manu-	
	(blinks)	autofocus.	ally.	
н :		Subject too bright; photo will be overexposed.	 Choose lower ISO sensitivity. Increase shutter speed. Choose smaller aperture (larger f/-number). Use optional Neutral Density (ND) filter. 	
Lo ^{Si} u		Subject too dark; photo will be underexposed.	 Choose higher ISO sensitivity. Decrease shutter speed. Choose larger aperture (larger f/- number). 	
	\$ (blinks)	 Flash required for correct exposure. blinks for 3s after flash fires: flash has fired at full power. 	 Raise built-in flash. View photo; if underexposed, adjust settings and try again. 	
(blinks)	\$ (blinks)	Optional Speedlight that does not support i-TTL set to TTL mode.	Change flash control mode for op- tional Speedlight.	
(blinks)		"bulb" selected in mode M and mode dial rotated to S .	Change shutter speed or select	
		"" selected in mode M and mode dial rotated to S .		
Err (blinks)		Camera malfunction.	Press shutter-release button again. If error persists, consult with Nikon- authorized service representative.	

	Indicator			
Monitor	Control panel		Problem	Solution
NO CARD PRESENT	[- E -]	[-£-] / ≧ (blinks)	No memory card.	Insert memory card.
CARD IS LOCKED	([x r] / (🛿) (blinks)	Memory card is locked (write protected).	Slide card write-protect switch to "write" position.
THIS CARD CAN NOT BE USED	([H R] (blinks)		card.	 Use Nikon-approved card. Card may be damaged. Contact retailer or Nikon- authorized service repre- sentative. Delete unwanted files or in- sert new memory card.
CARD IS NOT FORMATTED Format No	(For) (blinks)		Memory card has not been formatted for use in D80.	Highlight Format and press OK to format memory card.
FOLDER CONTAINS NO IMAGES			 Memory card is empty. Current folder is empty. 	 Insert another card. Set Playback folder to All.
ALL IMAGES HIDDEN			All photos in current folder are hidden.	Set Playback folder to All or use Hide image to reveal photos.
FILE DOES NOT CONTAIN IMAGE DATA			File created or modified using computer or other make of camera, or file is corrupt.	Delete file or reformat mem-
CHECK PRINTER Con- tinue Cancel			Printer is out of ink or ink is running low.	Replace ink. If error occurs with ink remaining in printer, check printer status.

Electro-Static Interference

Operation of the D80 is totally dependent on electrical power. Occasionally, the camera may stop functioning properly, or display unusual characters or unexpected messages in the viewfinder and LCD displays. Such behavior is generally due to the effects of a strong external electro-static charge. If this occurs try switching the camera off, disconnecting it from its power supply (remove the EN-EL3e battery, or unplug the EH-6 mains AC adapter), then reconnect the power, and switch the camera on again.

If this procedure fails to rectify the problem, turn the camera off, and open the rubber port cover on the left end of the camera. Located to the right of the four-pin external power supply terminal there is a small square button; this is the reset switch. Press the reset switch but note that this resets the clock to its default time, so you will need to changing the date/time settings appropriately. Should the symptoms persist the camera will require inspection by an authorized technician.

Approved Memory Cards

There are a plethora of memory cards on the market but Nikon have only tested and approved those listed in the table below for use with the D80.

Secure Digital technology is well established, so although Nikon will not guarantee operation with other makes of card you should not experience any problems.

Manufacturer	Card Type / Series	Capacity
SanDisk	All types and card write/ read speeds supported	64 MB, 128 MB, 256 MB, 512 MB 1 GB, 2 GB and 4 GB
Toshiba	All types and card write/ read speeds supported	64 MB, 128 MB, 256 MB, 512 MB 1 GB, and 2 GB
Panasonic	All types and card write/ read speeds supported	64 MB, 128 MB, 256 MB, 512 MB 1 GB, and 2 GB
Nikon	All types and card write/ read speeds supported	1 GB

Nikon D80-Approved Memory Cards

Note: If you use a memory card with a capacity of 2 GB or more, ensure that any card reader or image storage device supports 2 GB memory cards.

Note: Ensure that any card reader or other storage device used with a memory card that has a capacity of 4 GB or more supports the SDHC standard.

Nikon state that while other brands and capacities of cards may work, operation cannot be guaranteed. If you intend to use a memory card not listed in the table above it is advisable to check with the manufacturer in respect of its compatibility. Should you experience any problems related to the memory card use one of the approved cards for the purposes of trouble-shooting.

Memory Card Capacity

The table below provides information on the approximate number of images that can be stored on a 1 GB memory card at the various image quality, and size settings available on the D80. All memory cards use a small proportion of their memory capacity to store data required for the card to operate, therefore the amount of memory available for storing image files will be slightly less than the quoted maximum capacity of the card.

Quality	Size	File Size ¹	No. Images ¹	Buffer Capacity ^{1, 2}
NEF (Raw)	-	12.4	60	6
NEF (Raw) +	L	17.2	44	6
JPEG Fine 3	Μ	15.1	49	6
	S	13.6	54	6
NEF (Raw) +	L	14.8	50	6
JPEG Normal3	Μ	13.8	54	6
	S	13.0	56	6
NEF (Raw) +	L	13.6	54	6
JPEG Basic3	М	13.0	56	6
	S	12.7	58	6
	L	4.8	133	23
JPEG Fine	М	2.7	233	100
	S	1.2	503	100
	L	2.4	260	100
JPEG Normal	М	1.3	446	100
	S	0.6	918	100
	L	1.2	503	100
JPEG Basic	М	0.7	876	100
	S	0.3	1500	100

- 1. File size will vary according to the scene photographed, and the make of memory card used. Therefore, all figures are approximate.
- 2. This is the maximum number of image files that can be stored in the buffer memory, when sensitivity equivalent to ISO 100 is set. Capacity will be reduced if noise reduction is active.
- 3. Image size applies to JPEG file only; size of NEF Raw file cannot be altered. File size is the combined total for NEF (Raw) and JPEG image files.

Note: Some commentators have expressed surprise at the quoted size (12.4MB) of the NEF Raw file given that the expected size of a compressed NEF Raw file from the sensor of the D80 would be in the range of 8MB to 9.5MB based on the average reduction of a compressed NEF Raw file by between 40 - 50%. The file size figure shown in the D80 user manual is described by Nikon as a "design figure", which translates as the maximum file size a user may expect to achieve with a compressed NEF Raw file. In certain conditions, although the chances of it happening are extremely rare, it is possible for a compressed NEF Raw file.

Image Information

You may be surprised to learn that apart from image data the picture files generated by the D80 contain a wealth of other information that includes amongst other things, the shooting parameters and instructions about printing pictures. This information is "tagged" to the image file using a number of common standards depending on the sort of information to be saved with the image file.

Supported standards:

DCF (v 2.0): Design Rule for Camera File System (DCF) is a standard used widely in the digital imaging industry to ensure compatibility across different makes of camera.

DPOF: Digital Print Order Format (DPOF) is a standard used widely to enable pictures to be printed from print order created and saved on a memory card.

EXIF (v 2.21): The D80 supports Exchangeable Image File Format for Digital Still cameras (EXIF); this standard allows information stored with image files to be read by software, and used for ensuring image quality when printed on an EXIF-compliant printer.

PictBridge: A standard that permits an image file stored on a memory card to be output directly to a printer without the need to connect the camera to a computer, or download the image file from a memory card to a computer first.

Exchangeable Image File Format (EXIF)

The D80 uses the EXIF (2.21) standard to tag additional information to each image file it records (sometimes this information is referred to as metadata, which is a more generic term). Most popular digital imaging software is able to read and interpret the EXIF tags so the information can be displayed but other software is not as capable, in which case some or all of the EXIF data values may not be available. The information recorded includes:

- Nikon (the name of the camera manufacturer)
- D80 (the model number)
- Camera firmware version number
- Exposure information, including shutter speed, aperture, exposure mode, ISO, EV value, date/time, exposure compensation, flash mode, and focal length
- Thumbnail of the main image

Examining EXIF data by either viewing the image information pages on the camera's monitor screen, or accessing the shooting data in appropriate software is a great teaching aid as you can see exactly what the camera settings were for each shot. By comparing pictures and the shooting data you can quickly learn about the technical aspects of exposure, focusing, metering and flash exposure control.

International Press Telecommunications Council (IPTC)

Other information (metadata) that can be tagged to an image file includes the use of a standard developed by the International Press Telecommunications Council (IPTC). Known as Digital Newsphoto Parameter Record (DNPR), it can append information including details of the origin, authorship, copyright, caption details, and key words for searching purposes, of images. Any application that is DNPR compliant will show this information and allow you to edit it. If you are considering submitting any pictures you shoot with the D80 for publication you should make use of DNPR (IPTC) metadata, as most publishing organizations require it to be present before accepting a submission.

Note: DNPR data is often erroneously referred to as "IPTC data."

The connection ports are located under the large rubber cover on the left end of the camera; note the small reset switch located to the right of the 4-pin DC-in terminal.

Connecting to a Television or Video Monitor

The D80 can be connected to a television set or VCR for playback or recording of images. In many countries the camera is supplied with the EG-D2 video cable for this purpose. First, you need to select the appropriate video standard:

Open the Setup menu î and navigate to the <Video Mode> item. Press the multi selector button to the right, and highlight the required option: <NTSC> or <PAL>, and press the multi selector button to the right again to confirm your selection.

Note: NTSC is the video standard used in the USA, Canada, and Japan. PAL is used in most European countries.

Before connecting the camera to the video cord, make sure the camera power is switched off. Open the large rubber cover on the left end of the camera body to reveal the ports for video out (bottom), DC-in (center), and USB (top). Connect the narrow jack-pin of the EG-D2 to the camera and the other end to the TV / VCR (white plus to the audio terminal and yellow plus to the video terminal). Tune the TV to the video channel, and turn on the camera. The image that would normally be displayed on the LCD monitor will be shown on the television screen or can be recorded to videotape.

Note: The LCD monitor will remain blank but all other camera operations will function normally. So, you can take pictures with the camera connected to a TV set and carry out review / playback functions as you would on the monitor screen.

Note: If you intend to use the camera for an extended period for image playback via a TV or VCR it is probably best to use the EH-5 AC adapter to power the camera.

Connecting to a Computer

The D80 can be connected direct to a computer via the supplied UC-E4 USB cable. The camera supports the High-speed USB (2.0) interface that offers a maximum transfer rate of 480 Mbps. You can download images from the camera using the supplied Nikon PictureProject software, or Nikon View Pro, which is available separately. Alternatively, the D80 can be controlled from a computer using the optional Nikon Camera Control Pro software.

Hint: If you use the D80 tethered to a computer for any function ensure that the EN-EL3e battery is fully charged. Preferably, use the EH-5 mains AC adapter to prevent interruptions to data transfer by loss of power.

Before connecting the D80 to a computer appropriate Nikon software must be installed, and the camera must be configured for one of the two USB connection options, via the setup menu.

Open the Setup menu and navigate to the <USB> item. Press the multi selector button to the right to right to display the two options: <M Mass Storage> and <P PTP>. Highlight the required option (see descriptions below) and press multi selector button to the right to right to select it.

- Mass storage (default) In this configuration, the D80 acts like a card reader and the computer sees the memory card in the camera as an external storage device; it only allows the computer to read the data on the memory card. Use this option if computer is running Windows 2000 Professional.
- Picture Transfer Protocol (PTP) In this configuration, the D80 acts like another device on a computer network and the computer can communicate and control camera operations. Use this option if the computer is running Windows XP (Home or Professional), or Macintosh OS X

Note: If you use the *AM Mass Storage>* option, ensure the camera is un-mounted from the computer system in accordance with the correct procedure for the operating system in use, before the camera is switched off and disconnected from the USB cord.

Note: You must select <P PTP> to control the camera using the optional Nikon Camera Control Pro software. When Camera Control Pro software is running the camera will display "PC" in place of the number of exposures remaining.

Note: Mass storage can also be selected with Windows XP (Home or Professional), or Macintosh OS X.

Card Readers

Although the D80 can be tethered directly to a computer via a USB cord for transferring image data there are several reasons why you should consider using a dedicated memory card reader as an alternative:

- If you use the tethered camera method you will its drain battery power with a risk that data could be lost or corrupted if the power fails.
- Data transfer from the memory card to the computer will often be far faster using a card reader.
- Using a card reader allows you to run software to recover lost or corrupted image files as well as diagnose problems with the memory card.
- You can leave a card reader permanently attached to your computer, which further reduces the risk of losing or corrupting files as a result of a poor connection due to the wear and tear caused by constantly connecting the camera.

Direct Printing

As mentioned above the D80 supports a number of standards that amongst other features allow pictures to be printed direct from the camera, via a USB connection, without the aid of a computer. It is possible to select an individual image, or a group of images. Regardless, this feature is only compatible with JPEG format image files, and a printer that supports the PictBridge standard.

Note: Direct printing from the D80 is only supported for JPEG files. Nikon recommend images destined for direct printing should be recorded in the sRGB color space (i.e., when using the P, A, S, and M exposure modes you should set the D80 to either Color Mode I, or IIIa, using the <Custom> option of the <Optimize Image> menu).

Linking the D80 with a Printer

The D80 can be connected to a PictBridge compatible printer to print pictures direct from the camera. First, set the <USB> option in the Setup menu to <PTP> (see Connecting to a Computer section above). Next, turn the printer on and ensure the camera is switched off, and then connect the printer to the camera via the supplied UC-E4 USB lead.

Note: Printing cannot be performed with at the default <USB> option of <M Mass storage>.

Note: It is essential that you make sure the camera battery is fully charged before commencing direct printing from the camera; preferably use the EH-5 mains AC adapter.

Note: Nikon does not recommend connecting via a USB hub.

Turn the camera on, and a welcome message will be shown followed by the PictBridge playback display on the camera's monitor screen. To scroll through the images saved on the memory card press the multi selector button to left or right. To display an enlarged section of the displayed image press the sutton, and use the structure button to return to the full frame view. To view up to slx images at a time press a view is the multi-selector button to select a photograph, a yellow frame bounds the highlighted image, and press the selected photograph full frame.

There are two options for printing pictures: one-by-one, or in multiples.

Printing Pictures One at a Time: To print the image selected in the PictBridge playback display, press and release the button. The PictBridge printing menu will be displayed. Use the multi selector button to select the required option.

Option Start Printing	Description Select to print the image highlighted in the PictBridge display. To cancel func- tion press D button.
Page Size	Press the multi selector button up or down to select the appropriate paper size from <printer default=""> item: <3.5 x 5in>, <5 x 7in>, <hagaki>, <100 x 150mm>, <4 x 6 in>, <8 x 10in>, <letter>, <a3>, or <a4>. Then press the OK button to select and return to the print menu.</a4></a3></letter></hagaki></printer>
Number of Copies	Press the multi selector button up or down to select the number of copies of the highlighted image to be printed (maximum 99). Then press the DK button to select and return to the print menu.
Border	Press the multi selector button up or down to select <printer default=""> (uses default setting of current printer), <print border="" with=""> (white border), or <no border="">. Then press the OK button to select and return to the print menu.</no></print></printer>

Time Stamp

Cropping

Press the multi selector button up or down to select <Printer Default> (uses default setting of current printer), <Print Time Stamp> (date and time image was recorded is printed), or <No Time Stamp>. Then press the OK button to select and return to the print menu.

Press the multi selector button up or down to select <Crop> (picture can be cropped in-camera), or <No Crop> (printed full frame). Then press the Solution to select and return to the print menu.

If <Crop> is selected the image is displayed with a frame overlaid. Use the a , and buttons to determine the size of the crop. To position the cropping frame use the multi select button. Then press the button to select and return to the print menu.

Printing Multiple Images via PictBridge

To print multiple images, or an index print (contact sheet) connect the camera to a compatible printer as described above. Once the PictBridge display is open press button and a menu with three options will be displayed:

Option Description Print Select The selected images are printed The current DPOF print order set is Print (DPOF) printed (DPOF date and information options are not supported) Creates and index print of all images **Index Print** saved in the JPEG format. If the memory card contains more than 256 JPEG images only 256 will be printed. Press **ok** button to display a subthe menu with three further options: <Page

51ze>, <Border>, <Time Stamps. There have the same options as described in the table above for single image printing. To commence printing highlight <Start Printing> and press the button.

Choose <Print Select> from the <PictBridge> menu; six thumbnail images will be displayed on the monitor screen. Use the multi selector button to scroll through the images and press to see the highlighted image full frame.

To select the image highlighted currently press the multi selector button up; the number of copies to be printed is set to one <1>. To specify the number of copies of each image selected for printing press the multi selector button up to raise the number, and down to lower the number. To deselect a picture from printing press the multi selector button down until one <1> is displayed for the number of prints and then press it left, or right to highlight another picture. Repeat this process in respect of each image required to be printed. Display the print options and set page size, border type, and time stamp options as required according to the instructions above. To print selected images, highlight <Start Printing> and press the **O** button.

Note: Images saved in the NEF format will be displayed in the <Print Selected> menu, but it is not possible to select them for printing.

Digital Print Order Format (DPOF)

The D80 supports the Digital Print Order Format (DPOF) standard that embeds an instruction set in the appropriate EXIF data fields of an image file, which allows you to insert the memory card in to any DPOF compatible home printer or commercial mini-lab printer, and get a set of prints, automatically, of those images you wish to print. Apart from the fact you do not have to tether the camera to a compatible printer as described above, this feature can be particularly useful if, for example, you are away from home, say on vacation, as you can still produce prints from your digital files, even if you do not have access to your own printer, because prints can be made by any DPOF compatible printer.

To select images for printing highlight the <Print (DPOF)> option from the playback menu. The <Select/Set> option will be highlighted; press the multi selector button to the right to select it. The camera will display a thumbnail of all the images stored on the inserted memory card, in groups of up to six thumbnails. Use the multi selector button to scroll through the images; a yellow frame bounds the highlighted image. To view the highlighted image full frame, press the button.

To select the highlighted image for printing press the multi selector button up, and a small icon of a printer and a number will appear in the upper right corner of the thumbnail image; the number of copies to be printed is set to one <1>. To specify the number of copies of each image selected for printing press the multi selector button up to raise the number, and down to lower the number. To deselect a picture from printing press the multi selector button down until one <1> is displayed for the number of prints and then press it left, or right to highlight another picture. Repeat this process in respect of each image required to be printed.

Once all images to be printed have been selected press the button to save the selected group of images. A further two options are now displayed: to imprint shooting data on the image(s) highlight <Data Imprint> and press the multi selector button to the right to place a check mark in the option box. To print the date/time of image recording on all the pictures in the print set, highlight <Imprint Date> and press the multi selector button to the right to place a check mark in the option box. Finally, to finish and save the <Print Set> order, highlight <Done> and press the of button. To deselect an entire print set select <Print Set> from the Playback menu. Press the multi selector All?>. Highlight the required option, <Yes> or <No>, and press the button. To deselect All?>.

DK button to confirm the selection.

Note: ePrint Sets adjustions can only be made from IPEG format images stored on the memory card; if an image was shot using a NEF+JPEG option, only the JPEG image can be selected for printing.

Note: The print set option requires sufficient memory on the installed memory card to store the print order data as well as the image files, so always ensure there it has spare capacity before creating a print order.

Note: There are subtle differences in the functionality between the two direct printing routes, for example, direct printing with the D80 connected to a PictBridge compatible printer allows you to perform cropping of the image before printing, whereas printing from the memory card using a print set created using the DPOF standard images can only be printed full frame.

Nikon Software

It is beyond the scope of this book to describe fully the features and functions of Nikon's dedicated software, fully; details can be obtained from the technical support sections of the Web sites maintained the Nikon Corporation. The following is intended to provide a brief overview.

The D80 comes with a copy of Nikon PictureProject 1.7 Nikon's browser application 'intended' to replace the stalwart Nikon View. I say 'intended' because despite statements at the time, mid-2003, suggesting that Nikon View would be taken no further than version 6.0, the current iteration is at version 6.2.7. However, although Nikon View 6.2.7 can be used to transfer and browse images taken on the D80 Nikon do not guarantee full compatibility of the application with image files from the camera.

At the time of writing, fall 2006, Nikon have stated their intention to further upgrade Nikon View to a version that will be known as Nikon View Pro. That is the good news, the

bad news is that the release of View Pro has been delayed until "late 2006," and it will no longer be available for free download but will have to be purchased.

Note: For information about Nikon software and to download updates to existing applications updates I recommend you visit the various technical support websites maintained by Nikon, which can be accessed via: http://www.nikon.com

Nikon PictureProject

As mentioned above the D80 comes supplied with a copy of Nikon PictureProject 1.7; it is designed to facilitate the transfer of images from a memory card, either installed in a camera, or via a card reader, and allow a number of preferences to be set, including file naming and numbering. The application provides an image browsing capability to display images to review, sort, and edit them once they have been transferred to a computer, to help the user manage their image file collection.

As soon as the transfer is complete and images have been placed in the appropriate folder, the browser window will auto-launch and the last set of images to be imported will be displayed as a series of thumbnail pictures. Shooting data can be viewed in Nikon PictureProject by opening the Organize menu and selecting Information > Shooting Data, or alternatively click on the List button in the bottom right corner of the main pane, the information for each image shown in the main pane will be displayed beside it. You can search for other images in the directory tree shown to the left side of the main browser window.

PictureProject is designed to be intuitive and accessible to beginners and more experienced users alike, and the interface is presented in easy-to-understand manner with tools such as Color Boost and Auto Enhance.

- Image files are automatically imported when a camera is connected to a computer with thumbnail previews available to allow pre-selection of images and confirmation of the memory card contents.
- Drag-and-drop images into easy to locate and display "portfolios" for fast, and simple access to pictures.
- One-click access to the most recently imported images.
- Search features to locate any image quickly by parameters such as the file name, keyword, and date captured or modified.
- Basic digital editing tools including crop, rotate, and zoom the image, and a red-eye reduction tool.
- The Photo Enhance menu offers further options, including tools for controlling Brightness, D-Lighting, Color Booster, Photo Effects, Sharpening, and Straightening.
- The original images are always preserved after editing, ensuring that important pictures are never lost and the editing process can always be reversed.
- Slideshow with user-selectable background music track
- Design templates make it easy to share images in e-mail and attractive print layouts.

Note: If you have an earlier version of Nikon PictureProject installed on your computer you will need to update it to version 1.7.0 (or higher) to ensure fully support and compatibility with image files generated by the D80.

Note: Personally I find the degree of control offered in the image enhancement options of Nikon PictureProject is far to general for anything other than global effects. To adjust and enhance image files with any degree of finesse and accuracy I recommend, strongly, that you use an alternative application, such as Nikon Capture NX, or one of the many third party digital imaging applications.

Nikon View Pro

Once it is becomes available Nikon View Pro should include the following features:

• Fast image display – much quicker display of JPEG, TIFF and RAW (NEF) images

- Action key a single key to which up to five individual actions (selected and combined by user) can be assigned
- Digital Newsphoto Parameter Record (DNPR) data editing – allows DNPR data saved to the IPTC (International Press Telecommunications Council) standard to be edited and copied from one image to another
- Five display modes make it fast, easy and convenient to select images and check details
- Single image display mode offers a choice between 100% and 50% scale
- Multi image display modes (vertical and horizontal) make image comparisons easy, with one window to be fixed and the other to be replaced
- Full-screen display mode maximizes display size with a frameless window option
- Marking adds various possible operations (including sorting, moving, copying and organizing) to marked images
- FTP data transfer supports File Transfer Protocol (FTP) for transferring selected images

Nikon Capture NX

Nikon Capture NX is a far more sophisticated application compared with Nikon PictureProject, as it permits a much greater level of image control; it is available as an optional extra. It represents a complete re-write of the original Nikon Capture application by nik Software and incorporates their unique U-point technology that permits complex selections of an area(s) within an image to be made with an accuracy and speed that is far greater than can be achieved using current digital imaging software, which generally requires the use of complex masking or layering techniques. The user has an extensive toolbox available to enhance and modify any image file regardless of whether it was saved in the NEF, TIFF, or JPEG format. Adjustments to the image file data are both independent and completely variable, permitting complete control over all aspects of the image. The original image file data is always preserved allowing an infinite number of variations to be created and stored without the need to make duplicates of the original data, thus that saving considerable amounts of disk space.

Nikon Capture NX offers many features in addition to the unique U-Point technology, including:

- Advanced white balance control with the ability to select a specific color temperature, or sample from a black, white, or gray point
- Advanced NEF file control that permits attributes such as exposure compensation, sharpening, contrast, color mode, saturation, and hue to be modified after the exposure has been made, without affecting the original image data
- The Image Dust Off feature, which compares an NEF file with a reference image taken with the same camera to help reduce the effects of any dust particles on the lowpass filter
- The D-Lighting tool, which emulates the dodge and burn techniques of traditional photographic printing to control highlight and shadow areas to produce a more balanced exposure
- A Color Noise Reduction tool, which minimizes the effect of random electronic noise that can occur, especially at high sensitivity settings
- An Edge Noise Reduction tool that accentuates the boundary between areas of the image to make them more distinct
- The Color Moiré Reduction feature helps to remove the effects of moiré, which can occur when an image contains areas with a very fine repeating pattern
- LCH Editor allows for control of Luminosity (overall lightness), Chroma (color saturation), and Hue in separate channels

• Fisheye Lens tool converts images taken with the AF Fisheye-Nikkor DX 10.5mm f/2.8G lens so they appear as though they were taken using a conventional rectilinear lens with a diagonal angle-of-view equivalent to approximately 120°

Nikon Camera Control Pro

Nikon Camera Control Pro is an optional, standalone application that allows full remote control of a D80 while the camera both prior to and during shooting while it is connected to a computer via the supplied UC-E4 USB cable. It also supports the direct transfer of images from the camera to a computer, effectively turning the computer hard drive in to a large volume memory card. It also enables the user to create a custom tone (contrast) curve and upload it to too the D80 using the Custom option in the Optimize Image menu.

Web Support

Nikon maintains product support, and provides further information on-line at the following sites:

http://www.nikon.com/ - global gateway to Nikon Corporation

http://www.nikonusa.com/ - for continental North America

http://www..europe-nikon.com/support - for most European countries

http://www.nikon-asia.com/ - for Asia, Oceania, Middle East, and Africa

Glossary

aperture

The opening in the lens that allows light to enter the camera. Aperture is usually described as an f/number. The higher the f/number, the smaller the aperture; and the lower the f/number, the larger the aperture.

artifact

Information that is not part of the scene but appears in the image due to technology. Artifacts can occur in film or digital images and include increased grain, flare, static marks, color flaws, noise, etc.

bit

Binary digit. This is the basic unit of binary computation. See also, byte.

bit depth

The number of bits per pixel that determines the number of colors the image can display. Eight bits per pixel is the minimum requirement for a photo-quality color image.

bracketing

A sequence of pictures taken of the same subject but varying one or more exposure settings, manually or automatically, between each exposure.

buffer

Temporarily stores data so that other programs, on the camera or the computer, can continue to run while data is in transition.

bulb

A camera setting that allows the shutter to stay open as long as the shutter release is depressed.

byte

A single group of eight bits that is processed as one unit. See also, bit.

card reader

Device that connects to your computer and enables quick and easy download of images from memory card to computer.

CCD

Charge Coupled Device. This is a common digital camera sensor type that is sensitized by applying an electrical charge to the sensor prior to its exposure to light. It converts light energy into an electrical impulse.

CLS

Creative Lighting System. This is a flash control system that Nikon introduced with its SB-800 and SB-600 Speedlights. See also, Speedlight.

depth of field

The image space in front of and behind the plane of focus that appears acceptably sharp in the photograph.

diopter

A measurement of the refractive power of a lens. Also, it may be a supplementary lens that is defined by its focal length and power of magnification.

DPOF

Digital Print Order Format. A feature that enables the camera to supply data about the printing order of image files and the supplementary data contained within them. This feature can only be used in conjunction with a DPOF compatible printer.

DX

Nikkor lenses designed specifically for the Nikon DX format sensor.

ED glass

Extra-low Dispersion glass. Developed by Nikon, this glass was incorporated into many of their camera lenses to reduce the effects of chromatic aberration. See also, chromatic aberration.

EV

Exposure Value. A number that quantifies the amount of light within an scene, allowing you to determine the relative combinations of aperture and shutter speed to accurately reproduce the light levels of that exposure.

EXIF

Exchangeable Image File Format. This format is used for storing an image file's interchange information.

FP high-speed sync

Focal Plane high-speed sync. Some digital cameras emulate high shutter speeds by switching the camera sensor on and off rather than moving the shutter blades or curtains that cover it. This allows flash units to be synchronized at shutter speeds higher than the standard sync speed. In this flash mode, the level of flash output is reduced and, consequently, the shooting range is reduced.

1/slop

The size of the aperture or diaphragm opening of a lens, also referred to as f/number or stop. The term stands for the ratio of the focal length (f) of the lens to the width of its aperture opening. (f/1.4 = wide opening and f/22 = narrow opening.) Each stop up (lower f/number) doubles the amount of light reaching the sensitized medium. Each stop down (higher f/number) halves the amount of light reaching the sensitized medium.

gray card

A card used to take accurate exposure readings. It typically has a white side that reflects 90% of the light and a gray side that reflects 18%.

guide number

A number used to quantify the output of a flash unit. It is derived by using this formula: GN = aperture x distance. Guide numbers are expressed for a given ISO film speed in either feet or meters.

histogram

A graphic representation of image tones.

icon

A symbol used to represent a file, function, or program.

IF

Internal Focusing. This Nikkor lens system shifts a group of elements within the lens to acquire focus more quickly without changing the overall length of the lens (as occurs with conventional, helical focusing mechanisms).

image-processing program

Software that allows for image alteration and enhancement.

ISO

From ISOS (Greek for equal), a term for industry standards from the International Organization for Standardization. When an ISO number is applied to film, it indicates the relative light sensitivity of the recording medium. Digital sensors use film ISO equivalents, which are based on enhancing the data stream or boosting the signal.

i-TTL

A Nikon TTL flash control system that has a refined monitor preflash sequence and offers improved flash exposure control. See also, TTL.

JPEG

Joint Photographic Experts Group. This is a lossy compression file format that works with any computer and photo software. JPEG examines an image for redundant information and then removes it. It is a variable compression format because the amount of leftover data depends on the detail in the photo and the amount of compression. At low compression/high quality, the loss of data has a negligible effect on the photo. However, JPEG should not be used as a working format-the file should be reopened and saved in a format such as TIFF, which does not compress the image.

LCD

Liquid Crystal Display, which is a flat screen with two clear polarizing sheets on either side of a liquid crystal solution. When activated by an electric current, the LCD causes the crystals to either pass through or block light in order to create a colored image display.

lossless

Image compression in which no data is lost.

lossy

Image compression in which data is lost and, thereby, image quality is lessened. This means that the greater the compression, the lesser the image quality.

low-pass filter

A filter designed to remove elements of an image that correspond to high-frequency data, such as sharp edges and fine detail, to reduce the effect of moiré. See also, moiré.

Mbps

Megabits per second. This unit is used to describe the rate of data transfer. See also, megabit.

megabit

One million bits of data. See also, bit.

megabyte

Just over one million bytes.

megapixel

A million pixels.

memory

The storage capacity of a hard drive or other recording media.

memory card

A solid state removable storage medium used in digital devices. They can store still images, moving images, or sound, as well as related file data. There are several different types, including CompactFlash, SmartMedia, and xD, or Sony's proprietary Memory Stick, to name a lew. Individual card capacity is limited by available storage as well as by the size of the recorded data (determined by factors such as image resolution and file format). See also, CompactFlash (CF) card, file format.

microdrive

A removable storage medium with moving parts. They are miniature hard drives based on the dimensions of a CompactFlash Type II card. Microdrives are more susceptible to the effects of impact, high altitude, and low temperature than solid-state cards are. See also, memory card.

midtone

The tone that appears as medium brightness, or medium gray tone, in a photographic print.

NEF

Nikon Electronic File. This is Nikon's proprietary RAW file format, used by Nikon digital cameras. In order to process and view NEF files in your computer, you will need Nikon View (version 6.1 or newer) and Nikon Capture (version 4.1 or newer).

Nikkor

The brand name for lenses manufactured by Nikon Corporation.

noise

The digital equivalent of grain. It is often caused by a number of different factors, such as a high ISO setting, heat, sensor design, etc. Though usually undesirable, it may be added for creative effect using an image-processing program. See also, chrominance noise and luminance.

overexposed

When too much light is recorded with the image, causing the photo to be too light in tone.

pan

Moving the camera to follow a moving subject. When a slow shutter speed is used, this creates an image in which the subject appears sharp and the background is blurred.

perspective

The effect of the distance between the camera and image elements upon the perceived size of objects in an image. It is also an expression of this three-dimensional relationship in two dimensions.

pixel

Derived from picture element. A pixel is the base component of a digital image. Every individual pixel can have a distinct color and tone.

plug-in

Third-party software created to augment an existing software program.

RAW

An image file format that has little or no internal processing applied by the camera. It contains 12-bit color information, a wider range of data than 8-bit formats such as JPEG.

RAW+JPEG

An image file format that records two files per capture; one RAW file and one JPEG file.

rear curtain sync

A feature that causes the flash unit to fire just prior to the shutter closing. It is used for creative effect when mixing flash and ambient light.

resolution

The amount of data available for an image as applied to image size. It is expressed in pixels or megapixels, or sometimes as lines per inch on a monitor or dots per inch on a printed image.

slow sync

A flash mode in which a slow shutter speed is used with the flash in order to allow low-level ambient light to be recorded by the sensitized medium.

SLR

Single-lens reflex. A camera with a mirror that reflects the image entering the lens through a pentaprism or pentamirror onto the viewfinder screen. When you take the picture, the mirror reflexes out of the way, the focal plane shutter opens, and the image is recorded.

small-format sensor

In a digital camera, this sensor is physically smaller than a 35mm frame of film. The result is that standard 35mm focal lengths act like longer lenses because the sensor sees an angle of view smaller than that of the lens.

Speedlight

The brand name of flash units produced by Nikon Corporation.

stop up

To increase the size of the diaphragm opening by using a lower f/number.

synchronize

Causing a flash unit to fire simultaneously with the complete opening of the camera's shutter.

thumbnail

A miniaturized representation of an image file.

TIFF

Tagged Image File Format. This popular digital format uses lossless compression.

TTL

Through-the-Lens, i.e. TTL metering.

USB

Universal Serial Bus. This interface standard allows outlying accessories to be plugged and unplugged from the computer while it is turned on. USB 2.0 enables high-speed data transfer.

Wi-Fi

Wireless Fidelity, a technology that allows for wireless networking between one Wi-Fi compatible product and another.

Index

3D Color Matrix Metering (see Matrix metering) A mode (see Aperture-Priority mode) AA (see auto aperture) AE-L (see autoexposure lock) AF area modes 145-148 AF-assist illuminator 149-150 AF-C mode (see continuousservo autofocus mode) AF-L (see focus lock) AF-S mode (see single-servo autofocus mode) Aperture-Priority mode 39, 118, 258 auto aperture 207, 215, 260-261 autoexposure lock 121 batteries 28-29, 221 black and white 96, 110, 167, 175-177 bracketing 107-108, 123-125, 204, 206-207 buffer 127 built-in Speedlight 47-49, 215, 251-252 (see also, flash) bulb mode 42, 133 camera care (see cleaning) card reader 87, 226, 298, 310, 317

CCD (see sensor) center-weighted metering 40-41, 115 cleaning 133, 231-232, 297, 301-304 color temperature 98 continuous-servo autofocus mode 141 continuous frame shooting mode 44, 129, 157, 306 control panel 35, 36 default settings 61-62, 156 delete 162, 182-183 depth of field 151-154 Digital Vari-Program modes 38, 42, 60, 61, 62, 64-74 DPOF 313, 321-323 DX-format sensor (see sensor) EXIF 313-314 exposure compensation 39, 122-123 38-40, exposure modes 116-121 filters 292-293 flash 245-281 focus lock 148-149, 151 focus tracking 143-144 formatting 58, 223-224 histogram 158, 160, 162-

165

image overlay 145, 242 image processing 42 image quality 61, 94-97 image size 61, 94-97 IPTC 314 ISO 62, 108-111 JPEG 32, 88, 89, 90-91 LCD monitor 45-46 lenses 151, 283-291 M mode (see Manual exposure mode) Manual exposure mode 39, 120-121 manual focus 141-142 Matrix metering 27, 40-41, 112-115 memory cards 57-59 menus 179-242 metering 40-41, 111-116 white balance 41, 97-108 multiple exposure 134-135 workflow 297-300

- NEF 32, 33, 88, 89, 90, 92-94
- optimizing images 42, 74, 166-177

P mode (see Programmed Auto mode) Programmed Auto mode 39, 117-118 75, 161-162 protect

RAW (see NEF) remote release 44-45, 131, 132-133

S mode (see Shutter-Priority mode) Secure Digital (SD) cards (see memory cards) self-timer 44, 129-131, 219 sensor 29-32, 283-285 shooting modes 44-45, 128-131 Shutter-Priority mode 39, 118-120 single frame shooting mode 125, 128-129 single-servo autofocus mode 141 spot metering 41, 115-116 television 185, 225, 315 two-button reset 156-157 viewfinder 33-34, 204-205